D1343389

# CAVE ART

## A GUIDE TO THE DECORATED
## ICE AGE CAVES OF EUROPE

### Paul G. Bahn

F

FRANCES LINCOLN LIMITED
PUBLISHERS

Frances Lincoln Ltd
4 Torriano Mews
Torriano Avenue
London NW5 2RZ
www.franceslincoln.com

Cave Art

Copyright © Frances Lincoln 2007
Text copyright © Paul Bahn 2007
Photographs copyright © as page 223
Designed by Anne Wilson
Maps by Linda Dawes

First Frances Lincoln edition: 2007

Paul Bahn has asserted his right to be
identified as the author of this work in
accordance with the Copyright, Designs
and Patents Act 1988 (UK).

A catalogue record for this book is
available from the British Library.

ISBN 10: 0-7112-2655-5
ISBN 13: 978-0-7112-2655-5

Printed and bound in Singapore
9 8 7 6 5 4 3 2 1

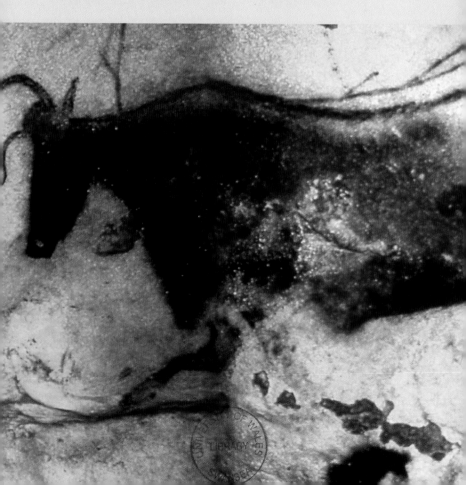

# For Nadine, who helped so much . . .

*Cavernario bisonteo,*
*tenebroso rito mágico,*
*introito del culto trágico*
*que culmina en el toreo.*

Miguel de Unamono

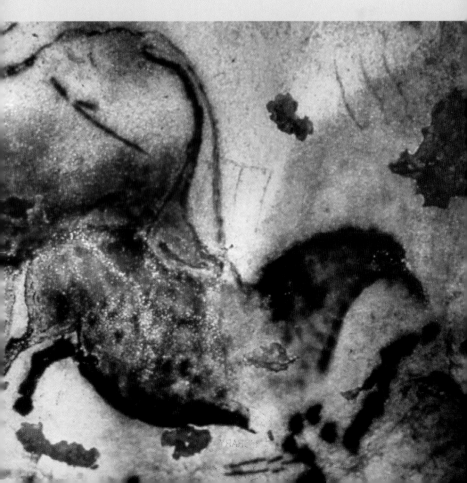

# CONTENTS

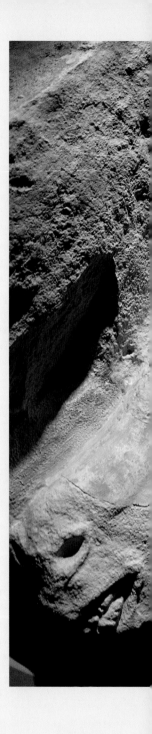

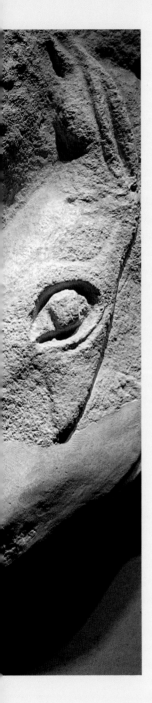

# INTRODUCTION

THERE ARE MANY REASONS for visiting the Ice Age decorated caves of Europe. You may be making a pilgrimage, in homage to the region's artists of 30,000–10,000 years ago; you may be visiting out of curiosity, books, television or lecture slides having triggered your interest. Whatever your motivation, there is simply no substitute for seeing the sites themselves. You will see some of humankind's greatest artistic achievements in their unusual, evocative and original settings. In addition, many of the caves are in regions of outstanding beauty and wonderful climates, famed for their wines and cuisines.

A visit to an Ice Age cave is a tremendous privilege. After more than a century of research, we still know of only about three hundred such sites in Eurasia, and because of difficulties of access or conservation concerns only a small fraction of these are open to the public. Thus Ice Age caves constitute a very limited and finite resource. In a cave visitors can approach original masterpieces really closely and see the images precisely where they were created, standing or crouching just where the artists did – an experience unparalleled by major art galleries such as the Louvre or the Prado.

In many cases, the journey to the cave entrance and the route through the chambers give your experience an immediacy, purity and vividness. There is nothing like a stalactite dripping on your head to remind you that you are in a pristine and natural setting. Entering a world far removed from one of commerce, art dealers and critics enhances a feeling of connection with the artists.

Although a number of decorated caves have had to be closed to the public in recent years (for example Santimamiñe, Maltravieso), others have been re-opened (for example Candamo). In addition some new discoveries have been opened for the first time – most notably El Pendo, Church Hole (Creswell Crags) and various open-air sites in Spain and Portugal. Moreover, such has been the enormous success of the facsimiles of the caves of Lascaux and

Altamira that a whole series of such replicas is already in production and will be opening in the next few years.

In view of the ever-growing popularity of Ice Age cave art, this book is intended to help you prepare for an enjoyable and meaningful visit. The excellent and knowledgeable guides at each site will further enhance your experience.

Strangely, there has been no English-language guidebook to the caves for over forty years (since Sieveking and Sieveking, 1962). One French guidebook (Vialou, 1976) featured only French caves and, somewhat perversely, included caves which are not open to the public; a second (Nougier, 1990) also covered Spain and Italy, but with minimal information. Hence the need for an up-to-date, useful handbook which not only describes each site but also provides a maximum of practical and logistical information.

The most important thing to bear in mind when visiting the caves is: do not touch! These images are infinitely older and more fragile than pictures in galleries, and our paramount concern must be their preservation. In addition, equal care must be taken to avoid brushing against the cave walls or against stalagmites, except where narrowness makes doing this unavoidable.

What may surprise and disappoint you is that photography, including digital photography, is forbidden in almost all the caves, even the facsimiles. However, it is well worth bringing your camera, since you may wish to take photos at the cave entrance, photograph your guide after the visit or capture the sometimes spectacular scenery in the vicinity.

Food and drink are not allowed inside the caves, since they can introduce undesirable bacteria and organisms, in addition to posing a potential litter problem. Similarly, to keep the cave environment as pristine as possible, smoking is prohibited, and no animals are allowed inside – which is somewhat ironic, since both Lascaux and Altamira were found by dogs.

Some caves have a minimum age requirement for children, as noted in the relevant information sections in this book. Where there is no such requirement, it is nevertheless advisable not to take

babies or infants inside, because many of them become frightened by the strange, cool, dark surroundings, and negotiating the passages and stairs can be difficult enough for an adult without needing to hold or carry a small child at the same time. It is preferable to take infants to the facsimiles instead.

Conditions inside the caves remain unchanged throughout the year – they are therefore cool in the summer and mild in the winter (usually around 11–13°C), with 98 or 99 per cent humidity. The weather outside, on the other hand, is highly variable. The experienced traveller will bring several layers of casual clothing, and since feet can get wet in some caves, extra socks are advisable. Some sites contain stairs, and slippery or muddy areas, so comfortable shoes with a good grip are essential. A number of caves are electrically lit, while others have few lights or none at all. In those cases, flashlights are provided for visitors. It is nevertheless useful to carry a small torch with you, and use it in accordance with the guide's instructions.

Most caves are simply too arduous for visits by people with physical disabilities. Those which are more easily accessed are noted throughout this guide. The facsimiles are a wonderful alternative. At least two caves – Font de Gaume and Les Combarelles – offer special visits for the blind, during which they are shown texts, cave plans and reproductions of the principal figures, all in Braille, and given statuettes of the main animal species to feel. They are also allowed to touch the rock outside the caves, and taken inside to feel the temperature and humidity, and to ascertain the volume of the spaces from the echoes.

Since only a few caves have facilities where valuables or cameras can be locked safely during your visit, and bags and backpacks are not allowed inside, it is advisable to wear a money belt or something similar, or garments with plenty of pockets.

Not all the caves have toilet facilities near by, so a supply of toilet paper, sanitizer and handwipes for emergencies is a wise precaution. Similarly, bottled water, sunscreen and a sun hat may prove invaluable. You may also find useful a pen and paper for

notes, and some local currency, in small denominations, for tips and souvenirs.

All the caves and sites in this book are well signposted and easy to find on regional maps. It is remarkable to reflect that the Ice Age artists journeyed to these places on foot or by river, simply by means of their knowledge and memory of the landscapes.

The details given in this guide concerning opening times, booking methods and prices were all current at the time of going to press, but obviously they may be liable to change – especially the prices.

In some decorated caves open to the public – for example Le Mas d'Azil (French Pyrenees) or Nerja (southern Spain) – the art is not shown, so they are not included here. In addition, some decorated caves which have been open to the public in the past are (at the time of writing) undergoing a change of ownership, so it is uncertain when or whether they will re-open to visits. This applies to St Cirq and La Mouthe. If you are in the Les Eyzies area, it may be worth enquiring whether they are accessible. If they re-open, they will certainly be included in the next edition of this book. Similarly the Cantabrian cave of Santián is due to re-open soon, and it is therefore worth checking the regional website (see page 135) to see if it can be visited. Finally, a new Parque de la Prehistoria, similar to France's Parc Préhistorique, with facsimiles of cave art from a variety of sites, is due to open in 2007 at Teverga, Asturias, 40 km from Oviedo.

Nougier, L-R., 1990, *Les grottes préhistoriques ornées de France, d'Espagne et d'Italie*, Editions Balland: Paris.

Sieveking, A. and Sieveking, G., 1962, *The Caves of France and Northern Spain*, Vista Books: London.

Vialou, D., 1976, *Guide des grottes ornées paléolithiques ouvertes au public*, Masson: Paris.

# CAVE ART

ALTHOUGH THE VAST MAJORITY of prehistoric rock art occurs in the open air or in shallow rock shelters – as for example in South Africa, North and South America and Australia – in a few parts of the world there is an important body of art (mostly paintings and engravings) lying in total darkness within deep caves. 'Cave art' is a term used to describe any kind of human-made figure on the walls, ceiling or floor of a cave or rock shelter. Although such images are found in many parts of the world and in many different periods, the term has become associated primarily with the parietal (wall) art of the European Upper Palaeolithic, between c.30,000 and 10,000 BC – the hundreds of decorated caves from the Ice Age of Eurasia.

Because caves appear to be mysterious and menacing places to us, there has long been a tendency to associate their art with secret, esoteric, exclusive rites redolent of fear and awe. Rock art in the daylight and the open air seems far less 'private'. But it would be simplistic to interpret art of the past in relation to such modern impressions: as we know from Australia, for example, open-air sites can be just as imbued with power and taboo as anything underground, and some of the art in deep caves appears to be 'public', being easily visible in large, readily accessible chambers. However, a great deal of it is undeniably private, in small niches, or chambers accessible only through a long journey or after negotiating difficult physical obstacles necessitating climbs, crawls or tight squeezes. There are cases – like the famous Ice Age clay bison of France's Tuc d'Audoubert – where it seems that the very acts of making the journey and of producing the images were what mattered, and that the artist(s) never returned to visit their work.

Why was art placed in such inaccessible locations? Deep caves are strange environments, bereft not only of light but also of sound – except perhaps for that of dripping water or, at times, bats. You experience utter blackness, total silence, a loss of sense of direction, a change of temperature and frequently a sense of claustrophobia.

To enter a deep cave is to leave the everyday world and cross a boundary into the unknown – a strange, supernatural world. It is easy to imagine that caves therefore symbolized transitions in human life and were used for rituals linked with those transitions, especially puberty rites. Or perhaps it was felt that by entering this world one could better commune with or summon up the supernatural forces which dwelt there, and hence the images were made to reach and compel those forces. Cave decoration certainly requires strong motivation, since it involves negotiating obstacles and taking both equipment and lighting into the site.

The existence of Ice Age art was first established and accepted through the discovery of small, portable decorated objects in a number of caves and rock shelters in south-west France in the early 1860s (a few objects had been found earlier, but there was then no conception of a Palaeolithic period and they were declared to be Celtic in date). Edouard Lartet, a French scholar, and Henry Christy, a London industrialist and ethnographer, were the main discoverers: their finds included a bear's head engraved on antler, from Massat (French Pyrenees) and a mammoth engraved on a fragment of mammoth ivory from La Madeleine (Dordogne). The objects were clearly ancient, since they were associated with early tools of stone and bone, and with the bones of Ice Age animals. Some of the drawings depicted creatures which were now extinct (such as the mammoth) or which had long ago deserted this part of the world (such as the reindeer).

These first discoveries triggered a kind of gold rush, with numerous people digging in caves and shelters in search of ancient art treasures. One or two noticed drawings on the cave walls, but thought nothing of them. The first real claim for the existence of Ice Age cave art was made in 1880 for the Spanish cave of Altamira by a local landowner, Marcelino Sanz de Sautuola. Unfortunately, most archaeologists of the time treated his views with great scepticism and even contempt, partly because Sanz de Sautuola was a complete unknown, rather than an established scholar, and partly because nothing similar had ever been reported before and almost all known

portable art came from France. The rejection of Altamira persisted for twenty years until a breakthrough was made at the cave of La Mouthe (Dordogne) where, in 1895, the removal of some earth exposed an unknown gallery with engravings on its walls, including one of a bison figure. The presence of Ice Age tools in the earth blocking the gallery made it clear that these pictures must be ancient. Finally, in 1901, engravings were found in the cave of Les Combarelles (Dordogne) and paintings in the nearby cave of Font de Gaume. In 1902, the world of archaeology officially accepted the existence of cave art.

Once again, a kind of gold rush followed, and numerous new sites and galleries were found when people started looking for them. Discoveries still continue in Europe; even today an average of one such cave per year is found in France and Spain.

Portable (or mobiliary) art objects – beads, figurines, small carvings, or engravings on pieces of stone, bone, antler or ivory – are found from Spain and North Africa to Siberia, with large concentrations in Western, Central and Eastern Europe. Tens of thousands of specimens are known, but while some sites yield few or none, others contain hundreds or even thousands of items of portable art.

The distribution of cave art is equally patchy, though it is most abundant in areas that are also rich in decorated objects: the Périgord (south-west France), the French Pyrenees and northern Spain. Ice Age decorated caves are found from Portugal and the very south of Spain to the north of France and England. Traces may have been found in south-west Germany, and there are concentrations in Italy and Sicily. A handful of caves are also known in former Yugoslavia, Romania and Russia. The current total for Europe is about three hundred sites. Some contain only one or a few figures on the walls, while others like Lascaux (in south-west France) or Les Trois Frères (The Three Brothers, in the French Pyrenees) have many hundreds.

Dating portable objects is relatively easy, since their position in the layers of a site, in association with stone and bone tools, gives a pretty clear idea of the period to which they belong, while

radiocarbon dating of organic material from these levels, or even from the art objects themselves, can give more precise results.

Dating art on the walls used to be far more difficult. Where the caves were blocked during or just after the Ice Age, or where all or part of the decorated walls are covered by datable deposits, a minimum age can be established. There are also a few cases where a fragment of decorated wall has fallen and lies in the archaeological layers, though this provides an approximate date for when the art fell rather than when it was made. Some caves contain occupation

Sculpted ibex on a block from Roc de Sers, in the Musée d'Archéologie Nationale.

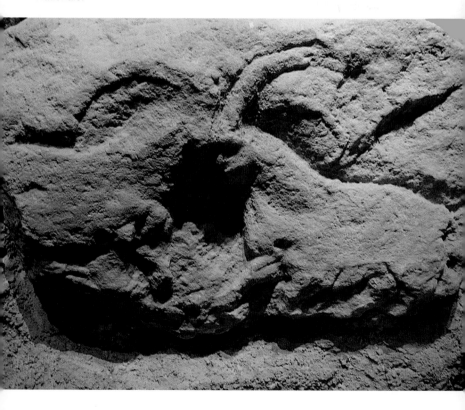

deposits that may plausibly be linked with art production (for instance through the presence of colouring materials). If a site with art on the walls has also produced portable art, there are sometimes clear similarities between the two in technique and style, thus providing a fairly reliable date for the wall decoration.

One of the earliest techniques adopted for dating different phases of cave art was that of studying superimpositions; some phases might be dated through comparison with portable art from the same caves. However, superimposition is a tricky chronological guide, since it can be difficult to establish the order in which layers were applied, and the timespan involved is impossible to assess – a superimposition could have been done in half an hour or after thousands of years.

For the many caves without occupation or without portable art, it became necessary to make comparisons of style with material from other sites and even other regions, a practice that led inevitably to subjectivity and to sequences of development that were far too simple, since all stylistic arguments are based on an assumption that figures which appear similar in style or technique were made at roughly the same time. Most specialists imagined that there had been an overall progression from simple, crude-looking forms to complex, detailed, accurate figures of animals.

The first such scheme was put forward by the abbé Henri Breuil, a French priest and doyen of palaeolithic art specialists, who based it primarily on the presence or absence of 'twisted perspective', a feature he considered primitive, and which means that an animal figure in profile still has its horns, antlers, tusks or hoofs facing the front. Breuil decided that this was an archaic feature, associated with early phases of cave art, whereas in the Magdalenian (the last phase of Ice Age culture, c.15,000 to 9,000 BC) everything was drawn in proper perspective. He therefore developed an 'evolution of perspective', which included a 'semi-twisted' stage at Lascaux. Unfortunately his scheme was inconsistent, since twisted hoofs are known in the Magdalenian (for example on the Altamira bison), while true perspective sometimes occurs in early phases. Overall,

Breuil saw a progression from schematic to naturalistic and finally to degenerate forms.

His scheme was eventually superseded by that of André Leroi-Gourhan, a French scholar who dominated cave art studies after Breuil's death in 1961. Basing his scheme primarily on the characteristics of what seemed to be securely dated figures, he proposed a series of four 'styles' which were seen as an unbroken development with a series of 'pushes' separated by long periods of transition. Like Breuil's scheme, it saw an overall progression from simple, archaic forms to complex, detailed, accurate figures of animals. Palaeolithic art was treated as an essentially uniform phenomenon, with diversity played down in favour of standardization and developments greatly oversimplified. Now, however, it is generally recognized that Ice Age art did not have a single beginning and a single climax: there must have been many of both. Each period probably saw the coexistence of a number of styles and techniques, as well as a wide range of talent and ability.

In the 1990s, thanks to advances in the sciences, detailed analysis of tiny amounts of pigment from wall paintings revealed that many black figures, previously assumed to be made of manganese (a mineral), actually contain or consist of charcoal (an organic material which can be dated). Radiocarbon dating used to require so much charcoal that a whole painting would have had to be sacrificed, which nobody would have allowed. However, the development of accelerator mass spectrometry means that it is now possible to obtain radiocarbon dates from very tiny samples, the size of a pinhead, which can be removed without damaging the paintings. A number of figures in Ice Age decorated caves have already been dated in this way. In many cases, the results suggest that the figures were accumulated in a more episodic and far more complex way than had previously been supposed, and sometimes spanned a far longer period than had been believed. The next few years will produce many more such dates, which will revolutionize our knowledge of precisely how caves were decorated.

There are sporadic occurrences of a variety of non-utilitarian objects in earlier periods, such as series of evenly spaced engraved lines on bones from the site of Bilzingsleben in eastern Germany, dating to about 350,000 years ago, and the 'female figurine' found by Israeli archaeologists in 1981 at Berekhat Ram on the Golan heights. Dating to at least 230,000 years ago, the latter is a small pebble of volcanic tuff, its natural shape something like a female, which had grooves purposely cut around its neck and along the arms to accentuate the resemblance. Both this art object and the German engravings must have been made by *Homo erectus*, an early form of human, while Neanderthals also produced occasional non-functional engravings around 50–60,000 years ago. However, the vast majority of surviving palaeolithic art was produced by *Homo sapiens sapiens*, fully modern people like ourselves, in the period between 40,000 and 11,000 years ago.

For the present, apart from occasional occurrences of a variety of simple art objects in earlier periods, the earliest known European Ice Age art occurs more than 30,000 years ago in the form of well-made ivory carvings of animals from several caves in south-west Germany. However, serious doubts persist about the attribution of all the incredibly sophisticated paintings of the cave at Chauvet to this early period. Ice Age art seems to peter out with the end of the Ice Age, about 11,000 years ago.

Portable art comprises a very wide variety of materials and forms. The simplest are the slightly altered natural objects – fossils, teeth, shells or bones that were cut, sawn or perforated to form beads or pendants. Some sites have hundreds of 'plaquettes' (slabs of stone with drawings engraved on to them). Engravings are also known on flat pieces of bone, such as shoulder blades, which are far more difficult to make and require very sharp tools. The technique of  *champlevé* was invented, where bone around a figure is scraped away, making the design stand out as in a cameo; and the skill was also developed of engraving on bone and antler shafts, not only lengthwise but also around the cylinder, keeping the proportions perfect even though the whole figure could not be seen at once.

Towards the end of the Ice Age, particularly in the Pyrenees, animal figures and circular discs were cut out of thin, flat bones. Antler spear throwers, another late speciality, either have animal heads or forequarters carved in relief along the shaft, or have figures carved in the round at the hook end of the object, where the roughly triangular area of available antler dictated the posture and size of the carvings. However, within these limits, the artists produced a wide variety of images such as fighting fawns, a pheasant, mammoths, a leaping horse and, most notable of all, a series of examples depicting a young ibex, its head turned to look back to where birds are perched on what seems to be an enormous turd emerging from its rear end. Up to ten intact or broken examples of this apparently very popular composition are known.

A few fired-clay models have survived in a number of different areas, especially Moravia (Czech Republic), but the vast majority of Ice Age statuettes – characterized by the well known but badly named 'Venuses' or female figurines – are made of mammoth ivory or soft stone. Ivory was also used to produce bracelets and armlets.

Cave art itself comprises an astonishing variety and mastery of techniques. One basic approach was the use of natural rock formations: the shapes of cave walls and stalagmites were employed in countless examples to emphasize or represent parts of figures.

The simplest form of marking cave walls was to run fingers over them, leaving traces in the soft layer of clay. This technique, perhaps the most ancient of all, probably spans the whole period and may have been inspired by the abundance of claw marks of cave bears and other animals on the walls. In some caves, the finger lines also include some definite animal and human-like figures. Engraving, as in portable art, is by far the most common technique on cave walls, with incisions ranging from the fine and barely visible to broad deep lines. Scratching and scraping were also used at times, where the wall was too rough for fine incisions, or to create a difference in colour between the light scraped area and the darker surroundings. The tools used for engraving varied from crude picks to sharp flint flakes.

Work in clay was a regional speciality that is restricted to the Pyrenees: it ranges from finger holes and tracings to engravings in the cave floor and figures made on artificial banks of clay. The finest clay figures are two famous statues of bison in the cave of Le Tuc d'Audoubert and the headless bear which crouches like the sphinx in the cave of Montespan, and which is made of about 1,500 pounds of clay.

Wall carvings are similarly limited in distribution, this time to the Périgord and Charente regions of south-west France, where the limestone could be shaped, as well as northern England. But whereas clay figures are known only from the dark depths of caves,

The leaping horse from Font de Gaume.

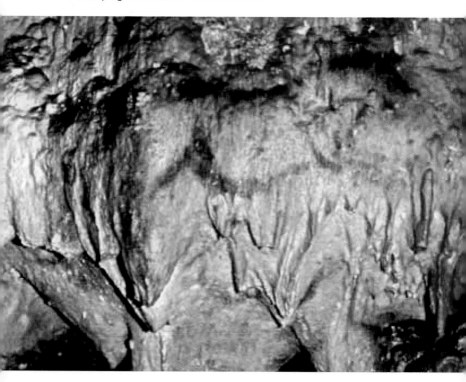

sculptures are always in rock shelters or the brightly lit front parts of caves. The figures were created with strong tools such as hammerstones and picks. Almost all the wall sculptures have faint traces of red pigment and were originally painted, like much portable art.

The red pigment used on cave walls is iron oxide (haematite, or red ochre), while the black is usually manganese or charcoal. The main colouring materials were readily available, either casually collected as fragments or mined from known sources. Studies of pigments, particularly at the cave of Niaux in the French Pyrenees, have revealed the possible use of specific 'recipes' combining colouring material with 'extenders' such as talc or feldspath, which made the paint go further. Analyses have also begun to detect traces of animal and plant oils used as binders, to help fix the pigments to the rock surface, while experiments suggest that in some cases cave water was used for this purpose.

The simplest way to apply paint to walls was with fingers, and this was certainly done in some caves, but normally paint was applied with some kind of tool, though none has survived. Lumps of pigment may have been used as crayons, but since they do not mark the rock well, they were more likely to be sources of powder. Experiments suggest that animal-hair brushes or crushed twigs were the best tools to use. In some cases, paint was clearly sprayed, either directly from the mouth or through a tube, to produce dots as well as hand stencils (a way of leaving a hand print by placing the palm against the rock and blowing paint on to it and all around it).

The vast majority of figures drawn with pigment in the caves are simple outlines or have some infill – for example, some of the animals in the Chauvet cave display a very sophisticated use of shading. The two-colour and multi-colour figures of the end of the Ice Age (such as the bison on the ceiling at Altamira) are rare in comparison with engravings and outlines.

Figures have been found not only on clay floors and on walls but also on ceilings (though not in the Pyrenees). Some, like the Altamira ceiling, were within easy reach, but for others a ladder or

scaffolding was required. At Lascaux, holes cut into the wall of one gallery give some idea how the scaffolding was constructed.

Light was provided by fireplaces in some caves, but portable light was necessary in most cases. Since only a few dozen definite stone lamps are known from the whole period, it is likely that burning torches were generally used which left little or no trace other than a few fragments of charcoal or black marks on the walls. However, since 1981 it has become apparent that Ice Age people also produced rock art in the open air, where it can survive in exceptional circumstances: about a dozen sites have so far been found in Portugal, Spain and the French Pyrenees, where the animal engravings are almost certainly of this period, judging by their style.

In wall art, unlike portable art, there was no great limit on size, and figures range from the tiny to the enormous (over 2.5m in some cases, with the great Lascaux bulls exceeding 5m). Small figures are often found with large; the ground was almost never drawn, and there are no landscapes.

For convenience, Ice Age drawings are normally grouped into three categories, although there is some overlap and uncertainty between them: these are animals, humans and non-figurative or abstract (known as 'signs'). The vast majority of animal figures are adults drawn in profile, most of them easily recognizable, although many are incomplete or ambiguous, and a few are quite simply imaginary, such as the two-horned 'unicorn' of Lascaux. Schematization, where a figure is reduced to its essential traits, is frequently seen in the isolated neck and back lines of horses, bison or mammoths.

The age of the animals can almost never be estimated, except for the very few juveniles known. The animals' sex is sometimes displayed directly, but almost always discreetly, so that secondary sexual characteristics such as antlers or size and proportions often have to be relied upon.

Engraved horse and ibex at Penascosa, Côa Valley.

Most figures seem motionless – in fact, many may well be wounded, dying or dead – and animated drawings are rare, most of them appearing towards the end of the Ice Age. 'Scenes' are very hard to identify in Ice Age art, since it is often impossible to prove that figures are associated, rather than simply next to each other. Only a very few definite scenes are known.

One central fact is the overwhelming overall dominance of the horse and bison among Ice Age depictions, although other species (such as the mammoth or deer) may dominate at particular sites. Carnivores such as cats or bears are rare in most sites (with the exception of Chauvet); fish and birds are far more common in portable art than in wall art. Insects and recognizable plants are limited to a very few examples in portable art.

In short, Ice Age art is neither a simple catalogue of the animals in the artists' world nor a random collection of artistic observations of nature. It has meaning and structure, with different species dominating in different periods and regions.

Depictions of people can be divided into definite humans, 'humanoids' and 'composites'. Definite humans are scarce in wall art (portable art accounts for over 75 per cent of Ice Age human depictions), and there are very few women resembling the 'Venus figurines', which actually depict females of a wide span of ages and types, and are by no means limited to the handful of fat specimens that are often claimed to be characteristic. Genitalia are rarely depicted, so one usually has to rely on breasts or beards to differentiate the sexes, and most humans have to be considered neutral. Clothing is rarely clear, and details such as eyebrows, nostrils, navels and nipples are extremely uncommon. Few figures have hands or fingers drawn in any detail.

Humanoids comprise all those figures interpreted, but not positively identified, as being human: grotesque heads, 'masks' and 'phantoms' could be either animal or human. Composites are figures that have clear and detailed elements of both. In the past all such figures were automatically and unjustifiably called sorcerers and were assumed to be shamans or medicine men in a mask or

animal costume. But they could just as easily be imaginary creatures, humans with animal heads. In any case, such composites (the most famous being the 'sorcerer' of Les Trois Frères) are very rare, occurring in only a handful of sites.

The non-figurative markings of the Ice Age have often seemed uninteresting, or impossible to explain or define; but nowadays researchers believe that these marks may have been of equal, if not greater, importance to Ice Age people than the 'recognizable' figures. Non-figurative marks are two or three times more abundant than figurative, and in some areas far more. The category covers a tremendously wide range of motifs, from a single dot or line to complex shapes and to extensive panels of apparently unstructured linear marks. 'Signs' can be totally isolated in a cave, clustered on their own panels or closely associated with the figurative.

In the past, some shapes were assumed to be pictographic (that is, to represent objects) on the basis of what they looked like – hence there arose terms like 'tectiforms' (huts), 'claviforms' (clubs), 'aviforms' (birds), etc. These are no longer taken literally but used merely as rough guides to shape. However, it is impossible to know whether they are real objects or abstract designs, or both.

The simpler motifs are more abundant and widespread, as one might expect, since they could be invented in many places and periods. The more complex forms, however, show great variability and are more restricted in space and time, to the extent that they have been seen as ethnic markers, perhaps delineating social groups of some kind. The marks were not set down at random, but follow some set of rules, as the animal figures do. What those rules might mean is the thorniest problem in Ice Age art.

The first and simplest theory put forward to explain the existence of art in this period was that it had no meaning: it was just idle doodling, graffiti, play activity – mindless decoration by hunters with time on their hands. This 'art for art's sake' view arose from the first discoveries of portable art, but once cave art began to be found it rapidly became clear that something more was involved: the limited range of species depicted, their frequent inaccessibility and

their associations in caves, the crowded and empty panels, the mysterious signs, the many figures that are purposely incomplete or ambiguous – all combine to suggest that there is complex meaning behind both the subject matter and the location of Ice Age figures. There are patterns that require explanation, repeated patterns suggesting that the individual artists were subject to a widespread system of thought.

At the beginning of the twentieth century, a new kind of theory took over: that the art was utilitarian – that is, it had a definite function. This theory was based largely on newly published accounts of Australian Aborigines which inspired researchers to compare these 'primitive' users of stone tools with those of Ice Age Europe, and thus to assume that the same purpose lay behind the art of both cultures. The Aborigines were said to perform ceremonies in order to multiply the numbers of the animals, and for this purpose they painted likenesses of these species on rocks. The analogy seemed perfect, and for decades all ideas and interpretations of cave art were subjectively chosen in this way out of the growing mass of ethnographic material from around the world.

'Sympathetic magic', including hunting magic, operates on the same basis as pins in a wax doll: that is, the depictions of animals were produced in order to control or influence the real animals in some way. Such ritual and magic were seen in almost every aspect of Ice Age art – breakage of decorated objects, images 'killed' ritually with images of spears or even physically attacked; claviforms were seen as clubs and tectiforms as pit traps.

This subjectivity and wishful thinking led to many errors, as the theory was stretched and adapted to fit the evidence or facts were carefully selected to fit the theory. Overall, there are very few Ice Age animal figures with 'spears' drawn on or near them, and most caves have no images of this type at all. The spears (whatever they are) also occur on some human and humanoid figures. There are no clear hunting scenes. Moreover, the animal bones found in many decorated caves bear very little relation to the species depicted on the walls, and it is clear that the artists were not, by and large,

drawing what they had killed or wanted to kill. This was not a 'hunters' art' in any simple sense.

Another popular and durable explanation of much Ice Age art is that it involves 'fertility magic': that is, that the artists depicted animals in the hope that they would reproduce and flourish to provide food in the future – a different kind of sympathetic magic. Once again, examples were selected which seemed to fit the idea, and researchers often saw what they wanted to find: animals mating, and an emphasis on human sexuality. Yet few animals have their sex shown, and genitalia are almost always shown discreetly. As for copulation, in the whole of Ice Age art there are only a couple of possible examples, and they are extremely doubtful. Similarly, where humans are concerned, few figures have their genitalia marked, and the one or two claimed depictions of copulation are very sketchy and dubious.

It is clear that the greater part of Ice Age art is not about either hunting or sex, at least in an explicit sense. The next major theoretical advance, however, introduced the notion of a symbolic sexual element. In the 1950s two French scholars, Annette Laming-Emperaire and André Leroi-Gourhan, concluded that caves had been decorated systematically rather than at random. They based their interpretation on all the figures in a cave rather than on a selected few. Wall art was treated as a carefully laid-out composition within each cave; the animals were not portraits but symbols.

An investigation of how many figures of each species existed in each cave, together with their associations and their location on the walls, led Leroi-Gourhan to divide animals into four groups, based on the frequency of their depiction in cave art as a whole. He also divided caves into entrance zones, central zones and side chambers and dark ends. It appeared that about 90 per cent of groups A (horse) and B (bison and wild ox) were concentrated on the main panels in the central areas; most C figures (ibex, deer, mammoth) were near the entrance and on the peripheries of the central compositions; while D animals (carnivores, rhinos) were clustered in the more remote zones. He then developed the concept of an

ideal or standard layout to which each cave was adapted as far as possible: these were organized sanctuaries, with repeated compositions separated by zones marked with appropriate animals or signs.

Unfortunately, there are many exceptions to Leroi-Gourhan's 'rules' – and the very central and prominent cats and rhinos in the cave at Chauvet, discovered after he died, have shown again how wrong he was. Moreover, his scheme worked on a presence/absence basis, not on abundance, so a single horse figure was seen as the equivalent of a mass of bison, or vice versa. Other variations such as colour, size, orientation, technique and completeness were also ignored. Recent detailed studies, both of individual caves and of regional groups, stress that each site is unique and has its own 'symbolic construction' adapted to its own shape and size.

Leroi-Gourhan lumped all Ice Age cave art into his scheme, and believed that it remained much the same for 20,000 years. There is certainly a degree of continuity over this timespan: caves are decorated with the same fairly restricted range of animals in profile, and seem to represent variations on a theme.

Leroi-Gourhan's other key approach was his discovery of repeated 'associations' in the art, and his claim that there was a basic 'dualism'. Laming-Emperaire believed the horse to be equivalent to the female and the bison to the male; for Leroi-Gourhan it was the other way round. The numerically dominant horses and bison, concentrated in the central panels, were thought to represent a basic duality that was assumed to be sexual. This idea was then extended to the signs, which were considered male (phallic) and female (vulvar).

More recent studies have confirmed the fundamental role and opposition of horses and bison; it was also found that some associations of animals are rare or non-existent – for example, one never finds depictions of bison with wild cattle, or bison with stags.

Bison on the ceiling of the Altamira facsimile.

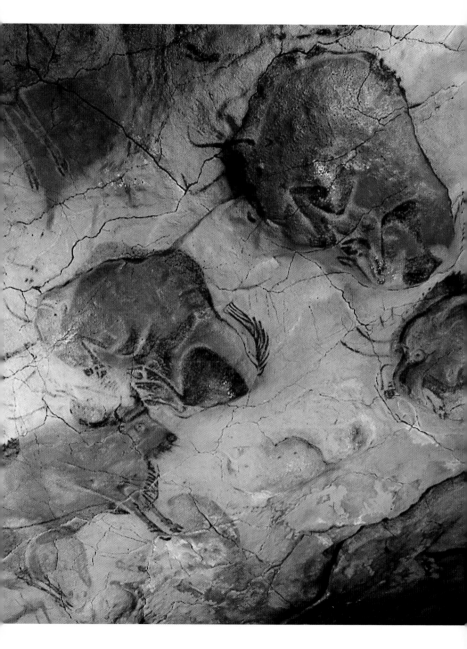

In other words, Leroi-Gourhan may not have found a universally applicable formula, but he did discover order and repeated associations. Laming-Emperaire eventually dropped this approach and instead adopted a theory reverting to totemism: that is, she saw a decorated cave as a model of a group's social organization, with animals of various sizes and ages representing either different generations or the mythical ancestors of different clans. This view was more flexible than that of Leroi-Gourhan, since it did not expect everything to remain stable through time and space, but rather to be different in each cave.

The work of these two scholars completely changed the way in which Ice Age art is studied. The images were seen no longer as simple representations with an obvious and direct meaning but as being full of conceptual ideas.

The most recent work on Ice Age art is splintering in many directions. One researcher, for example, has investigated the shape of wall surface beneath each figure, finding in some caves that a high proportion of horses, deer and hand stencils are on concave surfaces, while an equally high percentage of bison and cattle are on convex; another is seeking detailed and firm methods by which to recognize the work of individual artists – we do not, of course, know the sex of the Ice Age artists, and there is no justification for assuming that the art was all done by men and for men. Other researchers are investigating the acoustics in different parts of the cave, and finding a clear correspondence between the richest panels and the best acoustics, suggesting that sound played an important part in whatever ceremonies accompanied the production of cave art.

No single explanation can account for the whole of Ice Age art: it comprises at least two-thirds of known art history, covering 25,000 years and a vast area of the world; it ranges from beads to weapons and statuettes, from figures on blocks and rocks in the open air to complex signs hidden in the inaccessible crannies of deep caverns. Almost every basic artistic technique is represented, with everything from realism to abstraction. Not all of it is necessarily mysterious or religious, though some cave art is almost certainly linked to ritual

and ceremony. Some is private, some public; some figures are hidden, others draw attention to themselves. It is generally agreed that Ice Age art contains messages, no doubt of many kinds, but unfortunately we rarely know how to read them. Nevertheless, there is a great deal to be learned from their content, techniques, location and associations. Ice Age images provide us with a fascinating glimpse into the world of our ancestors: the animals (some of them now extinct) that were of importance to them; their beliefs; and their remarkable aesthetic sense and breathtaking artistic skills.

Bahn, P.G., 1998, *The Cambridge Illustrated History of Prehistoric Art*, Cambridge University Press: Cambridge.

Bahn, P.G. and Vertut, J., 1997, *Journey Through the Ice Age*, Weidenfeld & Nicolson: London/University of California Press: Berkeley.

Leroi-Gourhan, A., 1968, *The Art of Prehistoric Man in Western Europe*, Abrams: New York.

Leroi-Gourhan, A., 1982, *The Dawn of European Art*, Cambridge University Press.

Marshack, A., 1991, *The Roots of Civilization* (2nd edition), Moyer-Bell: New York.

Ucko, P. and Rosenfeld, A., 1967, *Palaeolithic Cave Art*, Weidenfeld & Nicolson: London.

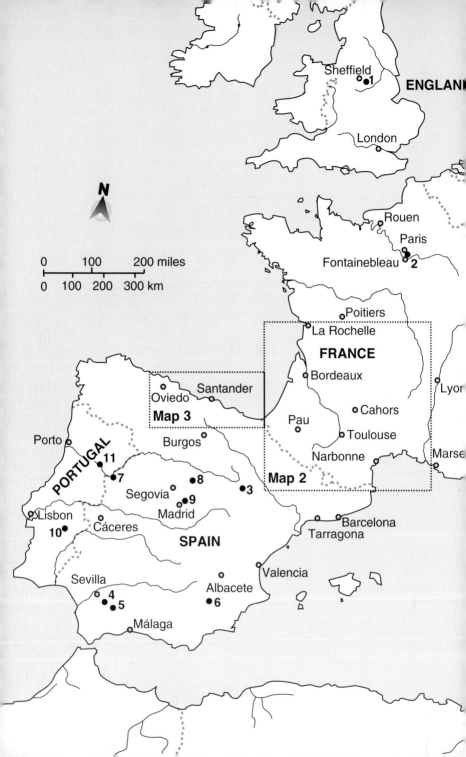

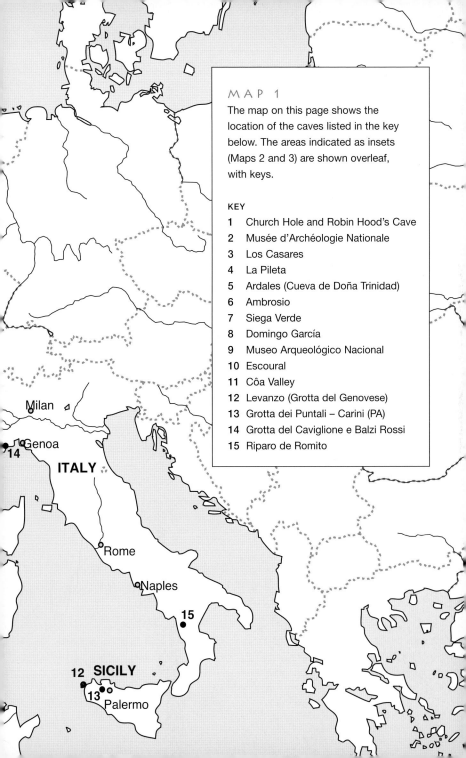

MAP 1

The map on this page shows the location of the caves listed in the key below. The areas indicated as insets (Maps 2 and 3) are shown overleaf, with keys.

**KEY**

1 Church Hole and Robin Hood's Cave
2 Musée d'Archéologie Nationale
3 Los Casares
4 La Pileta
5 Ardales (Cueva de Doña Trinidad)
6 Ambrosio
7 Siega Verde
8 Domingo García
9 Museo Arqueológico Nacional
10 Escoural
11 Côa Valley
12 Levanzo (Grotta del Genovese)
13 Grotta dei Puntali – Carini (PA)
14 Grotta del Caviglione e Balzi Rossi
15 Riparo de Romito

MAP 2

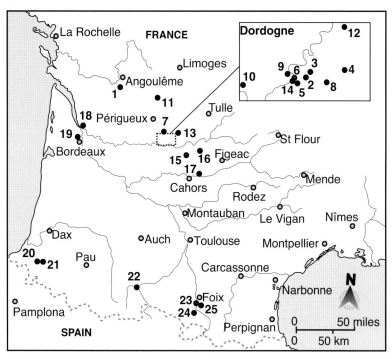

MAP 3

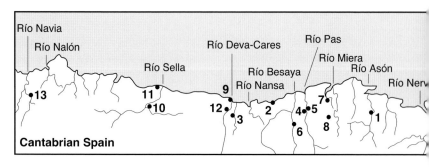

## MAP 2

KEY

1  La Chaire à Calvin
2  Font de Gaume
3  Les Combarelles
4  Cap Blanc
5  Abri Pataud
6  Cave Pataud
7  Rouffignac
8  Bernifal
9  Abri du Poisson (and Laugerie Haute)
10  Bara-Bahau
11  Villars
12  Abri Reverdit (Castel-Merle)
13  Lascaux II
14  Musée National de Préhistoire
15  Cougnac
16  Grotte des Merveilles
17  Pech-Merle
18  Pair-non-Pair
19  Musée d'Aquitaine
20  Isturitz
21  Oxocelhaya
22  Gargas
23  Bédeilhac
24  Niaux
25  Parc de la Préhistoire

## MAP 3

KEY

1  Covalanas
2  Altamira II
3  Chufín
4  El Castillo
5  Las Monedas
6  Hornos de la Peña
7  El Pendo
8  Salitre II (Sopeña)
9  El Pindal
10  El Buxu
11  Tito Bustillo
12  La Loja
13  La Peña de Candamo (and Interpretation Centre)

# ENGLAND

## CHURCH HOLE AND ROBIN HOOD'S CAVE

The beautiful little limestone valley at Creswell Crags is the location of one of Britain's most important clusters of palaeolithic dwellings, in sites as famous as Mother Grundy's Parlour, Pin Hole and Robin Hood's Cave. In the 1870s, all its caves were dug intensively by Victorian scholars, eager to find bones of extinct animals such as mammoth, bison and hyena, as well as the stone and bone tools of our ancestors. Consequently, with the methods, tools and standards of the time, the sediments of the valley's caves were dug out very rapidly, with little care, and dumped outside. Many bones and tools were indeed found, but far more were probably missed. One consequence of this activity was that, in the cave of Church Hole, the floor was lowered by about 2m from its original Ice Age level.

Excavations also revealed Britain's only examples of figurative portable art of the Ice Age: a horse engraving on a bone found in Robin Hood's Cave in July 1876, and a little human engraved on a rib in Pin Hole Cave in 1928. So, in view of the existence of this rich cluster of dwelling caves, plus the presence of portable art, there seemed to be good reason to suppose that, if cave art had ever existed in Britain, this would be a likely place to find it.

Consequently, in 2002 I invited Sergio Ripoll, a Spanish cave art specialist, and Paul Pettitt, a British Palaeolithic specialist, to join me in a preliminary search for possible cave art. We began our search at Creswell on 14 April 2003 and, on that first morning, spotted some figures in Church Hole. We were lucky to find them – most of the cave's figures are high up on the walls and ceiling,

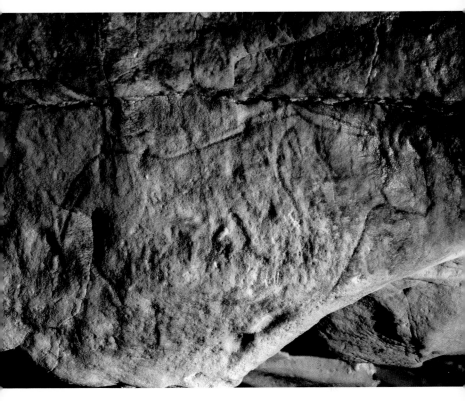

Bison engraving in Church Hole.

which is why they had gone undetected for so long. The Victorian lowering of the floor had effectively hidden them from view, unless one was specifically looking for art, as we were.

In subsequent campaigns that year and in 2004, we improved our ability to 'read' these strange surfaces of magnesian limestone, and increased the numbers of figures. Most are engravings, but some are also in bas-relief, and they include some world-class figures. At present, Church Hole is known to contain between twenty and thirty definite or probable figures. Their style is clearly 'Creswellian' (that is, the local Magdalenian), and before our discovery charcoal

from the Creswellian occupation level from the cave had already been radiocarbon dated to more than 12,000 years ago. Some of our engraved figures have a thin film of calcite over them, and samples from this calcite have been dated by the Uranium/Thorium method – proving that they must be at least 12,000 years old.

All the Church Hole figures are in the small entrance chamber, except for one small panel of engravings down the passage in the darkness. Only the most visible figures can be shown to a tour group after it has mounted the viewing platform. The highlights include a large engraving of a stag, facing left, which has unfortunately been much damaged by the graffiti scratched on to this panel by people who clambered on to a ledge here but did not see the art. In the 1950s or 1960s, however, one person clearly saw the stag's head; he or she must have thought it was a male goat (we ourselves initially suspected it might be an ibex), and carefully scratched a long beard under its chin. The animal's chin line and ear are particularly graceful, and its eye is a natural hole in the wall.

Below the stag are two series of short vertical lines – the first set of three, the second of nine; another set of three can be seen to the right. Further to the right is a bovid figure, which seems to be a bison, because of its pronounced hump, and despite its forward-pointing horn. Both the bison and the stag incorporate a certain amount of bas-relief in their outlines.

On the opposite wall are a number of minor figures, most notably two small engraved triangles (more examples of this motif have been found on the ceiling). On the ceiling itself, to the left of the stag, is the cave's most unique figure, an ibis-like bird in bas-relief and engraving. Birds are extremely rare in cave art, and this is the first example to be found in bas-relief.

The ceiling also features a number of examples where the natural rock shape may have been enhanced by the addition of ears, eyes and/or nostrils to make animal heads, some of which resemble bears.

Robin Hood's Cave, the largest and most important palaeolithic dwelling at Creswell, has also been found to contain a single engraving so far. On the right-hand wall as you enter, there is a

small triangle; Uranium/Thorium dating has confirmed that this is indeed palaeolithic in age.

Bahn, P. (with S. Ripoll, P. Pettitt and F. Muñoz), 2005, 'Creswell Crags: discovering cave art in Britain', *Current Archaeology* 197, May/June: 217–26.
Bahn, P., Pettitt, P. and Ripoll, S., 2003, 'Discovery of palaeolithic cave art in Britain', *Antiquity* 77, No. 296, June: 227–31.
Pettitt, P., Bahn, P. and Ripoll, S. (eds), 2007, *Palaeolithic Cave Art at Creswell Crags in European Context*, Oxford University Press, Oxford.
Ripoll, S., Muñoz, F., Bahn, P. and Pettitt, P., 2004, 'Palaeolithic cave engravings at Creswell Crags, England', *Proceedings of the Prehistoric Society* 70: 93–105.

**Address**
Creswell Crags Museum and Education Centre, Crags Road, Welbeck, Worksop, Nottinghamshire S80 3LH
Tel. (44) (0)1909 720378
www.creswell-crags.org.uk
info@creswell-crags.org.uk

**Nearest city/town** Worksop/Creswell.
**Nearest airport** Robin Hood Airport.
**Nearest car rental** Worksop.
**Nearest train station** Creswell.
**Nearest bus route** No. 77 between Worksop and Chesterfield; No. 33 between Worksop and Mansfield.
**Nearest taxi or private car hire** Creswell village.
**Restaurants in the vicinity** Some in Creswell; country pubs in neighbouring villages.
**Hotels in the vicinity** Several near Clowne, as well as further afield.

**When are these caves open?** The visitor centre and gorge are open between 10.30 and 16.30 every day between February and October, and Sunday only November–January. Cave tours only take place at weekends and on bank and school holidays; one CHC tour and 2 RHC tours run on those days.

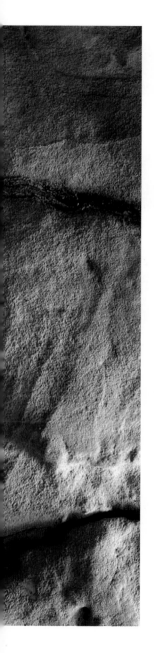

**Admission prices** Church Hole: £6 per adult, £3 per child; Robin Hood: £4.50 per adult, £3 per child.

**Storage facilities?** No.

**Do you have to make up a group?** Yes. Church Hole: 4 tours of 12 people per tour each day; Robin Hood: 3 tours of 25 people per tour each day.

**Can you reserve a place in a group?** Yes. Reservation is necessary.

**Languages of the guides** English.

**Length of tour** 1 hour each cave.

**Are the caves privately owned?** Yes.

**Is there a gift shop?** Yes.

**Is there a café (water)?** Refreshments available.

**Are there WC facilities?** Yes.

**Handicapped access?** Both caves have stairs. Partially sighted people can be accommodated with advance warning.

**Is any climbing necessary?** Staircases lead to both entrances; more stairs inside both caves.

**Distance to walk** About 250m to each cave from the visitor centre; only a few metres' walk inside each.

**Level of fitness required** Minimal.

**Equipment required** Hard hats and flashlights supplied by the visitor centre.

**What are the conditions inside the caves?** Flat and dry.

**Are they lit?** No.

**Are they slippery?** No.

**Is photography allowed?** Yes

'Ibis' in engraving and bas-relief on the ceiling of Church Hole.

# FRANCE

## LA CHAIRE A CALVIN

One of the few sculpted friezes of the Ice Age to have been discovered (see also Cap Blanc, page 54) is on open view in the rock shelter of La Chaire à Calvin (Calvin's Pulpit), illlustrated on pages 2–3. The shelter is 12m wide and up to 4m high; Upper Palaeolithic tools were being unearthed here in the 1860s, but the carvings were spotted much later, in June 1927: they had been masked by sediments, and it was excavation that exposed them. The frieze, on the right wall (as you face the shelter), starts about 1m from the entrance and is quite small, almost 3m in length. It comprises a series of animals in bas-relief: the two at left are facing each other. The first, headless, animal faces right; opinions are divided as to whether it is a horse or a bovid, since the hoofs are badly preserved. In the centre, facing left, is a clear horse, 90cm long and 60cm high, with the head of one carved on the head of the other. The double figure at right has sometimes been thought to be a copulating couple, but if that is the case, then the stallion is markedly smaller than the mare. It may simply be two superimposed horses, although some specialists have claimed that it is a bison figure which was later reworked into a smaller horse.

As with all known bas-reliefs of the period, the frieze was certainly painted originally, and when it was discovered some traces of paint were still visible here and there. The style of the figures has led most specialists to attribute it to the Middle Magdalenian period, around 14,000 years ago.

The frieze at La Chaire à Calvin.

de Sonneville Bordes, D., 1963, 'Etude de la frise sculptée de la Chaire à Calvin, commune de Mouthiers (Charente)', *Annales de paléontologie* 49: 181–93.

**Address**

Chemin de la Chaire à Calvin, 16440 Mouthiers sur Boëme

Tel. (33) (0)5 45 90 74 32

http://www.cg16.fr

**Nearest city/town** Angoulême/Mouthiers sur Boëme.

**Nearest airport** Angoulême.

**Nearest car rental** Angoulême.

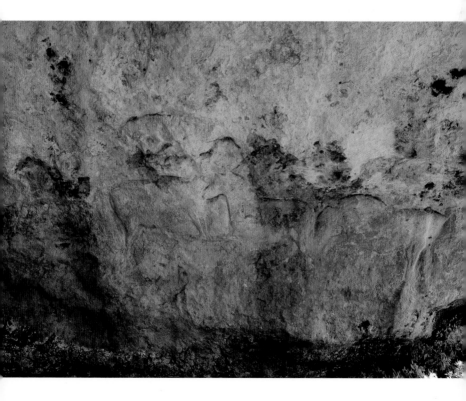

Nearest train station La Couronne.

Nearest bus route Mouthiers sur Boëme.

Nearest taxi or private car hire Angoulême.

Restaurants in the vicinity Mouthiers sur Boëme.

Hotels in the vicinity Mouthiers sur Boëme, La Couronne.

When is this cave open? Always visible.

Admission prices No charge.

Storage facilities? No.

Do you have to make up a group? No.

Languages of the guides Explanatory panel at the site, in French and English.

How long are you allowed in the cave? No limit.

Is the cave privately owned? No.

Is there a gift shop? No.

Is there a café (water)? No.

Are there WC facilities? No.

Handicapped access? No.

Is any climbing necessary? No.

Distance to walk You can park 500m from the site.

Level of fitness required Minimal.

Equipment required None.

What are the conditions inside the cave? Outdoor site.

Is it slippery? Not usually.

Is photography allowed? Yes.

# FONT DE GAUME

Located just outside Les Eyzies, Font de Gaume is a 'must' – one of the classic sites which played a significant role in the discovery and acceptance of cave art at the start of the twentieth century. It is the only decorated cave in France with polychrome paintings which remains open to the public.

The cave itself had always been known, but it was on 12 September 1901 that, following the discovery of the engravings in Les Combarelles (page 50) not far away, local schoolteacher Denis Peyrony decided to take a look inside Font de Gaume and came upon the paintings, some of them beneath graffiti.

Considered by the abbé Breuil to be one of the 'six giants', Font de Gaume contains about 230 paintings and engravings (dominated by 82 bison), but only a selection of the best can be shown to tour groups. As the cave is so narrow in places, it is necessary to be extra vigilant so that you do not brush against one wall while admiring the other.

Once through the entrance, you move along a passage about 60m long, which may once have been decorated, but in which nothing is now visible, thanks to weathering. You then cross a narrow cleft known as the Rubicon and enter the decorated gallery, also 60m in length.

Most of the figures, including all those shown to tour groups, are thought to date to the Magdalenian period of $c.15,000$–$10,000$ years ago. As you enter the decorated gallery, a whole series of large bison figures, with exaggerated humps, becomes visible on the right-hand wall. These are both engraved and painted (in black and reddish-brown) and display a tremendous mastery of three-dimensional art through subtle usage of the natural rock shapes.

On the left wall, opposite, there is a large polychrome bison, facing to the right; it was engraved and painted to fit within a bison-

OVERLEAF The best-preserved bison figure at Font de Gaume.

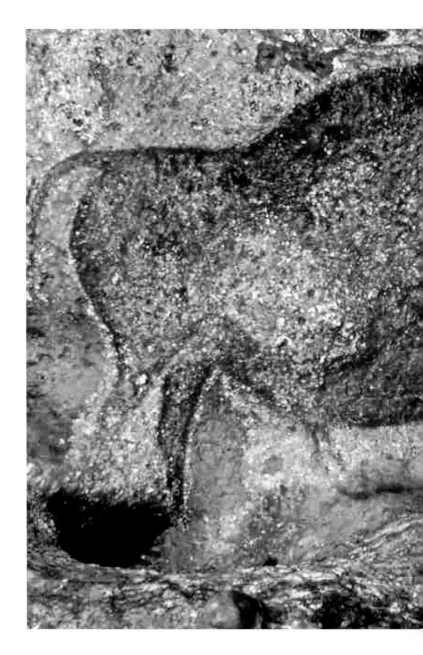

shaped area of rock. On its flank one can see four red symbols, known as tectiforms because of their supposed resemblance to huts or roofs. In the past, various strange interpretations of these symbols were proposed, including that of pit traps, but today they are seen simply as complex signs, being highly localized in space (a group of Dordogne caves within a small area) and time (the Magdalenian); the most likely explanation at present is that they may be some kind of tribal symbol, but basically what they are is anyone's guess. The bison is face to face with a smaller bison.

To the right of these bison is the glory of Font de Gaume, which arguably is the most beautiful scene in the whole of Ice Age cave art. A male reindeer, with sweeping black, stylized antlers, bends forward to lick the forehead of a smaller kneeling female, painted in red. The unique feature of the tongue touching the forehead is delicately engraved, and only visible with oblique light. The palaeolithic artist has imbued the scene with such tenderness that there can be no doubt of his or her sophisticated artistic prowess.

At the junction with a gallery going off to the right, you see a series of black animals high up on the left-hand wall – bison and reindeer. Similarly, as you turn right into the lateral gallery, more black animals can be seen high up on the left, including a fine reindeer with impressive antlers. The right-hand wall of the gallery presents the cave's famous 'leaping horse' (illustrated on page 20), a black animal with legs outstretched, which, like the second horse in front of it, makes great use of the natural rock shapes.

Returning to the main gallery, you turn right, and soon encounter the cave's finest surviving bison paintings – especially a series of them high up on the left wall. Finally, the Sanctuary of the Bison, a small chamber at the end, contains about a dozen bison paintings, often using natural bumps and hollows in the rock.

Capitan, L., Breuil, H. and Peyrony, D., 1910, *La caverne de Font de Gaume aux Eyzies (Dordogne)*, Chêne: Monaco.

**Address**
Grotte de Font de Gaume, 24620 Les Eyzies
Tel. (33) (0)5 53 06 86 00; fax (0)5 53 35 26 18
www.leseyzies.com/grottes-ornees
fontdegaume@monuments-nationaux.fr

**Nearest city/town** Sarlat/Les Eyzies.
**Nearest airport** Bergerac.
**Nearest car rental** Périgueux.
**Nearest train station** Les Eyzies, Périgueux, Le Bugue.
**Nearest bus route** None.
**Nearest taxi or private car hire** Périgueux.
**Restaurants in the vicinity** Many.
**Hotels in the vicinity** Many.

**When is this cave open?** 16 September to 14 May 09.30–12.30 and 14.00–17.30; 15 May to 15 September 09.30–17.30. Closed Saturdays, Christmas Day, New Year's Day, 1 May, 1 and 11 November. In the winter (November to January) more detailed visits of the cave, lasting about three hours, can be arranged.
**Admission prices** Adult 6,50 euros; students (18–25) 4,50 euros; children under 18 free; group rate 5,30 euros per adult.
**Storage facilities?** Bags can be locked away in the cavity to the left of the cave entrance.
**Do you have to make up a group?** Yes. All visits are in groups of up to 12 people, maximum of 180 people (i.e. 15 groups) per day.
**Can you reserve a place in a group?** Pre-booking is strongly advised. Book well ahead – preferably 2 weeks in advance. However, tickets for vacant places may be available at the cave at 09.30 each morning, depending on luck and the season.
**Languages of the guides** French. English is sometimes available; a visit in English should be arranged well in advance.
**Length of tour** About 1 hour.
**Is the cave privately owned?** No.
**Is there a gift shop?** Yes.
**Is there a café (water)?** No.

**Are there WC facilities?** Yes.

**Handicapped access?** No, but special visits are available for the blind (see page 10).

**Is any climbing necessary?** Yes – a staircase of 40 steps and an ascending path; a few stairs inside (5 up, 8 down).

**Distance to walk** About 400m to cave; 120m inside from entrance to back – a total of 1040m walking.

**Level of fitness required** Moderate.

**Equipment required** The cave has electricity; personal flashlights not allowed.

**What are the conditions inside the cave?** Flat and dry.

**Is it lit?** Underfoot lighting plus lighting.

**Is it slippery?** No.

**Is photography allowed?** No.

# LES COMBARELLES

Located on the left bank of the River Beune, 3km from Les Eyzies, the cave of Les Combarelles is one of the greatest and most famous repositories of palaeolithic art, dating to c.14,000 to 12,000 BC. The cave had always been known, but its engravings were first discovered by the proprietor in September 1901.

Les Combarelles takes the form of a narrow, winding gallery, about 240m in length, with no side passages. Its width is just over 1m, and its height never more than 2m, although when the art was found, some sections of the cave were extremely narrow or required crawling. Since then, many concretions have been broken and the floor has been lowered to facilitate access.

The abbé Breuil claimed that there were about three hundred recognizable figures as well as over a hundred unidentifiable 'image fragments', but in fact figures are still being discovered in the cave today. The figures – mostly engravings, though a few black drawings are also known, as well as a hand stencil – are often on top of each other, making them difficult to decipher, and few are readily visible to the untrained eye. Their style is quite homogeneous, and they

have been attributed to a period from the early Magdalenian to the beginning of its late phase *c*.16–12,000 years ago.

The first known engravings occur 70m from the entrance, but the first clear figures are found about 161m in, and they are fairly continuous after that, drawn on both walls (though not on the ceiling, as its surface was not suitable) and grouped in panels separated by spaces. There are many superimpositions, which make it harder to disentangle the lines, and they require oblique light to display them to the viewer.

A rough guide to content can be obtained from Breuil's albeit outdated list: 116 horses, 37 bison, 7 cattle, 19 bears, 14 reindeer, 13 mammoths, 9 ibex, 9 deer, 5 lions, 1 to 4 canids, 1 to 3 rhinos, 1 fox, 1 fish, 1 snake, 4 tectiform (that is, rooflike or hutlike) signs,

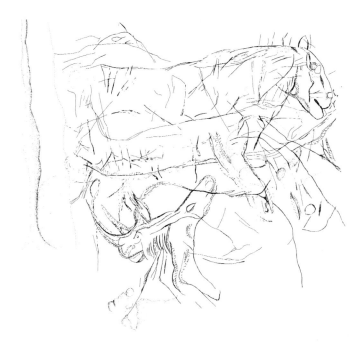

Tracing of the feline/rhino panel at Les Combarelles (after Barrière).

39 anthropomorphs and 4 sexual symbols. The lines vary from deeply to finely engraved, and the animal outlines – mostly up to 1m in length – are often enhanced with extra detail such as hatching for hair.

Obviously, tourist groups can only be shown a fraction of the art, and what is shown will depend on the guide and the number of visitors, but any visit will include some of cave art's most famous images – in particular a bear, a mammoth with curled trunk, a lion (with a pebble inserted next to its eye in modern times) and a rhino, a 'drinking' reindeer, some bizarre humanoids including a 'seated man' and many horses and bison.

The cave of Les Combarelles II, next door, which contains only thirty-three figures, was discovered in 1909, and is not open to the public.

Barrière, C., 1997, *L'art pariétal des Grottes des Combarelles*, Paléo, Hors série.

Capitan, L., Breuil, H. and Peyrony, D., 1924, *Les Combarelles aux Eyzies (Dordogne)*, Masson: Paris.

**Address**
Grotte des Combarelles, 24620 Les Eyzies
Tel. (33) (0)5 53 06 86 00; fax (0)5 53 35 26 18
www.leseyzies.com/grottes-ornees
fontdegaume@monuments-nationaux.fr

**Nearest city/town** Sarlat/Les Eyzies.
**Nearest airport** Bergerac.
**Nearest car rental** Périgueux.
**Nearest town** Les Eyzies.
**Nearest train station** Les Eyzies, Périgueux, Le Bugue.
**Nearest bus route** None.
**Nearest taxi or private car hire** Périgueux.
**Restaurants in the vicinity** Many.
**Hotels in the vicinity** Many.

**When is this cave open?** 16 September to 14 May 09.30–12.30 and 14.00–17.30; 15 May to 15 September 09.30–17.30. Closed Saturdays, Christmas Day, New Year's Day, 1 May, 1 and 14 November.

**Admission prices** Adult 6,50 euros; students (18–25) 4,50 euros; children under 18 and unemployed free; group rate 5,30 euros per adult. Tickets from the Font de Gaume office (see page 49).

**Storage facilities?** Bags can be locked away in the guides' building.

**Do you have to make up a group?** Yes. Maximum of 6 people per group, maximum of 10 groups per day.

**Can you reserve a place in a group?** Yes. Pre-booking is strongly advised. Book well ahead – preferably 2 weeks in advance. However, tickets for vacant places may be available at Font de Gaume at 09.30 each morning, depending on luck and the season.

**Languages of the guides** French, English.

**Length of tour** About 1 hour.

**Is the cave privately owned?** No.

**Is there a gift shop?** No – the shop is at Font de Gaume.

**Is there a café (water)?** No.

**Are there WC facilities?** Yes.

**Handicapped access?** Yes; and visits for the blind are available (see page 10).

**Is any climbing necessary?** There are just 12 steps up to the entrance; no stairs inside.

**Distance to walk** About 50m from the car park; about 230m inside the cave.

**Level of fitness required** Minimal.

**Equipment required** None. The guides deal with the lighting.

**What are the conditions inside the cave?** Flat and dry.

**Is it lit?** Yes.

**Is it slippery?** No – there are metal walkways.

**Is photography allowed?** No.

# CAP BLANC

There are very few sculpted bas-reliefs in Ice Age art, and Cap Blanc has the finest set of original sculptures open to the public *in situ*. They were discovered in 1909 by workmen excavating the shelter, and – since nothing similar had ever been found before – they were not spotted until considerable damage had been done by their pickaxes. The deposits that had masked the sculptures date to the Middle Magdalenian *c*.15,000 years ago, and since they contained tools which had clearly been used by the artists, this dating gives a good idea of the carvings' date.

A small but outstanding museum has been built in front of the shelter. This gives an excellent introduction to the region's decorated sites, the technique of carving used and the finds from the shelter. The carved frieze itself constitutes a dramatic climax to a visit.

As with all palaeolithic friezes, traces of paint were found, indicating that the colourful carvings must have been visible from some distance. On the left, you see a section of the sediments which used to fill this south-facing, 16m-wide shelter. The first two animals on the left are large horses, facing right; one of them has a ring carved into the rock above it, presumably for hanging or fastening something – perhaps out of the reach of animals or small children. To the right is the largest and most imposing figure of the frieze: a great horse, more than 2m long and facing left. Above it can be seen the two small heads of deer, facing right. To the right are a possible depiction of a human hand, two further horses, much damaged and facing right, and two probable partial bison facing left. In both pairs of horses facing right, the head of the first horse masks the rump of the second. As at La Chaire à Calvin (page 42), there seems to have been some recarving of the frieze, with changes of animal.

Two fragments of the frieze are now housed in Bordeaux's Musée d'Aquitaine (page 106), along with many of the stone tools found

Head of the central horse at Cap Blanc.

in the excavations. However, casts of these fragments have been placed in the shelter – a small horse head is now held in position on a metal rod; a carved bison on a block is placed in the alcove at the far right.

In front of the frieze lies the cast of the skeleton of a young Magdalenian lady, who was buried here in what seems to be a place of honour, in front of the central horse. (The original skeleton, excavated in 1911, is in the Field Museum, Chicago.) Could she have been the artist? Studies suggest that the artist was left-handed, and the skeleton displays strong musculature on that side. A small ivory point found in her abdomen area may indicate a cause of death. In any case, together with Romito (page 215), this is the only known case of a person being buried in front of a decorated panel.

Bahn, P.G., 2002, 'The Cap Blanc lady', pp. 108–13 in (P.G. Bahn, ed.), *Written in Bones: How Human Remains Unlock the Secrets of the Dead*, David and Charles: Newton Abbot, Devon.

Lalanne, G. and Breuil, H., 1911, 'L'abri sculpté de Cap-Blanc à Laussel (Dordogne)', *L'anthropologie* 22: 386–402.

Roussot, A., 1994, *Visiter le Cap Blanc*, Sud Ouest: Bordeaux.

**Address**

c/o Grotte de Font de Gaume, 24620 Les Eyzies
Tel. (33) (0)5 53 06 86 00; fax: (0)5 53 29 89 84
www.leseyzies.com/cap-blanc
fontdegaume@monuments-nationaux.fr

**Nearest city/town** Périgueux/Les Eyzies.
**Nearest airport** Bergerac.
**Nearest car rental** Périgueux.
**Nearest town** Les Eyzies.
**Nearest train station** Les Eyzies, Périgueux, Le Bugue.
**Nearest bus route** None.
**Nearest taxi or private car hire** Périgueux.

**Restaurants in the vicinity** Many.
**Hotels in the vicinity** Many.

**When is this cave open?** April to June, September and October 9.30–12.30 and 14.00–17.30; July and August 10.00–19.00. Closed Saturdays. Open to groups, but only with reservation.
**Admission prices** Adults 6,50 euros; students (18–25) 4,50 euros; children under 18 free.
**Storage facilities?** No.
**Do you have to make up a group?** No.
**Can you reserve a place in a group?** Yes.
**Languages of the guides** French. Printed translations of the tour text are available in English, Dutch, German, Italian and Spanish.
**Length of tour?** About 45 minutes. No limit in museum.
**Is the cave privately owned?** No.
**Is there a gift shop?** Yes.
**Is there a café (water)?** Refreshments are available.
**Are there WC facilities?** Yes.
**Handicapped access?** Impossible for groups, but individuals can be brought to the site by car.
**Is any climbing necessary?** There is a sloping path of 185m with steps down to the site. There are no stairs inside.
**Distance to walk** About 200m to the museum; a few metres inside.
**Level of fitness required** Minimal.
**Equipment required** None.
**What are the conditions inside the cave?** Dry and flat.
**Is it lit?** The site is lit.
**Is it slippery?** No. The path from the car park can be slippery in inclement weather.
**Is photography allowed?** No.

# ABRI PATAUD
# AND CAVE PATAUD
## (ABRI MOVIUS)

From 1958 to 1964, a major excavation took place in the huge Abri Pataud, directed by Professor Hallam Movius of Harvard University. This is generally recognized as the first modern excavation to have been carried out in the region, drawing on the latest techniques, carefully removing each layer and recording the position of, and conserving, every object encountered.

Active research still continues today on the more than 1.5 million finds unearthed then. Only about one-tenth of the site was excavated, so much remains here for future generations. The stratigraphy is more than 9m in height and contains a succession of occupation layers. It was found that this great shelter had been occupied through a long span of the Upper Palaeolithic, c.35,000–20,000 years ago, during which time the climate had changed markedly from cold to warmer and back again, several times, and these changes had led to constant change in the shape and size of the shelter as its ceiling progressively collapsed, its back wall flaked off, and both ceiling and wall retreated backwards about 12m. Fragments of rock found in each layer showed that the shelter had always been decorated – with painting and engraving. None of this art now survives *in situ*, but the site is well worth a visit, not only as a fine example of a major palaeolithic excavation but also for the sculpted blocks which can still be seen, and especially for the small museum next door.

During the excavations, the HQ was the old farmhouse of the Pataud family (now the ticket office), while the tools and finds were stored in the Cave Pataud, an old building next to the farmhouse, comprising a façade built on to the front of a small shelter, where the Pataud family used to keep their tools. In the 1980s, the decision was taken to clean up the Abri Pataud to present its excavations to the public and to transform the old store into a finds

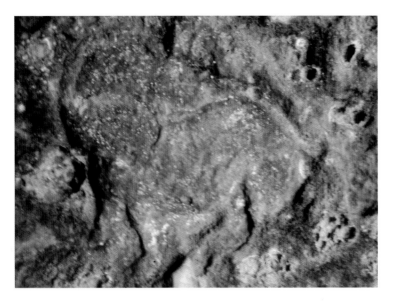

The sculpted ibex on the ceiling of the Cave Pataud.

museum. During the preparation of the small shelter, in 1986, it was suddenly noticed that there was a bas-relief sculpture of an ibex on its ceiling, just inside the entrance to the left.

Most of the rest of the ceiling is badly eroded, but this spot has miraculously survived – suggesting that the whole of the shelter's ceiling may once have been sculpted and painted. This sculpture is admirably presented by means of a mirror and a drawing, to save your neck muscles. Its style has led specialists to assign it to the Solutrean period, around 20,000 years ago.

The museum is important for its displays of material from the Pataud excavations – pollen, animal bones, stone tools and human remains, as well as a statue of a reconstruction of a sixteen-year-old girl whose skeleton was found at the back of the site together with that of her newborn child. But for the purposes of this book, the most interesting exhibits are engraved blocks from the site, as well as the original Pataud 'Venus', an unusual carving of a slender

female on a small stone block; some decorated fallen fragments of the great shelter's wall and ceiling; lots of jewellery and some incredibly tiny perforated bone beads; and a couple of small pebbles bearing fine engravings which require a raking light and an explanatory drawing to be at all discernible.

Delluc, B. and Delluc, G., 1986, 'Un bouquetin sculpté de style solutréen dans la cave troglodytique Pataud (Les Eyzies, Dordogne)', *L'anthropologie* 90: 603–12.

Delluc, B. and Delluc, G., 1998, *Visiter l'abri Pataud,* Sud-Ouest: Bordeaux.

**Address**
20 rue du Moyen-Age, 24620 Les Eyzies
Tel. (33) (0)5 53 06 92 46; fax (0)5 53 06 13 14.
Group reservations: tel. (0)5 53 05 65 60; fax (0)5 53 06 30 94
www.semitour.com
contact@semitour.com

**Nearest city/town** Périgueux/Les Eyzies.
**Nearest airport** Bergerac.
**Nearest car rental** Périgueux.
**Nearest train station** Les Eyzies, Périgueux, Le Bugue.
**Nearest bus route** None.
**Nearest taxi or private car hire** Périgueux.
**Restaurants in the vicinity** Many.
**Hotels in the vicinity** Many.

**When is this cave open?** Closed January. July and August 10.00 to 19.00; February and March and October to December 10.00 to 12.30 and 14.00 to 17.30; April to June and September 10.00 to 12.30 and 14.00 to 18.00. Closed Saturdays except in July and August. In February, March and October only groups can visit on Fridays and Sundays, with prior reservation.
**Admission prices** Adults 5,70 euros; children (6–12) 3,70 euros; children under 6 free. Group rates: 4,70 euros per adult; 3 euros per student and high school child; 2,50 euros per primary school child.
**Storage facilities?** No.

**Do you have to make up a group?** Yes. There is a maximum of 20 people per group.

**Can you reserve a place in a group?** Yes.

**Languages of the guides** French, and sometimes English.

**Length of tour** 1 hour.

**Is the cave privately owned?** No.

**Is there a gift shop?** Yes.

**Is there a café (water)?** No.

**Are there WC facilities?** Yes.

**Handicapped access?** Yes.

**Is any climbing necessary?** Yes – stairs or slopes to the cave. Some stairs inside the Abri Pataud.

**Level of fitness required** Minimal.

**Equipment required** No personal flashlights necessary.

**What are the conditions inside the cave?** Flat and dry.

**Is it lit?** Yes.

**Is it slippery?** No.

**Is photography allowed?** No.

# ROUFFIGNAC

The huge cave of Rouffignac is very different from all other decorated caves, in that it resembles a massive tunnel, without stalagmites and stalactites; instead, it has innumerable nodules of flint sticking out of its walls. In addition, because the natural floor is a particularly sticky and unpleasant clay, and because of the long distances involved, an electric train was installed in the cave in 1959. This makes visits particularly easy, but the lack of exercise leads many people to believe that this cave is colder than others, which is not the case – it just seems to be!

The cave has always been known, and descriptions were published in the sixteenth century. An engraving of a bovid was first spotted in Rouffignac by speleologists in 1955, but it was in 1956 that the bulk of its decoration was discovered: more than 250

figures. They comprise both engravings and black drawings, as well as finger markings, and figures are found throughout the cave's 8km of galleries on three different levels. At first, specialists were divided into believers and non-believers in the art's age and authenticity. The major reasons for the rejection of Rouffignac were some vehement denials by earlier visitors to the cave that any art existed before 1956; it seemed incredible that such large and clear figures could have been missed. But the cave is huge, and engravings are often invisible until lit from the side. Today, a few

Mammoth and ibex on the Rouffignac ceiling.

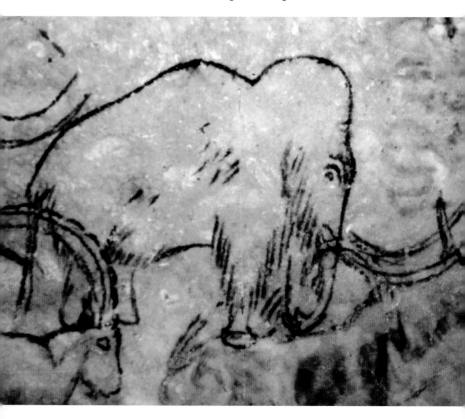

non-French specialists still have lingering doubts about a handful of figures, but nobody can deny that Rouffignac is a major palaeolithic decorated cave.

The most astounding fact about this cave's decoration is the incredible dominance of mammoths – about 160 of them are known, with more being found even today. This is about one-third of all mammoth depictions known in cave art at present (more than 500 mammoths in 46 caves).

In the absence of any palaeolithic occupation (the cave had Mesolithic material at the entrance and some Iron Age burials inside), the art can only be dated by its style, which seems to be Middle Magdalenian, c.14,000 years old.

The cave is also noteworthy for the abundance of its traces of cave bears. Cave bears did not actually live in caves but merely hibernated in them, and since, over the course of millennia, many animals died during the winter, huge quantities of bear bones have been found in caves. The bears often made themselves a hollow in the ground to sleep in, and innumerable examples can be seen in Rouffignac. In addition, on waking at the end of winter, bears would have sharpened their claws on the nearest surfaces, and Rouffignac displays extensive areas of wall covered in millions of such claw marks.

Obviously, in the face of such a vast and heavily decorated cave, only a fraction of the clearest figures can be shown to tourists from the train. After a long journey, you see some cave bear scratches, and then the first large engravings of mammoths on the left, some 700m from the entrance – two animals facing each other, which were the first discoveries in 1956. The one facing left has a natural nodule as its eye. Forty metres further on, in the Galerie Breuil, you see the famous frieze of three black drawings of woolly rhinos on the right and, beyond them, a black horse head drawn on a flint nodule protruding from the wall. On the left-hand wall, there are two more engraved mammoths facing each other – the bigger, more detailed animal, facing left, is known as the 'patriarch' – and a bearded horse facing right. On the right, once again, you see a great 7m frieze of black drawings of mammoths, in two groups facing

each other and standing on a natural ground line; six are going left, and four toward the right. Some 'macaronis' – that is, meandering finger marks – can be seen on the ceiling, with five more engraved and confronted mammoths on the right, two heading into the cave and three heading out.

Finally, the train stops and you move forward a few metres on foot to see the famous ceiling of Rouffignac, covered in sixty-five large black drawings of horses, bison, mammoths and no less than twelve ibex, the only ones depicted in the whole cave. This ceiling used to be covered in graffiti, but it was cleaned a few years ago, making the animal figures far more visible as they swirl around in all directions above your head, around the edge of a broad natural shaft. The floor has also been lowered here to enable visitors to stand and walk in comfort; the original artist(s) had less than 1m of space to crawl around in, so could not see the large animal figures easily, let alone the whole composition. You then return to the train, which heads back to the entrance by the same track.

Barrière, C., 1982, *L'art pariétal de Rouffignac*, Picard: Paris.

Plassard, J., 1999, *Rouffignac: le sanctuaire des mammouths*, Le Seuil: Paris.

---

**Address**
Grotte de Rouffignac, 24580 Rouffignac-St-Cernin
Tel. (33) (0)5 53 05 41 71; fax (0)5 53 35 44 71
www.grottederouffignac.fr
grottederouffignac@wanadoo.fr

**Nearest city/town** Périgueux/Montignac, Les Eyzies.
**Nearest airport** Bergerac.
**Nearest car rental** Périgueux.
**Nearest train station** Les Eyzies, Le Bugue, Périgueux.
**Nearest bus route** None.
**Nearest taxi or private car hire** Périgueux.
**Restaurants in the vicinity** Many.
**Hotels in the vicinity** Many.

**When is this cave open?** Palm Sunday to 30 June and 1 September to 31 October 10.00 to 11.30 and 14.00 to 17.00; 1 July to 31 August 9.00 to 11.30 and 14.00 to 18.00.

**Admission prices** Adults 6,20 euros; children (6–12) 3,90 euros; children under 6 free. Group rates (minimum 20 people): 4,40 euros per adult; 2,90 euros per child. No reduction for students, unemployed or OAPs.

**Storage facilities?** No.

**Do you have to make up a group?** Yes. 30 people are carried per train, with a maximum of 550 people per day.

**Can you reserve a place in a group?** Yes.

**Languages of the guides** French; English and German are available for groups or if you are lucky.

**Length of tour** 1 hour.

**Is the cave privately owned?** Yes.

**Is there a gift shop?** Yes.

**Is there a café (water)?** Cold drinks are available.

**Are there WC facilities?** Yes.

**Handicapped access?** Yes.

**Is any climbing necessary?** No.

**Distance to walk** A few metres from the car park; 80m to the train inside.

**Level of fitness required** Minimal.

**Equipment required** The guide deals with the lighting.

**What are the conditions inside the cave?** Flat and dry.

**Is it lit?** The cave has lighting.

**Is it slippery?** No.

**Is photography allowed?** No.

# BERNIFAL

Reached by a footpath across the valley, not far from Les Combarelles (page 50), Bernifal is a cave that is still fairly pristine, without any electric light installed. It was discovered in 1902, and comprises three chambers over a length of about 80m, joined by sometimes narrow passages. The cave is particularly important for its 24 mammoth depictions and 13 tectiform (that is, rooflike or hutlike) signs – the two motifs are often associated here. In the entrance chamber, one important figure is a large bison head which is mostly natural – the artist merely added a red horn, eye and nostril to a hanging rock of the right shape; above it is a small red mammoth, while to the right is a strange human face looking straight out of the rock, again a mixture of natural forms and applied pigment. On the left-hand wall of the entrance chamber there are also some engraved lines somewhat resembling hands, a black aurochs head and, further in, a series of red and black dots; on the wall opposite are three small black hand stencils, and, above them, a bear-like figure, comprising a natural rock shape to which an eye and other lines have been added.

In a tight, bottleneck passage which you reach after ducking under a low arch, you encounter an abundance of engraved figures, including both mammoths and tectiforms. Immediately on the left is a small equid figure (ass?), a star-like shape and a mammoth, followed by a tectiform and a rounded triangle. The major panel on the right features several large mammoths covered with tectiforms, a bison, deer, horse, etc.

You then descend a rather slippery slope. To the left can be seen a low niche containing a black mammoth figure, facing back towards the entrance; higher up is another niche housing a black doe, also facing the entrance. There are also other traces of red and black marks on this wall. At the bottom of the slope you reach the last visitable chamber. On the right-hand wall is an especially important figure – an isolated tectiform in reddish-brown paint. The paint has run on the humid wall, but infrared photography has

revealed that this figure was carefully painted with dots, and features series of loops – four along the 'floor' and three under each side of the 'roof'. This final chamber is also notable for two small black mammoths painted on its high ceiling – nobody really knows how this was achieved. At the bottom of the chimney on the left a large flint blade can be seen sticking out of a hole in the wall. The style of all the cave's more than 110 figures (59 engraved, 51 painted) places Bernifal's art in the Middle Magdalenian, *c.*14,000 years ago.

Capitan, L., Breuil, H. and Peyrony, D., 1903, 'Les figures gravées à l'epoque paléolithique sur les parois de la grotte de Bernifal (Dordogne)', *Comptes rendus de l'Académie des Inscriptions et Belles-Lettres*, 29 May, 219–30.

**Address**
Grotte de Bernifal, 24220 Meyrals
Tel. (33) (0)5 53 29 66 39 or (0)6 74 96 30 43
http://perso.wanadoo.fr/prehistoirepassion/grotte%20bernifal.htm

**Nearest city/town** Sarlat/Les Eyzies.
**Nearest airport** Bergerac.
**Nearest car rental** Périgueux.
**Nearest train station** Les Eyzies, Périgueux, Le Bugue.
**Nearest bus route** None.
**Nearest taxi or private car hire** Périgueux.
**Restaurants in the vicinity** Many.
**Hotels in the vicinity** Many.

**When is this cave open?** 1 June to 30 September 9.30 to 12.30 and 14.30 to 18.30. At other times by arrangement.
**Admission prices** Adults 6 euros; children (6–12) 4 euros, children under 6 free. Group rate (depending on numbers): 5 euros per adult; 3,50 euros per child. Credit cards not accepted.
**Storage facilities?** No.
**Do you have to make up a group?** No.

**Languages of the guides** French.
**Length of tour** At least an hour.
**Is the cave privately owned?** Yes.
**Is there a gift shop?** No.
**Is there a café (water)?** No.
**Are there WC facilities?** No.
**Handicapped access?** No.
**Is any climbing necessary?** There is a gentle slope up from the stream; no stairs in the cave.
**Distance to walk** 500m from car park to cave entrance; about 120m in the cave.
**Level of fitness required** Moderate.
**Equipment required** The guides provide lighting.
**What are the conditions inside the cave?** Normal.
**Is it lit?** Unlit.
**Is it slippery?** It can be very slippery both inside and outside, especially on the slopes.
**Is photography allowed?** No.

Bison eye/horn, mammoth and human face drawn on a hanging rock in Bernifal.

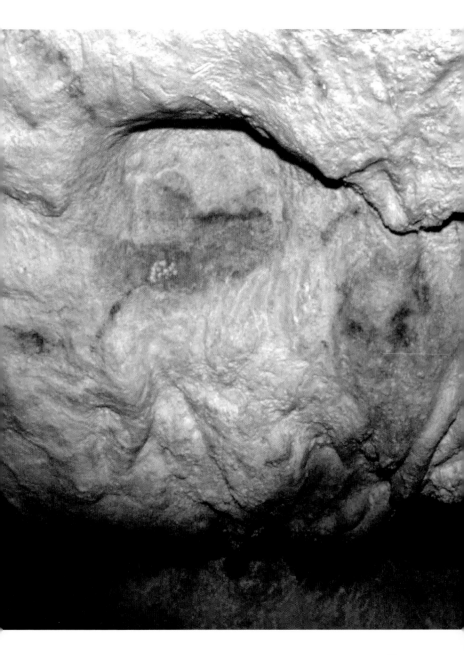

# ABRI DU POISSON
## (AND LAUGERIE HAUTE)

Located just outside Les Eyzies, on the way into the Gorge d'Enfer, close to the great Laugerie shelters (the hugely important occupation site of Laugerie Haute is included in the visit), this is a very small rock shelter, only 8m wide and 7m deep; yet it houses one of the most striking images in all cave art – the great sculpted fish on its ceiling, 2.5m above the present floor. More than 1m in

The bas-relief fish on the ceiling of the Abri du Poisson.

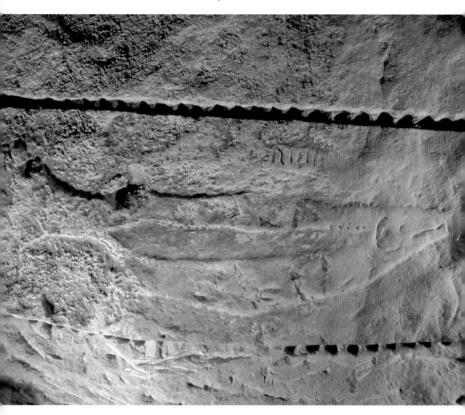

length, this bas-relief depicts an exhausted male salmon after spawning – hence the hook on its jaw. There is a series of seven parallel grooves in a small rectangle above the fish, somewhat akin to the series of notches below the stag in England's Church Hole (see page 36), and two broken rings in the rock by its tail fin. Like most bas-reliefs, it was originally painted red.

The fish figure was discovered, covered in lichens, in 1912, although the shelter had been excavated in the late nineteenth century. That same year an attempt was made by Professor Carl Schuchhardt to acquire it for Berlin's Anthropological Museum (of which he was the director); he agreed a price with the owner of 10,000 francs (around £14,000 today), but fortunately the owner's attempt to detach it was thwarted in December 1912, though it left the ugly holes and grooves that surround the fish.

Decades later, in 1975, a black hand stencil was also spotted on the ceiling, 1.5m to the right of the fish. It is certain that the shelter originally had far more decoration, as almost a hundred engraved and painted ceiling fragments were found in the spoil heap of the old excavations. Both of the surviving figures are thought to date to the Gravettian, about 25,000 years ago.

Delluc, B. and Delluc, G., 1997, 'L'affaire de l'abri du Poisson aux Eyzies: Otto Hauser non coupable', *Bulletin de la Société Historique et Archéologique du Périgord* 124: 171–77.

Peyrony, D., 1932, 'Les abris Lartet et du Poisson à Gorge d'Enfer (Dordogne)', *L'anthropologie* 42: 241–67.

White, R. 2006, *L'affaire de l'abri du Poisson: patrie et préhistoire*, Fanlac: Périgueux.

**Address**

Abri du Poisson, 24620 Les Eyzies
Tel: (33) (0)5 53 06 86 00; fax (0)5 53 35 26 18
www.leseyzies.com/grottes-ornees
fontdegaume@monuments-nationaux.fr

**Nearest city/town** Sarlat/Les Eyzies.
**Nearest airport** Bergerac.
**Nearest car rental** Périgueux.
**Nearest train station** Les Eyzies, Périgueux, Le Bugue.
**Nearest bus route** None.
**Nearest taxi or private car hire** Périgueux.
**Restaurants in the vicinity** Many.
**Hotels in the vicinity** Many.

**When is this cave open?** All year round, but closed Saturdays and 1 January, 1 May, 1 and 11 November, 25 December. No fixed hours – open on demand.
**Admission prices** Adults 3 euros; children under 18 free. Tickets from the Font de Gaume office (page 49).
**Storage facilities?** No.
**Do you have to make up a group?** Yes. About 20 people per group.
**Can you reserve a place in a group?** Yes.
**Languages of the guides** French, English.
**Length of tour** 1 hour for the Abri du Poisson; about 2 hours to see both sites.
**Is the cave privately owned?** No.
**Is there a gift shop?** No – the shop is at Font de Gaume.
**Is there a café (water)?** No.
**Are there WC facilities?** No.
**Handicapped access?** Yes at Laugerie, but not at the Abri du Poisson.
**Is any climbing necessary?** There is a sloping path up to the shelter; no stairs inside the cave.
**Distance to walk** About 100m to the Abri du Poisson. No distance inside.
**Level of fitness required** Moderate.
**Equipment required** The guide deals with lighting.
**What are the conditions inside the cave?** Flat and dry.
**Is it lit?** Daylight.
**Is it slippery?** No, but the path up to the shelter can be tricky in inclement weather.
**Is photography allowed?** No.

# BARA-BAHAU

The name means something like 'badaboom' in the local patois. The cave takes the form of a big, single, almost straight corridor, about 100m long, 12m wide and up to 6m high, with numerous flint nodules emerging from the walls and a chaos of blocks on the floor. The engravings were discovered by famed French speleologist Norbert Casteret on 1 April 1951. They are located in the farthest part of the cave, the Rotunda, which is beyond a narrow passage, and were placed on a steeply sloping wall. The eighteen figures cover an area 12m long by 5m high, in three panels, and comprise a series of animals – six horses, as well as bison, deer, aurochs and bears – and geometric signs. The cave was also much frequented by cave bears, *c.*50–80,000 years ago, and they left behind their bones and numerous claw marks on the soft walls. The artists sometimes

The bear engraving of Bara-Bahau.

made use of these, turning one set of claw marks into a hand and others for animals' coats. Many of the engravings are hard to discern, being quite crudely drawn in the irregular and soft walls, which have been likened to white cheese. The floor has been lowered in front of the decorated panel, for reasons of conservation and ease of viewing, and tracings of the main figures in front of the panel make it easier to understand what you are seeing. Stylistic arguments ascribe the engravings to the Middle Magdalenian *c.*14,000 years ago.

Delluc, B. and Delluc, G., 1997, 'Les gravures de la grotte ornée de Bara-Bahau (Le Bugue, Dordogne)', *Gallia préhistoire* 39: 109–50.

---

**Address**
Grotte de Bara-Bahau, 24260 Le Bugue sur Vézère
Tel./fax (33) (0)5 53 07 44 58
www.best-of-perigord.tm.fr/sites/prehisto/barabahau/caverne-oursuk.html
grotte-bara-bahau@hotmail.fr

**Nearest city/town** Périgueux/Le Bugue.
**Nearest airport** Bergerac.
**Nearest car rental** Périgueux, Bergerac.
**Nearest train station** Les Eyzies, Périgueux, Le Bugue.
**Nearest bus route** None, but the cave is only 600m from Le Bugue.
**Taxi or private car hire** Le Bugue.
**Restaurants in the vicinity** Many.
**Hotels in the vicinity** Many.

**When is this cave open?** February to June 10.00 to 12.00 and 14.00 to 17.30; July and August 9.30 to 19.00; September to December 10.00 to 12.00 and 14.00 to 17.00. Last visit 30 minutes before closing. Closed in January.
**Admission prices** Adults 5,90 euros; children (6–15) 3,90 euros; children under 6 free. Group rate (20 people); 4,90 euros per adult; 3,50 euros per child. Credit cards not accepted.
**Storage facilities?** Bags can be left behind the caisse.
**Do you have to make up a group?** No.

**Languages of the guides** French, English.

**Length of tour** 35 minutes.

**Is the cave privately owned?** Yes.

**Is there a gift shop?** Yes.

**Is there a café (water)?** Drinks are available, and a picnic area.

**Are there WC facilities?** Yes.

**Handicapped access?** No.

**Is any climbing necessary?** There are steps and a slope up from the car park and 4 steps inside the cave.

**Distance to walk** The entrance is 50m from the car park; you walk about 100m into the cave and the same out again.

**Level of fitness required** Minimal.

**Equipment required** Flashlights not necessary.

**What are the conditions inside the cave?** 15°C.

**Is it lit?** Yes.

**Is it slippery?** It can be slippery sometimes.

**Is photography allowed?** No.

# VILLARS

The cave of Villars was discovered by speleologists in 1953, and bluish-black marks were found at the end of 1957. The small paintings were spotted in January 1958 by speleologists and the abbé Glory. Villars has apparently always had very active growth of concretions; the palaeolithic artists broke some stalagmites, and calcite covers many of the figures, making them quite hard to see.

Most of the decoration is located in the two principal chambers. The Salle des Cierges contains some signs as well as a black bison and a black horse head on the ceiling. The Salle des Peintures, which lies beyond what was a very low and narrow passage for the artists, features more signs, but also five black horses, including the well-known small 'blue horse', which seems to be galloping; and the cave's most famous figures, an apparent scene of a confrontation between a bison and a human.

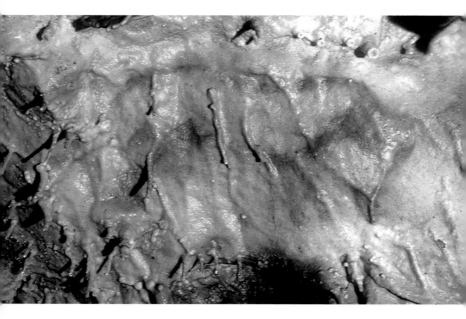

The 'blue horse' of Villars.

The paintings were originally thought to be very archaic, because of their simple and stiff appearance, but specialists now ascribe them to the Solutrean or Early Magdalenian, *c*.17–18,000 years ago.

Visitors to the cave are presented with a *son et lumière* and a twenty-minute video.

Delluc, B. and Delluc, G., 1974, 'La grotte ornée de Villars (Dordogne)', *Gallia préhistoire* 17: 1–67.

**Address**
Grotte de Villars, 24530 Villars
Tel. (33) (0)5 53 54 82 36; fax: (0)5 53 54 21 73
www.grotte-villars.com
contact@grotte-villars.com

**Nearest city/town** Périgueux/Brantôme.
**Nearest airport** Périgueux, Bergerac.
**Nearest car rental** At the airports.
**Nearest train station** Thiviers (15km away).
**Nearest bus route** None.
**Nearest taxi or private car hire** Brantôme, Thiviers.
**Restaurants in the vicinity** Brantôme, Thiviers, St Jean de Cole.
**Hotels in the vicinity** Brantôme, Thiviers, St Jean de Cole.

**When is this cave open?** April, May, June and September 10.00 to 12.00 (last visit 11.30) and 14.00 to 19.00 (last visit 18.30); July and August 10.00 to 19.30 (last visit 19.00); October 14.00 to 18.30 (last visit 18.00). Open to groups all year with advance reservation.
**Admission prices** Adults 6,90 euros; children (5–12) 4,50 euros; children under 5 free; students (up to 25 years old, with card) 5,50 euros. Group rates: adults 5,50 euros; children (5–12) 3,50 euros; children (over 12) 4 euros. Groups must have a minimum of 20 people. Credit cards accepted.
**Storage facilities?** Yes.
**Do you have to make up a group?** No.
**Can you reserve a place in a group?** No.
**Languages of the guides** French, English. Text available in English, German, Dutch, Spanish and Italian.
**Length of tour** 45 minutes.
**Is the cave privately owned?** Yes.
**Is there a gift shop?** Yes.
**Is there a café (water)?** Yes, and a picnic area.
**Are there WC facilities?** Yes.
**Handicapped access?** No.
**Is any climbing necessary?** A 150m path leads down to the cave from the car park, so must be ascended at the end; there are about 20 steps inside.
**Distance to walk** 150m from car park; total walk inside the cave 500m.
**Level of fitness required** Minimal.
**Equipment required** None.
**What are the conditions inside the cave?** 13°C. Easy and flat.
**Is it lit?** Yes.
**Is it slippery?** Non-slip floor.
**Is photography allowed?** No.

# ABRI REVERDIT
## (CASTEL-MERLE)

The Abri Reverdit is just one of a series of rock shelters at the foot of the hill of Castel-Merle in Sergeac. It was excavated in the late nineteenth and early twentieth centuries, and found to contain Magdalenian material. It is about 15m wide, up to 5m deep and 3m high. In about 1923 it was also found to contain a little horizontal frieze, about halfway up the wall, of very eroded sculptures in bas- and haut-relief – from left to right a small horse head (very doubtful), a horse about 1m long, a bison of the same length, the dorsal line of

Sculpted bison in the Abri Reverdit.

a possible small bison and finally another longer bison. All the animals face right. Part of the horse and the two larger bison are the easiest to discern. They are thought to date to the Middle Magdalenian, around 14,000 years ago. A stratigraphic section can also be seen in the shelter, containing a well-preserved fireplace.

The visit also includes the private family museum, which contains some fine objects; the Abri Labattut, which has a reconstruction of a flint-knapping area – this site has yielded a number of decorated blocks, including one bearing a horse engraving, 1m long, which is now in New York's American Museum of Natural History; and the Abri de la Souquette, which was occupied in the Aurignacian (when beads of mammoth ivory were manufactured here), Solutrean, Magdalenian and medieval times.

Groups are given a demonstration of flint knapping. Individuals can also arrange to see this demonstration, but need to reserve a place at least one week ahead.

Delage, F., 1935, 'Les roches de Sergeac (Dordogne)', *L'anthropologie* 45: 281–317.

**Address**
Site de Castel-Merle, 24290 Sergeac
Tel. (33) (0)5 53 50 79 70 or (0)5 53 53 77 78; fax (0)5 53 50 74 79
www.castelmerle.com
castelmerle24@aol.com

**Nearest city/town** Montignac/Sergeac.
**Nearest airport** Bergerac, Brive.
**Nearest car rental** Brive.
**Nearest train station** Brive, Souillac, Les Eyzies.
**Nearest bus route** None.
**Nearest taxi or private car hire** Montignac.
**Restaurants in the vicinity** Many, notably the Auberge de Castel-Merle near by (there are none in the village itself).
**Hotels in the vicinity** Many at Montignac.

**When is this cave open?** May, June, September and October 14.00 to 18.30; July and August 14.00 to 19.00. Closed Saturdays. Open all year for groups with reservation.

**Admission prices** Adults 5 euros; children (7–12) 2,80 euros; children under 7 free. Group rates: 4 euros per adult or child. Credit cards not accepted.

**Storage facilities?** Yes.

**Do you have to make up a group?** No.

**Can you reserve a place in a group?** Yes.

**Languages of the guides** French, English. A booklet in English, German or Dutch can be borrowed for the visit.

**Length of tour** 45 to 90 minutes.

**Is the cave privately owned?** Yes.

**Is there a gift shop?** Yes.

**Is there a café (water)?** Yes.

**Are there WC facilities?** No.

**Handicapped access?** Yes.

**Is any climbing necessary?** Just 6 steps and a slope up from the car park; no stairs.

**Distance to walk** About 50m from car park to site, and a total of 400m in the visit.

**Level of fitness required** Minimal.

**Equipment required** None.

**What are the conditions inside the cave?** Normal.

**Is it slippery?** It can be slippery here and there.

**Is photography allowed?** Not inside the museum or site.

# LASCAUX II

Of all decorated caves, by far the most famous and spectacular is that of Lascaux, which was discovered by four boys in September 1940 (the hole was found by a dog on the 8th, but the boys entered the cave on the 12th), and which houses the most spectacular collection of Ice Age wall art yet found.

It is best known for its 600 magnificent paintings of aurochs, horses, deer and signs, but it also contains almost 1,500 engravings dominated by horses. The decoration is highly complex, with numerous superimpositions, and clearly comprises a number of different episodes. The best-known feature is the great Hall of the Bulls, containing several great aurochs figures, some of them 5m in length – the biggest figures known in Ice Age art; the hall also contains an enigmatic figure baptized the 'unicorn'. One remarkable painted figure at the end of the Axial Gallery, dubbed the 'falling horse', is painted around a rock in such a way that the artist could never see the whole figure at once, yet when the figure is 'flattened out' with photographs it proves to be in perfect proportion.

A shaft features a painted scene of what seems to be a bird-headed man with a wounded bison and a rhinoceros, which has often been interpreted in shamanistic terms, though with little justification. The narrow Cabinet of the Felines forms the farthest extremity of the cave, and is filled with engravings, including a remarkable horse seen from the front, as well as the eponymous felines. It was in a shaft in this narrow corridor that a piece of Ice Age twisted rope was found.

Stone tools for engraving were found in the cave's engraved zones. Many lamps were also recovered (one of them a particularly well-carved specimen in red sandstone), as well as 158 fragments of pigment and colour-grinding equipment, including crude 'mortars' and 'pestles', stained with pigment, and naturally hollowed stones still containing small amounts of powdered pigment. There are scratches and traces of use-wear on many of the mineral lumps. It was found that there were sources of ochre (red) and of manganese

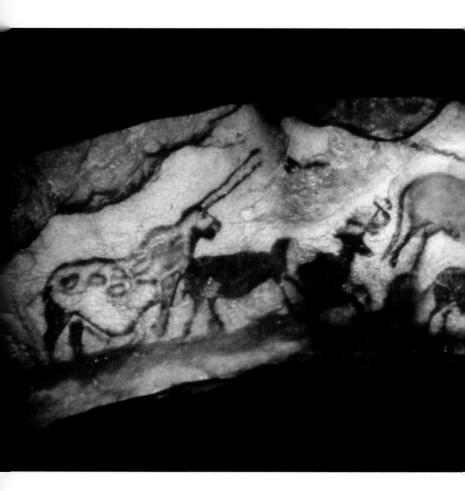

dioxide (black) within 500m and 5km of the cave respectively. The shades vary considerably – the colour of ochre is modified by heat, and Ice Age people clearly knew this. At Lascaux they also mixed different powdered minerals and were apparently experimenting with different combinations and heating procedures.

Photomontage of the 'unicorn' panel at Lascaux.

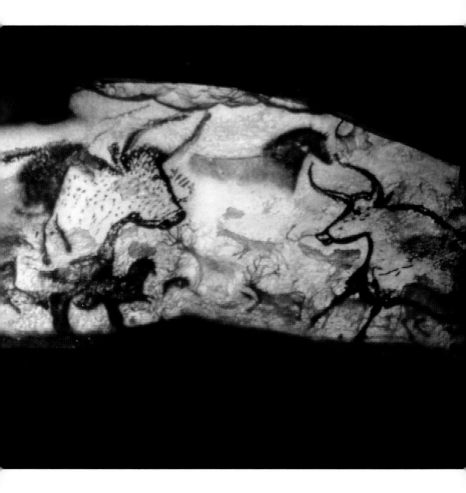

Scaffolding was clearly used in some galleries to reach the upper walls and ceiling – the Axial Gallery preserves the actual sockets for beams that must have supported such a scaffold. Much of the cave floor was lost when the site was adapted for tourism in the 1940s, but the site was probably never a habitation, being visited briefly for artistic activity or ritual. Charcoal fragments from the cave floor have provided radiocarbon dates around 15,000 BC and in the seventh millennium BC.

The cave was closed to tourists in 1963 because of pollution – a 'green sickness', consisting of a proliferation of algae, and a 'white sickness' of crystal growth had been noticed in the 1950s and were worsening. It was possible to reverse the effects of the green sickness and arrest the development of the white; but to ensure the survival of the cave's art, it was necessary to restrict the number of visitors drastically. As compensation, a facsimile, Lascaux II, was opened near by in 1983, which permits the public to visit exact replicas of the main painted areas of the cave.

The entrance steps down to the facsimile resemble those of the original cave. You enter a first dark room where photographs and diagrams explain the geology of the cave, the history of its discovery and the green and white sicknesses. A second larger room contains displays about the tools, lamps and pigments found in the cave, photographs of its art, a facsimile panel of some engraved horses and aurochs (look in particular for the horse with the strangely bent leg) and a facsimile of the famous panel of the two bison facing in opposite directions, with overlapping rumps.

The facsimile itself follows, and comprises the Hall of the Bulls and the Axial Gallery. Although they are dimly lit, you can still see most of the figures quite easily – and of course, the originals were created and always seen in conditions of feeble light. Cave art was never intended to be seen with the bright lights of today, and in these modern times we have forgotten how much one can see with minimal illumination.

One feature to notice in Lascaux – in addition to the astounding use of colour and shading (much of the pigment must have been blown or sprayed on to the wall, or applied with pads) – is the ingeniously simple way in which the legs at the far side of many animals are depicted: a small gap is left between the legs and the body, which immediately conveys that they are at the far side.

In the Hall of the Bulls, you see the 'unicorn', the famous huge bulls and also numerous horses and deer of different sizes. A bear is largely masked by the belly of one bull. In the Axial Gallery there is a whole cavalcade of wonderful images: aurochs, deer, ibex and

signs of many kinds (illustrated on pages 4–5). Some of the best-known figures in cave art are here, such as the 'Chinese' horse and the jumping cow, both on the right. At the far end is the 'falling horse'. In the original cave, being located at a cul de sac, its hidden extremity cannot readily be seen. One advantage of the facsimile is that the exit is beyond the falling horse, so you can see the whole of the image, as well as other little-known figures on the right-hand wall in this zone, such as a large bison. It is worth bringing a flashlight, however, as this area is particularly dark.

Aujoulat, N., 2005, *Glory of Lascaux: Rediscovering the Great Treasure of Prehistoric Art*, Thames and Hudson: London (*Lascaux: Movement, Space and Time*, Abrams: New York).

Laming-Emperaire, A., 1959, *Lascaux: Paintings and Engravings*, Pelican: Harmondsworth.

Leroi-Gourhan, A. and Allain, J. (eds), 1979, *Lascaux inconnu: XIIe supplément à Gallia Préhistoire*, CNRS: Paris.

Ruspoli, M. 1987, *The Cave of Lascaux: The Final Photographic Record*, Thames and Hudson: London.

**Address**
Grotte de Lascaux II, 24290 Montignac
Tel. (33) (0)5 53 51 95 03; fax (0)5 53 50 82 83. Group reservations:
tel. (0)5 53 05 65 60; fax (0)5 53 06 30 94. Tickets: tel. (0)5 53 51 96 23
www.semitour.com
contact@semitour.com

**Nearest city/town** Périgueux/Montignac.
**Nearest airport** Bergerac, Brive.
**Nearest car rental** Brive.
**Nearest train station** Brive; Souillac (TGV).
**Nearest bus route** None.
**Nearest taxi or private car hire** Brive (37km away).
**Restaurants in the vicinity** Many.
**Hotels in the vicinity** Many.

**When is this cave open?** July and August 09.00 to 20.00; February, March, November and December 10.00 to 12.30 and 14.00 to 17.30; April to June and September 09.30 to 18.30; October 10.00 to 12.30 and 14.00 to 18.00. From Easter to the end of September, tickets can be bought only in the centre of Montignac. Closed Mondays in low season, and closed in January, but open every day in July and August.

**Admission prices** Adults 8,20 euros; children (6–12) 5,20 euros; children under 6 free. No reduction for students, unemployed or OAPs. Group rates: 6,50 euros per adult, 5,20 euros per high school child; 4 euros per primary school child. Tickets are also available for a visit combining Lascaux II with the animal park of Le Thot – prices roughly 2 euros higher than the above rates.

**Storage facilities?** No.

**Do you have to make up a group?** Yes. Maximum of 40 people per group.

**Can you reserve a place in a group?** Yes.

**Languages of the guides** French, English, German; Spanish if arranged in advance; Dutch sometimes in the summer.

**Length of tour** 40 minutes.

**Is the cave privately owned?** No.

**Is there a gift shop?** Yes.

**Is there a café (water)?** Yes.

**Are there WC facilities?** Yes.

**Handicapped access?** No.

**Is any climbing necessary?** There is a slight climb up from the car park; there are some stairs down to the entrance to the cave.

**Distance to walk** About 250m to the cave from the car park and 80m inside.

**Level of fitness required** Minimal.

**Equipment required** None.

**What are the conditions inside the cave?** Flat and dry.

**Is it lit?** Yes.

**Is it slippery?** No. The area outside can be slippery in inclement weather.

**Is photography allowed?** No.

# MUSEE NATIONAL DE PRÉHISTOIRE
## (LES EYZIES)

In 1913, the old ruined castle above the village of Les Eyzies became the regional prehistory museum, which was later to become the Musée National de Préhistoire. It was officially inaugurated in 1923, and in front of it the famous statue of Neanderthal man by Paul Dardé was unveiled in 1931. By the 1980s, the available space had become woefully inadequate, both for the collections and for the number of visitors, and in the late 1990s a new building was erected, covering 5,000 sq. m and providing more than 1,500 sq. m of exhibition galleries devoted to palaeolithic life, technology and art. Of the 6 million objects housed here, about 18,000 are on display. Numerous pieces of Ice Age portable art and ornamentation are included; where parietal art is concerned, note the art on blocks from the Aurignacian more than 30,000 years ago (with a whole range of motifs, usually interpreted as 'vulvas'), and the aurochs in bas-relief on the block from Le Fourneau du Diable.

**Address**
Musée National de Préhistoire, 1 rue du Musée, 24620 Les Eyzies
Tel: (33) (0)5 53 06 45 45 or (for guided tours) (0)5 53 06 45 65;
fax (0)5 53 06 45 55
www.musee-prehistoire-eyzies.fr
mnp.eyzies@culture.gouv.fr

**Nearest city/town** Périgueux/Les Eyzies.
**Nearest airport** Bergerac.
**Nearest car rental** Périgueux.
**Nearest train station** Les Eyzies, Périgueux, Le Bugue.
**Nearest bus route** None.
**Nearest taxi or private car hire** Périgueux.
**Restaurants in the vicinity** Many.
**Hotels in the vicinity** Many.

**When is this museum open?** July and August
09.30 to 18.30; June and September 09.30 to
18.00; October to May 09.30 to 12.30 and
14.30 to 17.30. Closed Tuesdays except in July
and August.

**Admission prices** Adults 5 euros; students (18–25)
3,50 euros. Free on first Sunday of each month.
Under 18s and unemployed free. No reduction
for OAPs.

**Storage facilities?** Yes.

**Do you have to make up a group?** No.

**Can you reserve a place in a group?** No.

**Languages of guides** French, English.

**Is the museum privately owned?** No.

**Is there a gift shop?** Yes.

**Is there a café (water)?** Yes.

**Are there WC facilities?** Yes.

**Handicapped access?** Yes.

**Is any climbing necessary?** There are stairs, but
also an elevator.

**Level of fitness required** Minimal.

**Is photography allowed?** Yes.

Aurochs figures on a block from Le Fourneau
du Diable, in the Musée National de Préhistoire.

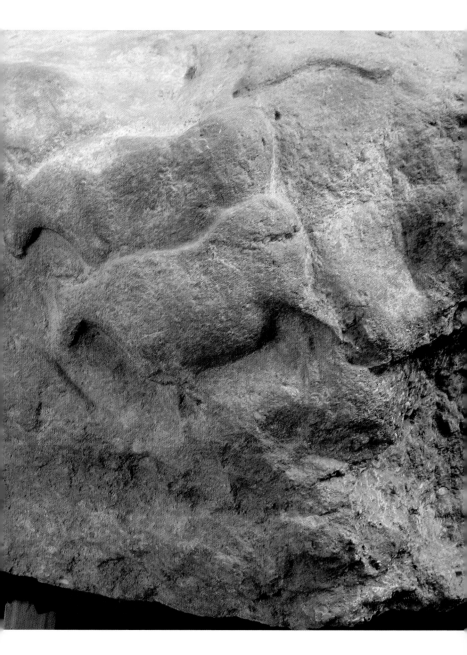

# COUGNAC

Cougnac is one of the most beautiful decorated caves, not only for its unique and striking paintings but also and especially for its amazing profusion of fine concretions. There are two caves, one decorated, and the other of purely geological interest, but equally beautiful. The latter also contains some interesting cave-bear claw marks.

The caves were found in 1949 (the undecorated cave) and 1952 (the decorated site), the latter by a water dowser. Excavations in the entrance of the decorated cave encountered only Mousterian (Neanderthal) material. The present entrance and path run alongside the original palaeolithic access. After about 60m and just before you reach the main decorated chamber, a passage leads off to the left. Along here, on the right, in a couple of large alcoves you find an important series of six complex signs, drawn in black, known as 'aviform' (bird-like) or 'chimney' signs (they vary greatly in size, and one has a double chimney). These are identical to three drawn in Pech-Merle (see page 96), and indeed the two caves are only 35km apart; but in the 1980s, seven engraved specimens were discovered in the cave of Le Placard in Charente, 165km away. Since they could be securely dated at Placard to more than 20,000 years ago, they have been renamed Placard signs, and they help to confirm the dates of Cougnac and Pech-Merle.

On the left wall as you move round from the side passage to the decorated chamber, there are a couple of strange 'phantoms', some dots and lines, and the front of a black stag, facing right.

The decorated chamber is noteworthy on several counts: it is one of the few caves without a bovid depiction, and the horse is limited to an abbreviated back and mane. Instead the frieze, along the left wall, comprises mammoths, ibex, two humanoids (each with possible 'spears' sticking in them – one has three, the other seven) and especially a series of three megaloceros (extinct giant deer), which, like the central ibex, make tremendous use of the natural rock shape. It is only from depictions such as these that we know

the megaloceros had a great hump of muscle and fat on its shoulder – the hump, of course, does not fossilize.

This frieze was clearly meant to be seen by people grouped at the other side of the chamber, and concretions were broken to make it more visible. At the same time, the two pillars of stalagmite in front of the central ibex were coated with red pigment to form a framework for viewing the figure. In this chamber and other parts of the cave, you find numerous finger marks in red and black, made by people who seem to have felt the need to touch and mark the walls and concretions.

Central ibex in the Cougnac panel, framed by red-coated stalagmites.

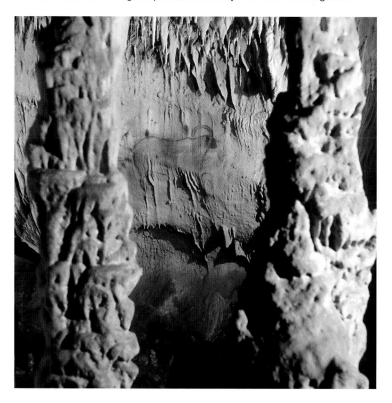

As you leave the decorated chamber, notice, on the floor, the place where a stock of red ochre powder is located. Tests have been carried out to see if this ochre is local (it is), and whether it was used to make the cave's red figures (it was). Cougnac also has the distinction of being the place where the very first direct radiocarbon date was obtained for Ice Age cave art. In the late 1980s, Michel Lorblanchet had a sample taken from a black charcoal dot located near the last mammoths at the right end of the frieze. It yielded an age of about 14,290 years ago; samples of paint from one male megaloceros later produced two different dates of 23,610 and 22,750 years ago, while the female megaloceros yielded two very different dates of 25,120 and 19,500 years ago. If all these dates are accurate – which is a very big 'if' with such cutting-edge science and such tiny samples – it may indicate that the cave's art, originally produced c.23–25,000 years ago, was touched up a few millennia later, while the dot indicates that some Magdalenians entered the cave much later and, while respecting the existing art, marked the walls with their fingers quite extensively.

Lorblanchet, M. and Jach, F., 1997, *Cougnac: les grottes magiques* . . . , Edition des Grottes de Cougnac.
Méroc, L. and Mazet, J., 1954, *Cougnac: grotte peinte*, Kohlhammer Verlag: Stuttgart.

**Address**
Grottes de Cougnac, 46300 Gourdon
Tel./fax (33) (0)5 65 41 47 54
www.grottesdecougnac.com
grottes.de.cougnac@wanadoo.fr

**Nearest city/town** Toulouse/Gourdon.
**Nearest airport** Toulouse.
**Nearest car rental** Gourdon.
**Nearest train station** Gourdon.
**Nearest bus route** Gourdon.

**Nearest taxi or private car hire** Gourdon.

**Restaurants in the vicinity** Gourdon.

**Hotels in the vicinity** Gourdon.

**When is this cave open?** All year round. 10 April to 30 June and 1 to 30 September 10.00 to 11.30 and 14.30 to 17.00; 1 July to 31 August 10.00 to 18.00; 1 October to 1 November 14.00 to 16.00, closed Sundays. At other times, arrange a time and day.

**Admission prices** Adults 6 euros; children (5–12) 4 euros. No reduction for OAPs, unemployed or students. Group rates (minimum of 20 people): 4,60 euros per adult; 3,60 euros per child. Special visits are possible on Wednesday mornings from 09.00 to 11.00, costing 12 euros.

**Storage facilities?** Yes.

**Do you have to make up a group?** Yes. A maximum of 25 people per group, and up to 15 visits per day.

**Can you reserve a place in a group?** Yes.

**Languages of the guides** French, English.

**Length of tour** 60 to 75 minutes. Seeing both caves takes 2 hours.

**Is the cave privately owned?** No.

**Is there a gift shop?** Yes.

**Is there a café (water)?** Hot and cold drinks are available at the ticket office.

**Are there WC facilities?** Yes.

**Handicapped access?** No.

**Is any climbing necessary?** There is a staircase up to the decorated cave. One staircase takes you up to the path leading to the decorated cave; two staircases lead down into each cave.

**Distance to walk** About 300m from the ticket office to the cave; about 175m into the cave, and the same out.

**Level of fitness required** Moderate.

**Equipment required** None.

**What are the conditions inside the cave?** Easy and flat.

**Is it lit?** The cave is lit with electricity.

**Is it slippery?** It can be wet and slippery in places.

**Is photography allowed?** Not in the decorated caves; yes in the undecorated.

# GROTTE DES MERVEILLES

This modest cave, only about 45m long, 25m wide and 4m high, is filled with stalactites and artificial lakes, and contains some faint red and black paintings, few of them easy to see. It was discovered in 1920, and the paintings were spotted later that year. The 22 figures comprise 6 hand stencils, 6 horses, 1 feline, 1 deer, 2 groups of dots and 6 undetermined figures. Nearly all are concentrated on the right wall, at the foot of the entrance staircase, but 13 red dots are located on the left wall opposite. Most of them were clearly spat or sprayed on to the wall, and their style – similar to that of Cougnac (page 90) and Pech-Merle (page 96) – ascribes them to the late Gravettian period, *c.*23,000 years ago.

Deer and horse from the Grotte des Merveilles.

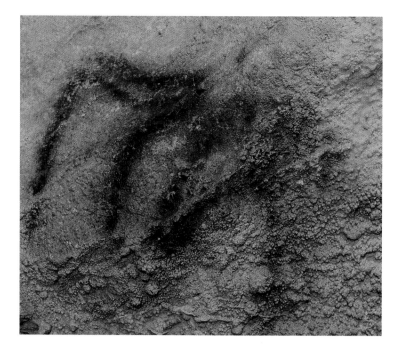

Lorblanchet, M., 1970, 'La grotte des Merveilles à Rocamadour (Lot) et ses peintures préhistoriques', *Bulletin de la Société des Etudes du Lot 7*: 1–32.

**Address**
Grotte des Merveilles, L'Hospitalet, 46500 Rocamadour
Tel./fax (33) (0)5 65 33 67 92
http://grotte-des-merveilles.com/
rocamadour@wanadoo.fr and contact@rocamadour.com

**Nearest city/town** Sarlat/Rocamadour.
**Nearest airport** Toulouse.
**Nearest car rental** Rocamadour.
**Nearest train station** Rocamadour (3km away).
**Nearest bus route** None.
**Nearest taxi or private car hire** Rocamadour.
**Restaurants in the vicinity** Rocamadour.
**Hotels in the vicinity** Rocamadour.

**When is this cave open?** April to June and September to November 10.00 to 12.00 and 14.00 to 18.00; July and August 9.30 to 19.00.
**Admission prices** Adults 6 euros; children (5–11) 4 euros; children under 5 free. Groups of at least 15 people: adults 5 euros; children 5–11 3,50 euros; children 13–18 4 euros. Credit cards not accepted, but a bank machine is located close to the cave.
**Storage facilities?** Yes.
**Do you have to make up a group?** No. Visits take place every 40 minutes.
**Can you reserve a place in a group?** Yes.
**Languages of the guides** French, English, German; a text in Dutch, Spanish and Italian can be borrowed for the visit.
**Length of tour** 35 minutes.
**Is the cave privately owned?** Yes.
**Is there a gift shop?** Yes.
**Is there a café (water)?** Refreshments available.
**Are there WC facilities?** Yes.
**Handicapped access?** No
**Is any climbing necessary?** There are 22 steps down to the entrance and a few more inside.

**Distance to walk** About 80m from car park to cave, and about 100m inside.
**Level of fitness required** Minimal.
**Equipment required** None.
**What are the conditions inside the cave?** Easy and comfortable.
**Is it lit?** Yes.
**Is it slippery?** It can be very slippery at times.
**Is photography allowed?** No.

# PECH-MERLE

Situated near Cabrerets (Lot), in the Quercy region of France, the cave of Pech-Merle is one of the most stunning decorated caves open to the public – beautiful both for its formations and for its famous images. It was decorated at different periods between c.25,000 and 12,000 years ago.

Although the cave was known throughout history, its wealth of palaeolithic art was first discovered on 4 September 1922, while the Combel Gallery and its art were discovered in October 1949 after a passage was forced through the rubble blocking it. Pech-Merle was opened to the public in 1924, and material excavated from its interior is housed in a museum near the entrance, which also provides a fine introduction to the prehistory of the region, and to the art of Pech-Merle, including those parts which the public cannot visit. The cave is spacious, dry and pleasant (there are 1,300m of galleries, with an average width of 10m and a ceiling often 5m or even 10m high); an artificial entry shaft and staircase were constructed close to the original entrance.

The cave's art has been assigned to three phases: the first two lie between c.25,000 and 15,000 years ago, while the third dates to the Middle Magdalenian, c.13,000 years ago. The earliest comprises dots, circles, hand stencils and simple finger meanders on the 40 sq. m 'hieroglyph ceiling'. The masterpiece of this phase is the famous 'spotted horse' panel, 4m in length, featuring two

horses, back to back and partly superimposed, and a long red pike, 6 black hand stencils (all of the same hand, alternating palm up and palm down, and using the same pigment), 7 red stencils of what may be bent thumbs, a red circle, 28 red dots and 224 black dots, placed in and around the horses. The right-hand horse uses the rock's shape, which naturally resembles a horse head (it was never shaped by the artists), although the two animals have stylized, very tiny heads. The horses, hands and dots were all made by spitting pigment. An experiment by Michel Lorblanchet to replicate this panel required thirty-two hours of work; a radiocarbon date of 24,640 years ago was obtained from charcoal in the right-hand horse's paint. An uncorrected radiocarbon date of 18,400 years ago has also been obtained from a butchered reindeer bone left in front of the horse panel.

The second phase includes the figures made of finger tracings on the ceiling (mammoths, an ibex and some women bending forward with hanging breasts – two of them are headless). It also comprises the cave's 40 black outline drawings, 24 of which are grouped on the famous 7m Black Frieze or Chapel of the Mammoths, 80m from the entry (11 mammoths, 5 bison, 4 horses, 4 aurochs and red dots). Close analysis by Lorblanchet has revealed that the whole thing was probably done in a spiralling composition by one artist, who started with a big horse at the centre, and then placed the bison around it and finally an outer ring of mammoths; the aurochs were put in last. No eyes and few hoofs were drawn. Experimentation suggests that the whole panel could have been done in an hour.

The final phase comprises some engravings, including one well-known figure of a bear head. Among the cave's other notable figures, one should mention the collection of over a hundred red dots in different patterns (including a big rectangle) on the ceiling of the Combel Gallery (not accessible to the public), some done by pad and others by spraying; a hand stencil next to another group of red dots; a series of motifs which Leroi-Gourhan believed to be 'bison-women' and which helped to inspire his theory that the bison was a female symbol; and a humanoid figure apparently

pierced by eight 'missiles', next to a motif known as a 'chimney' sign (see Cougnac, page 90).

At present, a total of 576 engraved and painted figures are known, if one counts every dot as a separate unit. Using this system of counting, abstract signs dominate heavily, since there are only about 60 animals: 21 mammoths, 12 bison, 7 horses, 6 aurochs, 6 deer, 2 ibex, 1 lion, 1 bear and 3 imaginary animals baptized 'antelopes', with tiny heads, short horns and a hypertrophied body with a big stomach (they are drawn in a particularly inaccessible part of the Combel Gallery). There are also 12 humans, 4 of them fairly realistic and 8 very schematic.

Palaeolithic people never inhabited the cave and the scant traces they left (a few bones and flints, and a dozen footprints of a young adolescent) suggest a series of rapid visits.

Before entering the ticket office, note the slender oak trees outside: why does one of them have a white question mark painted on its trunk? All will be revealed later. On descending the steep staircase down to the artificial entrance into the cave, you turn left, and after 80m you come to the Black Frieze. A short climb leads up to a natural balcony, from which there is a splendid view down to the 'spotted horse' panel. Up here there are further black drawings on the ceiling and on the left-hand wall, of stylized bison and mammoths, often making major use of the natural rock shape. You then reach the famous ceiling with its swirling finger marks and drawings of women and mammoths. Next comes a major chamber with huge natural stalagmitic discs that have fallen from the ceiling; there are also huge formations which closely resemble the shaggy mammoths of the Black Frieze, and which may well have inspired the cave's artists. Some cave-bear claw marks can also be seen.

After walking past the preserved footprints of an adolescent, you reach the lowest point in the cave. An artificial tunnel leads to the bear gallery, where the engraving of a bear head can be seen, 150m

Hand stencil and dots at Pech-Merle.

from the original entrance. Note that the palaeolithic artist had to crawl through this space, where you are now walking upright. Walking past the point where the boys who discovered the cave's art emerged after crawling through a 140m tunnel, you reach the area with the humanoid (hit by 'spears'), the chimney sign, an aurochs and ibex and several red signs. A staircase of twenty-three steps leads down past the unique natural cave 'pearls' formation, to a stag drawing, opposite which is the hand stencil with dots, and the overhang housing the ambiguous 'bison-women' images and other animals. Finally, you reach the famous 'spotted horse' panel, and, before exiting, an area where bones of animals from the cave have been stored together.

Lemozi, A., 1929, *La grotte-temple du Pech-Merle: un nouveau sanctuaire préhistorique*, Picard: Paris.
Lemozi, A., Renault, P. and David, P., 1969, *Pech Merle, Le Combel, Marcenac*, Akademische Druck- und Verlagsanstalt: Graz.

**Address**
Centre de Préhistoire du Pech-Merle, 46 Cabrerets
Tel. (33) (0)5 65 31 27 05 or (0)5 65 31 23 33; fax (0)5 65 31 20 47
www.pechmerle.com
info@pechmerle.com

**Nearest city/town** Cahors/Cabrerets.
**Nearest airport** Toulouse.
**Nearest car rental** Cahors.
**Nearest train station** Cahors.
**Nearest bus route** Cahors to Conduche.
**Nearest taxi or private car hire** Cahors.
**Restaurants in the vicinity** Cabrerets.
**Hotels in the vicinity** Cahors and Cabrerets.

**When is this cave open?** 1 April to 4 November, every day including Sundays and holidays. Tickets on sale 9.30 to 12.00 and 13.30 to 17.00. First morning tour at 09.45, first afternoon tour at 14.00, with visits every 15 or 30 minutes afterwards. Closed 15 December to 15 January. At other times, visits are possible for groups if reservation is made in advance. It is recommended that groups reserve at least a week in advance and individuals at least 24 hours (but 3 or 4 days in July and August). Reservations are cancelled 15 minutes before scheduled departure, so don't be late.

**Admission prices** 15 June to 15 September: adults 7,50 euros; children (5–18) 4,50 euros; children under 5 free; 'family' single 5,50 euros. Groups of adults 6 euros per person; groups of children (5–18) 3,50 euros. At other times: adults 6 euros; children 3,80 euros; children under 5 free; 'family' single 3,80 euros; groups of adults 4 euros per person; groups of children (5–18) 3,50 euros.

**Storage facilities?** Yes.

**Do you have to make up a group?** Yes. Up to 25 people per group are admitted, with a maximum of 700 people per day.

**Can you reserve a place in a group?** Yes.

**Languages of the guides** French, English; large-print booklets available in Dutch, German, Italian, Spanish, Danish or Hebrew which can be read inside the cave.

**Length of tour** 50 minutes in the summer, or 1 hour in winter.

**Is the cave privately owned?** No.

**Is there a gift shop?** Yes.

**Is there a café (water)?** Yes.

**Are there WC facilities?** Yes.

**Handicapped access?** No.

**Is any climbing necessary?** There is a slight descent from the car park, a staircase of 50 steps down to the entrance and several staircases inside.

**Distance to walk** The cave entrance is about 100m from the car park; you walk 400m into the cave, and the same back.

**Level of fitness required** Moderate.

**Equipment required** None.

**What are the conditions inside the cave?** Easy.

**Is it lit?** The cave is lit with electricity.

**Is it slippery?** Not usually.

**Is photography allowed?** No.

# PAIR-NON-PAIR

A small cave just north of Bordeaux, Pair-non-Pair (Odds or Evens) is small but interesting with some fine, archaic deep engravings. Holes in the roof used to bring daylight into the cave in palaeolithic times, when they also served to rid the cave of smoke. In 1881, a gentleman named François Daleau discovered the cave and began digging here, finding Ice Age animal bones. On 29 December 1883 he noticed engravings on the walls exposed by the removal of occupation layers, but he paid little attention to them, apart from mentioning the fact in his notebook. It was not until thirteen years later that the discoveries at the cave of La Mouthe (Dordogne) led him to clean the walls with a water spray from the vineyards and study the pictures. He drew sketches of the animal figures in his notebook and published an article about them. Since some of them had been covered by Gravettian occupation layers, it was indisputable that the pictures were at least as old as that, c.25,000 years old.

When Daleau began digging, the sediments were less than 1m from the ceiling. Moreover, the present cave is really just the end portion – some of the original cave ceiling collapsed to form the natural passage by which you now approach it. The figures begin on the right as soon as you enter, and most of them must originally have been in half-light.

In the first panel, there are five ibex, including two facing each other; below them are a mammoth facing left, a bison facing left, nose to nose with another animal, and two horses, both facing right.

The next panel, the most famous of the cave, features two horse figures known as Agnus Dei (Lamb of God) because they are both looking back over their shoulders. One puzzle is that the lower horse has disproportionately large forelegs with cloven hoofs, so these may in fact belong to a different animal.

The Agnus Dei panel at Pair-non-Pair.

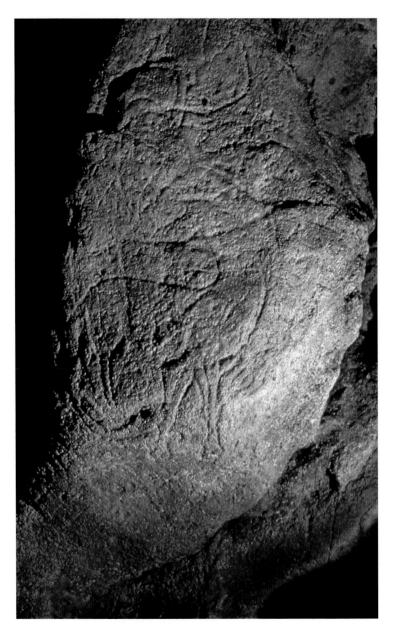

The third panel along the right wall contains an ibex facing right, a megaloceros (extinct giant deer) facing left, and a large stag facing right, as well as an enormous horse figure facing right. Opposite, on the left wall, facing the modern entrance, the figures include what seem to be two deer facing each other, the stag facing right and the doe left. Opposite them is a small mammoth figure.

The cave contains around forty figures, but many are too eroded or vague to be shown in a normal visit. The small side passage leading to the original entrance (now blocked) has a stone ring carved in its ceiling.

Cheynier, A., 1963, 'La caverne de Pair-non-Pair, Gironde: fouilles de François Daleau (relevés des gravures par H. Breuil avec M. E. Boyle, F.S.A. Scot et R. L. Doize)', *Documents d'Aquitaine II*, publication de la Société Archéologique de Bordeaux.

Lenoir, M. et al, 2006, *La Grotte de Pair-non-Pair*, Société Archéologique de Bordeaux: Bordeaux.

**Address**
Grotte de Pair-non-Pair, 33710 Prignac-et-Marcamps
Tel./fax (33) (0)5 57 68 33 40
www.monum.fr

**Nearest city/town** Bordeaux/Bourg-sur-Gironde, Blaye.
**Nearest airport** Bordeaux.
**Nearest car rental** Bordeaux.
**Nearest train station** St André-de-Cubzac.
**Nearest bus route** Bordeaux to Prignac.
**Nearest taxi or private car hire** Bordeaux.
**Restaurants in the vicinity** Bourg-sur-Gironde, Bordeaux.
**Hotels in the vicinity** Bourg-sur-Gironde, Bordeaux.

**When is this cave open?** All year round, daily except Mondays, 1 January, 1 May, 1 and 11 November, and 25 December. Visits at 10.00, 10.45, 11.30, 14.30, 15.30 and 16.30. Between 15 June and 15 September there are extra visits at 12.30, 13.30 and 17.30.

**Admission prices** Adults 6,50 euros; students (18–25) 4,50. Group rate (at least 20 people): 5,30 euros per person; under 18s free, except for school groups. Credit cards not accepted.

**Storage facilities?** Yes.

**Do you have to make up a group?** Groups of up to 19 people.

**Can you reserve a place in a group?** Yes.

**Languages of the guides** French; English and Spanish if arranged in advance.

**Length of tour** 30 to 45 minutes.

**Is the cave privately owned?** No.

**Is there a gift shop?** Yes.

**Is there a café (water)?** Planned for 2007.

**Are there WC facilities?** Yes.

**Handicapped access?** No.

**Is any climbing necessary?** There are 30 easy, shallow steps down to the cave, and 20 back up again. No stairs inside cave.

**Distance to walk** 40m to the cave and 20m inside.

**Level of fitness required** Minimal.

**Equipment required** The guide provides lighting.

**What are the conditions inside the cave?** Easy and very dry.

**Is it lit?** No.

**Is it slippery?** Rarely (in winter).

**Is photography allowed?** No.

# MUSÉE D'AQUITAINE

Bordeaux's fine Musée d'Aquitaine is well worth a visit by those interested in cave art. It contains photos of the engravings in the cave of Pair-non-Pair (page 102), as well as artefacts from the cave and copies of some pages from the notebooks of its excavator, Daleau, including one of the first sketches of cave art ever made. It also contains an abundance of portable art pieces, notably from the Abri Morin; and a full-size facsimile of the so-called 'swimming deer' panel from Lascaux.

However, the most important exhibits here are from two neighbouring rock shelters: Cap Blanc (page 54) and Laussel. From the former, there are stone tools, as well as two pieces that became detached from the sculpted frieze – a small horse head and a bas-relief bison. From Laussel, there are two blocks bearing engraved motifs that are interpreted as 'vulvas'; and, above all, the famous 'Venus with horn', a bas-relief, 47cm high, which was removed from a block found in the rock shelter in 1911/12. It represents a woman with voluptuous breasts and hips, who is holding what may be a bison horn in her right hand; it has thirteen lines engraved on it. The fingers of the woman's left hand are engraved on her belly, and there are traces of red ochre on her chest. There have been many interpretations of this figure, often involving menstruation or lunar cycles. The Laussel block also bore other figures, one of which – another 'Venus' holding a curved object – ended up in Berlin and disappeared during the Second World War. It is represented here by a cast. The other figures – a possible male, and also an enigmatic 'double' figure (often seen as a birthing or copulation scene) – have sometimes been displayed in the past, but were not on view at the time of writing.

The Venus of Laussel in the Musée d'Aquitaine.

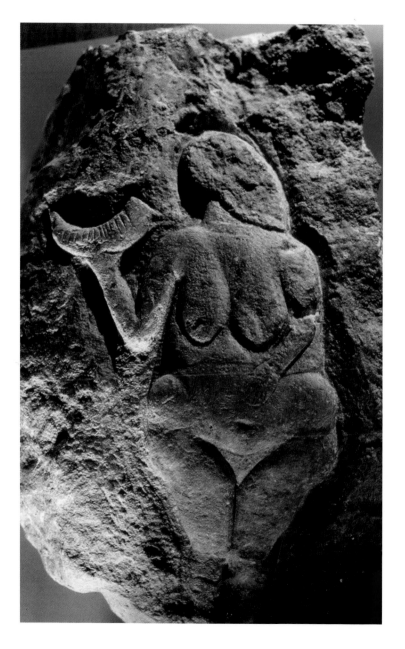

**Address**
20 cours Pasteur, 33000 Bordeaux
Tel. (33) (0)5 56 01 51 00; fax (0)5 56 44 24 36
www.mairie-bordeaux.fr
musaq@mairie-bordeaux.fr

**Nearest city/town** Bordeaux.
**Nearest airport** Bordeaux.
**Nearest train station** Bordeaux.
**Nearest taxi or private car hire** Bordeaux.
**Restaurants in the vicinity** Many.
**Hotels in the vicinity** Many.

**When is this museum open?** 11.00 to 18.00. Closed Mondays and holidays.
**Admission prices?** Free.
**Storage facilities?** Yes.
**Is the museum privately owned?** No.
**Is there a gift shop?** No.
**Is there a café (water)?** No, but there are plenty in the immediate vicinity.
**Are there WC facilities?** Yes.
**Handicapped access?** Yes.
**Is photography allowed?** Yes.

# ISTURITZ AND OXOCELHAYA

The cave of Isturitz is one of the 'supersites' of the French Upper Palaeolithic for the importance and wealth of its repeated occupations (from the Mousterian over 50,000 years ago to the end of the Ice Age), the quantities of artefacts they have yielded and the great abundance of portable art objects. There are actually three caves here, on top of each other. Isturitz is the upper cave. The middle cave, Oxocelhaya-Hariztoya, contains a few parietal figures which can be visited. The bottom cave, Erberua, which contains much parietal art and some work in clay, cannot be visited since it requires diving equipment to enter it.

Isturitz has two galleries (running parallel in the single great chamber), both over 100m long, which were excavated in the first half of the twentieth century, first by Passemard and then by the Count de Saint-Périer. A large stalagmitic cone in the northern part of the cave is decorated with some bas-relief sculptures, which were

The decorated panel of Isturitz.

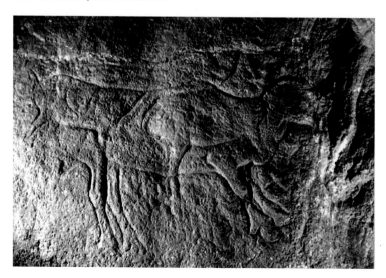

discovered by Passemard in 1913. They were originally covered by Middle Magdalenian occupation deposits, but their style ascribes them to that period (*c.*14,000 years ago), and they would have been made in daylight, like all known Ice Age bas-reliefs.

The figures, located on the northern side of the column, include a reindeer facing right, over 1m long, at bottom left. It has two other animals (deer?) superimposed on it, also facing right. Opposite them is a bear and, above it, the remains of an ibex and a horse.

The cave of Oxocelhaya is normally visited for its spectacular concretions. Its art, discovered in 1955, is only shown during special visits on Sunday mornings at eleven, or if prearranged. The Galerie Georges Laplace primarily contains a frieze of three big horses, each reduced to the dorsal line and forequarters.

Passemard, E., 1944, 'La caverne d'Isturitz en Pays Basque', *Préhistoire* 9: 1–95.

de Saint-Périer, S., 1968, 'Gravures pariétales de la grotte inférieure d'Isturitz', pp. 359–67 in *La préhistoire: problèmes et tendances*, Editions du CNRS: Paris.

---

**Address**
Grottes Préhistoriques d'Isturitz et Oxocelhaya, 64640 St Martin d'Arberoue
Tel. (33) (0)5 59 29 64 72 or (0)5 59 47 07 06; fax (0)5 59 47 30 17
www.grottes-isturitz.com
cromagnon@grottes-isturitz.com

**Nearest city/town** Bayonne/Cambo, Hasparren.
**Nearest airport** Biarritz.
**Nearest car rental** Bayonne, Biarritz.
**Nearest train station** Bayonne, Biarritz.
**Nearest bus route** Hasparren.
**Nearest taxi or private car hire** Hasparren.
**Restaurants in the vicinity** Many.
**Hotels in the vicinity** Many bed and breakfasts in the area. Many hotels in Bayonne and Biarritz.

**When is this cave open?** 15 March to 31 May and 1 October to 15 November: every day 14.00 to 17.00; on holidays at 11.00 and 14.00 to 17.00. June and September: every day at 11.00 and 12.00 and 14.00 to 17.00. July and August: every day from 10.00 to 13.00 and 14.00 to 18.00. Private visits available all year, to be arranged in advance.

**Admission prices** Adults 6,60 euros; children (7–14) 3,30 euros; children under 7 free.

**Storage facilities?** Yes.

**Do you have to make up a group?** No. Groups are of 20 people. Visits every 30 minutes.

**Can you reserve a place in a group?** No.

**Languages of the guides** French, English, Spanish, Basque.

**Length of tour** 45 minutes.

**Is the cave privately owned?** Yes.

**Is there a gift shop?** Yes.

**Is there a café (water)?** Yes.

**Are there WC facilities?** Yes.

**Handicapped access?** No.

**Is any climbing necessary?** Inside there are 86 steps going down, and a slope plus a few stairs back up.

**Distance to walk** From the car park to the cave mouth, 500m; inside the cave, a total of 600m.

**Level of fitness required** Minimal.

**Equipment required** None.

**What are the conditions inside the cave?** 14°C.

**Is it lit?** Yes.

**Is it slippery?** No.

**Is photography allowed?** No.

# GARGAS

The cave of Gargas, near Montréjeau in the foothills of the central French Pyrenees, was decorated in several periods of prehistory and history. The cave had already long been known for its richness in the skeletons of Ice Age fauna when, in 1906, its art was first reported by Félix Regnault, a local scholar. The material recovered in subsequent excavations is housed in Paris's Institut de Paléontologie Humaine and Toulouse's Muséum d'Histoire Naturelle.

The cave comprises 530m of galleries in two different sectors at separate levels. The lower cave originally had a huge porch, which subsequently collapsed, and an artificial entry has been punched through it, leading to an enormous gallery about 140m in length and 25m wide, which contains many large stalagmitic formations and several side chambers. The upper cave, reached nowadays by a staircase, is narrower and more tortuous.

Gargas is one of the finest caves in the Pyrenees, worth visiting for its formations alone – a fact which makes its unique art a special bonus. Its stalagmites and its ease of access have attracted the curious throughout history, and the cave was first mentioned in print in 1575 by François de Belleforest, who thought it was a place where idolaters used to sacrifice to Venus or to the Infernal gods. The visitor may wonder what Venus had to do with caves: the connection springs from the innumerable vertical stalagmites which de Belleforest describes as an 'infinite number of Priapic images and other filth' – in other words, to sixteenth-century eyes these innocent works of patient Nature were simply phallic statues for a fertility rite.

Some visitors of around this period left engravings of crossbows on the walls, but there are other graffiti in the cave which may be medieval or even older. Modern visitors are urged not to emulate their predecessors.

Gargas also had its own 'Jack the Ripper': around 1780 a notorious criminal lunatic called Blaise Ferrage was said to have used the cave as his refuge. This small but tremendously strong man, armed with a shotgun, a dagger and a beltful of pistols, carried

Some of the hand stencils at Gargas.

off a succession of young girls and women at gunpoint. He cut off their breasts and thighs, and pulled out their intestines and liver, which he ate. It is said that he massacred over eighty victims in this way until he was at last arrested; he was executed at Toulouse, in the Place St Georges, on 13 December 1782. Archives of the period confirm Ferrage's existence, his arrest and execution, and perhaps even the number of his crimes (though the cannibalism is likely to be an embroidering of the facts); unfortunately for Gargas, however, they also indicate that the crimes were committed in Ariège, and his link with the cave seems mere legend.

Excavations have been carried out in Gargas since the 1860s – not all of them archaeological, however, because palaeontologists found that parts of the cave were extremely rich in the bones of extinct animals. For a long time during the Ice Age it was a bear cave, used probably for hibernation and giving birth. Many bears died here during the winters, or lost their footing in the dark and fell down shafts to their deaths. Fossilized bear droppings have been found in the cave, and bear claw marks can still be seen on the walls. Hyenas also used the cave at times, as did wolves and other animals.

In the centre of the cave is a small hole in the floor (away from the tour path). This artificial access to a lower cave was made in the 1880s, when Félix Regnault, an intrepid scholar from Toulouse, used to squeeze through it and down a 20m vertical shaft to reach the heaps of bones of Ice Age animals that had lain there for thousands of years. From these 'oubliettes' came fine, complete skeletons of cave bears and hyenas which taught the world much about these powerful animals.

The archaeological excavations, meanwhile, discovered hearths in the cave, with stone tools and bones of Ice Age animals; clearly people had also used Gargas as their home at that time. Subsequently, a whole series of occupations from different periods (from hundreds of millennia to c.25,000 years ago) were uncovered: the Acheulian, the Mousterian (Neanderthals) and finally the early phases of the Upper Palaeolithic, up to the Gravettian. It appears that the original entrance collapsed after that period, which explains why lower Gargas has no art of the Magdalenian. The present entrance was blasted through in 1818.

Despite all the scholarly activity in the cave during the last decades of the nineteenth century, it was not until 1906 that Félix Regnault first spotted some red hand stencils on the walls. As in other caves, the art had not been noticed before because it was not thought to exist; or, if it had been seen, it was assumed to be modern. By 1906, however, enough cave art had been discovered and authenticated to make scholars alert to the possibilities of other caves and their walls. Subsequent visitors to Gargas found more and

more such hands until, by 1910, over 150 had been recorded. In that year, Henri Breuil also found the engravings on the walls.

Today, a total of 231 hand stencils are known in the cave, comprising 143 done in black (often charcoal), 80 in red, 1 in white and 7 in other shades. Left hands are about six times as numerous as right, which would be a clear indication of the dominance of right-handedness at this time (the right hand being employed in the process of applying the paint) if we could be sure that the hands were placed on the wall palm downward – which we can't.

The diffuse halo of pigment around most Gargas hands clearly indicates that they were made by blowing powder on to a wet wall or by applying the paint with a pad around the hand, and a lot of experiments have been done which try to copy the stencils using a variety of techniques – with hands palm down or up, with pigment in liquid or powder form, sprayed from the mouth or through a tube, and so forth. But the experimenters' conclusions about how the hands were stencilled are generally coloured by their views on why most of the Gargas hands are incomplete – the feature which gives this cave a very special importance.

Stencils of hands are quite common in Ice Age art, and occur in several of the caves in this book (for example Pech-Merle, page 96, El Castillo, page 148); but apart from those at Gargas and a few other caves, all these hands are intact. At Gargas, for every complete hand there are about fifteen incomplete specimens, ranging from those with a single phalange missing to hands with almost no fingers left at all.

Over the years, three different theories have been put forward to account for the mystery of the Gargas hands.

The first theory is that of deliberate mutilation, either for ritual purposes or for punishment. There are plenty of examples around the world of peoples who cut off phalanges or whole fingers for a wide variety of reasons; they usually remove the little finger, which is the least used and the most dispensable. However, at Gargas, some of the hands have virtually no fingers left at all, which seems a pretty severe form of mutilation to inflict

within a society where serviceable hands must have been crucial to one's survival.

A second theory is that of Ali Sahly, a Tunisian doctor, who believed that the missing fingers of Gargas were the result of various pathological conditions. He found that the stencils comprised adults, women and/or youths, and children including infants – in other words, apparently the whole group; he also noted that the various combinations of missing phalanges are only on the fingers, not the thumb. Almost 30 per cent have the last two phalanges of all four fingers gone, and he claimed that repetitions of the same hands were detectable. If the Gargas hands were indeed mutilated or incomplete, then it is some comfort to reflect that fewer than 20 people probably account for the 231 prints. He concluded that conditions such as frostbite, gangrene and Reynaud's disease (which attacks only the fingers and very rarely the thumb) were responsible; and he claimed to have discovered actual handprints in clay, not only at Gargas but also at Lascaux, which seemed to have phalanges missing. He also examined finger holes in clay at Gargas, casts of which seemed to end in stumps rather than fingertips.

Nevertheless, in recent years, a third and simpler explanation has been gaining support: namely, that none of the hands was really mutilated or incomplete. The stencils were made in this way by bending the fingers. Some experimenters claim to have duplicated all the 'Gargas variations' by bending their fingers, and point out that there are stencils with clearly bent thumbs at Gargas and Pech-Merle. Others, however, have found that bending the fingers causes pigment to infiltrate behind the hand, which was not the case in the Gargas stencils, and implies that the Ice Age phalanges were indeed missing. But if we accept that the fingers were bent, what was the purpose? In fact, there are good examples around the world of simple hand signs of this type being employed by hunters (especially during silent stalking); in Australia, for example, there are many stencils of hands with fingers clearly bent, which are known to be a kind of language of gestures or signals.

The debate over the Gargas hands has been raging for a hundred

years, and shows no sign of being settled. Visitors should read the alternative theories, look at the original hand stencils in the cave and choose whichever version of prehistory they prefer.

There are a few paintings (one in the lower cave, four in the upper) of animals such as bison and ibex, and innumerable 'macaronis' or meandering digital tracings on the ceiling, some of which form animal figures. However, the fame of Gargas rests on its animal engravings as well as on its hand stencils, all of which are located in the lower cave. The engravings are grouped primarily in side chambers, especially one called the Camarin; 148 animal figures are known.

It is very difficult to date any of the Gargas images. Clearly everything in the main cave must be Gravettian or earlier, but the upper cave's figures are most likely Magdalenian (it was always a separate cave – there was no connection between the two until the Middle Ages). The only clue to a more precise date comes from a handful of engravings on small slabs of stone, found stratified in the main cave's Gravettian layer. One or two features of these animal figures resemble the engravings on the black stone, so they probably belong to roughly the same period – c.25,000 BC. The tracings in clay and the hands, undatable at present, are at least equally old and perhaps far older. Fragments of bone stuck into fissures in the wall next to the hands have given radiocarbon dates of c.27,000 years ago, which fits well with direct dates from similarly 'mutilated' hand stencils in the underwater cave of Cosquer.

Visits to Gargas were greatly improved a few years ago by the installation of new discreet lighting along the floor, and by the pioneering introduction of cold fibre-optic lights to illuminate the hand stencils. You now enter the upper cave first, descending to some lines of black dots and a red dot. You then descend further to a black ibex and a red ibex figure (both facing right) and a small black deer facing left. A bison figure is painted above the steps leading down to the lower cave – you might call it a step bison.

On descending, you enter the innermost end of the lower cave. Off to the right is the area beneath which lie the 'oubliettes', source

of so many skeletons of Ice Age animals. You first see the three red hand stencils which were the first images to be spotted by Regnault. Around to the left is the Chapel of the Hands, with the famous 'hand stencil in a niche' by its entrance; further on is La Conque, the only place in the cave where tourists can have access to engravings (though it is necessary to crouch to see them properly): an aurochs, reindeer, horse and mammoth. After passing a fissure filled with red paint, which may denote a large vulva, you reach the important and unique big panel of the hands. A small museum can also be visited by the ticket office.

Barrière, C., 1976, 'Palaeolithic Art in the Grotte de Gargas', *British Archaeological Reports*, International Series No. 14, Oxford, 2 vols.
Foucher, P. et al, 2007, *La grotte de Gargas: un siècle de découvertes*, Communauté de communes du canton de Saint-Laurent-de-Neste.

---

**Address**
Grottes préhistoriques de Gargas, route départementale 26, 65660 Aventignan
Tel. (33) (0)5 62 39 72 39; fax (0)5 62 39 76 18
www.gargas.org
contact@gargas.org

**Nearest city/town** Toulouse/Aventignan.
**Nearest airport** Tarbes, Pau, Toulouse.
**Nearest car rental** Montréjeau.
**Nearest train station** Montréjeau.
**Nearest bus route** Montréjeau.
**Nearest taxi or private car hire** Montréjeau.
**Restaurants in the vicinity** Montréjeau.
**Hotels in the vicinity** Montréjeau.

**When is this cave open?** July and August 10.00 to 12.00 and 14.00 to 18.00 (maximum 13 visits a day). At other times of year 10.00 to 12.00, 14.00 to 17.00.
**Admission prices** Adults 7 euros; children (6–16) 4 euros; children under 6 free; students 5.50 euros. Groups (minimum 10 people): 5.50 euros per adult;

3.50 euros per child. Family ticket (2 adults and 2 children under 16) 19 euros.
**Storage facilities?** No.
**Do you have to make up a group?** Yes. Maximum of 20–25 people per group, and a limit of 250 visitors per day.
**Can you reserve a place in a group?** Yes.
**Languages of the guides** French; English and Spanish available.
**Length of tour** 1 hour.
**Is the cave privately owned?** No.
**Is there a gift shop?** Yes.
**Is there a café (water)?** No, but there is a coffee machine and cold drinks.
**Are there WC facilities?** Yes.
**Handicapped access?** No.
**Is any climbing necessary?** About 100 steps to the cave. Inside there are stairs (notably 32 steps down from the upper cave to the lower).
**Distance to walk** 200m outside the cave and 300m inside.
**Level of fitness required** Moderate.
**Equipment required** Flashlights are not required.
**What are the conditions inside the cave?** Easy and flat, apart from the stairs between the caves; 14°C.
**Is it lit?** The cave is electrically lit.
**Is it slippery?** It can be slippery in places.
**Is photography allowed?** No.

# BEDEILHAC

The vast cave of Bédeilhac has the most impressive porch of any decorated site, 17m high. In the last few centuries, the stalactites and stalagmites at the entrance were gradually removed by visitors, and in the late nineteenth century and the years between the wars, archaeologists dug into the Magdalenian occupation levels – there were numerous hearths in the first 400m. But it was during the Second World War that the greatest damage was done, when a French industrialist and, later, occupying German forces installed an aircraft works in the cave, thus protecting it from Allied attack.

The first few hundred metres were flattened and concrete laid; however, the war ended before any planes could be flown in or out. Nevertheless, the French military maintained a presence here after the war, and extended the German work to a point 300m inside the cave. In the mid-1970s French television produced a drama, *Le Passe-Montagne*, about the Resistance, and during the filming here a small plane was flown into and out of the cave – a remarkable sight which can be seen in a photograph in the ticket office.

The cave art of Bédeilhac was discovered in 1906. Most of it lies in side galleries which are not accessible to tourist visits – for example the Galerie Vidal, with its large animal paintings, now very faded and almost invisible, thanks to fumes from the military operations; the Diverticule, with its fine bison drawing, so similar to those of Niaux (page 123), in a position which only a really small adult or a child could have reached; and the Galerie des Modelages, with its famous small clay figures, including a bas-relief bison and a vulva.

However, some important and varied pieces of parietal art can be seen in the main gallery, which is also well worth visiting for its vast

The clay bas-relief of a bison and vulva in Bédeilhac's Galerie des Modelages.

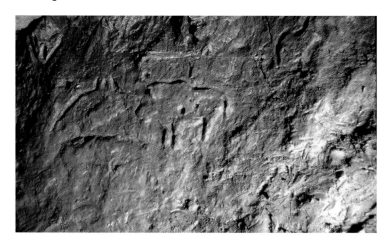

size and its enormous stalagmites. It is more than likely that the gallery was decorated from the entrance inwards, but nothing has survived until about 350m in, where you encounter some red dots on the left wall. After more red dots to left and right, you reach a huge area in which some enormous stalagmitic columns have toppled – but did they make a sound if nobody was there to hear it? There is a bison engraved on a rock at left; its black colour is natural. On the end wall, you see a big black painting of a bovid, with twelve red dots below it and some engraved claviform (club-like) signs above it. After passing a truly vast stalagmite, no less than 160m in circumference, you reach the Labyrinth, an area with five big stalagmites.

You are now close to the other area of the cave with drawings on clay. After a reproduction of the figures from the Galerie des Modelages, mentioned above, you see a long-horned bison on the ceiling, drawn in charcoal, and then two more charcoal bison on the ceiling, close to a reproduction of some fine engravings on the clay floor – a beautiful little horse head and a small bison. Near by, the leg and belly of another animal, engraved in clay, have survived a landslide. The floor has therefore been lowered in this area, leaving a depiction of a deer quite high up. Finally, as you start back towards the entrance, there are two right- and left-hand prints in red and black on a big stalagmitic column.

The style of the cave's figures is clearly Middle Magdalenian, c.14,000 years ago, a period well represented in its occupation material and abundant portable art.

Beltrán, A., Robert, R. and Gailli, R., 1967, *La cueva de Bédeilhac,* Universidad de Zaragoza: Zaragoza.
Gailli, R., 2006, *La Grotte de Bédeilhac, Préhistoire, Histoire et Histoires.* Larrey CDL: Toulouse.

**Address**
Grotte de Bédeilhac, 09400 Tarascon sur Ariège
Tel. (33) (0)5 61 05 95 06; fax (0)5 61 05 13 15

www.grotte-de-bedeilhac.org
contactgrotte@clubinternet.fr

**Nearest city/town** Toulouse/Tarascon sur Ariège.
**Nearest airport** Toulouse, Carcassonne.
**Nearest car rental** Foix.
**Nearest train station** Tarascon.
**Nearest bus route** Toulouse station to Tarascon.
**Nearest taxi or private car hire** Tarascon.
**Restaurants in the vicinity** Bédeilhac, Tarascon, Foix.
**Hotels in the vicinity** Tarascon, Foix.

**When is this cave open?** Every day in July and August 10.00 to 17.30 (last visit); April to June and September, visits at 14.15 and 17.00 with an extra visit at 15.15 on Sundays. In other months, every Sunday at 15.00.
**Admission prices** Adults 9 euros; children (5–12) 5 euros. Credit cards not accepted.
**Storage facilities?** Yes.
**Do you have to make up a group?** No.
**Can you reserve a place in a group?** Yes.
**Languages of the guides** French, English, Spanish, Catalan, German, Italian.
**Length of tour** 90 minutes.
**Is the cave privately owned?** Yes.
**Is there a gift shop?** Yes.
**Is there a café (water)?** No, but the village is only 700m away.
**Are there WC facilities?** Yes.
**Handicapped access?** No.
**Is any climbing necessary?** Only if you go on foot rather than by vehicle. There are a few stairs inside.
**Distance to walk** The car park is at the cave mouth; you walk 850m into the cave, and the same distance out.
**Level of fitness required** Moderate.
**Equipment required** Flashlights are provided.
**What are the conditions inside the cave?** Usually good, mostly flat.
**Is it lit?** The cave is electrically lit.
**Is it slippery?** It can be wet and slippery in places.
**Is photography allowed?** No.

# NIAUX

The great palaeolithic decorated cave of Niaux is located at 678m altitude, and 100m above the nearby River Vicdessos, in Ariège, French Pyrenees; its art is assigned to the end of the last Ice Age, the middle eleventh millennium BC. It was well known throughout history, as shown by its numerous graffiti (dating back to 1602), and the many tourists destroyed and removed most of its concretions – a fact which, together with Niaux's size and almost horizontal floor, makes it a particularly easy cave to visit, while the abundance and quality of its art make it a definite 'must'.

The cave's art was certainly seen by early visitors. A Ruben de la Vialle wrote his name in 1660 not only in the main passage but also in the Salon Noir, on an empty panel next to some bison figures – he must have seen them, but what could the depiction of a bison have meant to a seventeenth-century Frenchman? Niaux also narrowly missed being the first decorated cave to be discovered when a local scholar, Félix Garrigou, visiting it in 1866, described in his notebook his perplexity at the drawings on the walls. It was not until 1906, however, that their significance was finally realized. Further black drawings were found in a gallery beyond a lake in 1925, a few wall engravings (the only ones in the whole cave) in 1975, and some black and red signs in the 1980s.

At present, Niaux has an extremely grandiose entrance, artificially punched through the back of a vast rock shelter, and now horribly marred (or enhanced, depending on one's taste) by a vast sculpture in rusty metal. Originally, however, the only known access was through a far more modest hole in the hillside. The cave is over 2km long, but its prehistoric visitors had explored all of it. They left behind not only their drawings but also, in places, their naked footprints. As far as we know, however, they did not live here, since only a few tools and bones and traces of a hearth survived on the floor of the Salon Noir.

Niaux's art was traditionally assigned to the Middle Magdalenian, c.14,000 years ago, though comparison with the style and pigments of dated portable art in the nearby cave of La Vache across the valley

(also open to the public) suggested the mid-thirteenth millennium BP (before the present); analysis has shown that some of Niaux's black figures were initially sketched with charcoal. A direct radiocarbon date of 12,890 + 160 BP was obtained from one such bison, and a date of 13,060 + 200 BP from a black mark, thus confirming the Late Magdalenian estimate; but a second bison gave a date of 13,850 + 150 BP, confirming the Middle Magdalenian estimate. In short, the art in Niaux is not homogeneous, and seems to belong to at least two phases.

At least six different pigment recipes have been detected in the cave, showing how particular panels, and the cave as a whole, were decorated in separate episodes, with different mineral binders and extenders (such as talc or feldspar) perhaps being added to the pigment to make it go further and adhere better to the wall.

Horse head and stag in Niaux's Salon Noir.

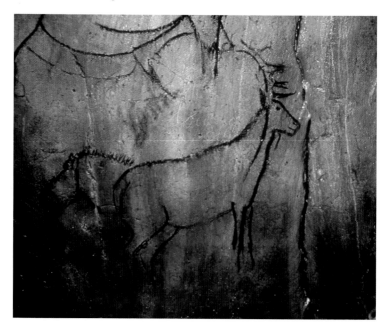

The first figures, some signs in red ochre, occur about 500m from the present entry. You then reach a major 'crossroads' of galleries, where three panels of simple abstract signs have often been interpreted as indicators linked to the topography. Certainly, if you follow the right-hand wall and climb a great sand dune, you eventually reach the Salon Noir and the principal concentration of drawings: there are six main panels, separated by gaps, covered in black figures of bison, horse, ibex and deer. There are big drawings and small, complete and incomplete, elaborate and schematic. Details include winter coats on the horses, infill done with small lines, individualized faces, and marks on some bison and ibex often interpreted, quite subjectively, as missiles.

The density of figures in this 'sanctuary' contrasts markedly with their sparser scattering in the rest of the cave and the total absence of detailed animals elsewhere. There are also far more signs outside the Salon Noir than inside.

Niaux is also very important for the number and quality of its engravings in clay on the floor, protected under overhangs, including a famous fish (salmonid) and a bison drawn around some dripmark cupules, one of which is used for its eye, and with some 'arrows' drawn in. None of these can be visited *in situ*, but facsimiles of them can be seen inside the building of the Parc de la Préhistoire (page 127). In addition, the figures in the Salon Noir have suffered much over the millennia from occasional waterflows down the walls (most recently in 1978 and 1979, when the stag and other important figures were damaged), as well as by calcite formation. Hence the construction of the facsimile in the Parc de la Préhistoire, which presents the Salon Noir as it would have looked when new.

No trace of palaeolithic occupation has so far been found in Niaux, but it is rich in parietal art, whereas, across the valley, La Vache – to which it is clearly closely linked – has no palaeolithic parietal art but is rich in occupation material and portable art. The two caves have often been seen as a classic example of a dwelling, with its unoccupied place of worship near by.

Beltrán, A., Gailli, R. and Robert, R., 1973, *La cueva de Niaux*, Universidad de Zaragoza: Zaragoza.

Clottes, J., 1995, *Les cavernes de Niaux*, Le Seuil: Paris.

---

**Address**
09400 Niaux
Tel. (33) (0)5 61 05 10 10 or (0)5 61 05 88 37
www.sesta.fr
sesta3@wanadoo.fr

**Nearest city/town** Foix/Tarascon sur Ariège.
**Nearest airport** Toulouse, Carcassonne.
**Nearest car rental** Foix.
**Nearest train station** Tarascon.
**Nearest bus route** Toulouse station to Tarascon.
**Nearest taxi or private car hire** Tarascon.
**Restaurants in the vicinity** Niaux, Tarascon, Foix.
**Hotels in the vicinity** Tarascon, Foix.

**When is this cave open?** All year round except 25 December, 1 January and Mondays from November to end March, excluding school holidays and national holidays. Visits 9.00 to 17.45 (last visit) in the summer and 10.30 to 16.15 (last visit) in the winter.
**Admission prices** Adults 9,40 euros; children (5–12) 5,70 euros; youngsters (13–18) 7 euros; children under 5 free. Students (up to the age of 26) 7.50 euros. Family of 2 adults and 2 children 27 euros; an extra child 4.20 euros. Group rates: 7.80 euros per adult; 4 euros per child.
**Storage facilities?** No.
**Do you have to make up a group?** Yes. Up to 20 people per group, with a maximum of 11 groups per day. There are 9 to 11 daily visits in the summer, 6 in the low season and 3 in the winter.
**Can you reserve a place in a group?** Yes.
**Languages of the guides** French; English available, especially in the summer; and Spanish at times.
**Length of tour** 75 to 90 minutes.
**Is the cave privately owned?** No.

**Is there a gift shop?** Yes.

**Is there a café (water)?** No.

**Are there WC facilities?** Yes.

**Handicapped access?** No.

**Is any climbing necessary?** No, unless you arrive on foot rather than in a vehicle. Inside there are some stairs here and there, as well as a fairly steep slope up to the Salon Noir.

**Distance to walk** 900m into the cave and the same out again.

**Level of fitness required** Considerable.

**Equipment required** Flashlights are provided.

**What are the conditions inside the cave?** Wet and slippery in places, and many areas where you can trip – sure-footedness and sturdiness are essential.

**Is it lit?** No.

**Is it slippery?** It can be wet and slippery in places.

**Is photography allowed?** No.

# PARC DE LA PREHISTOIRE

The Parc de la Préhistoire (Prehistoric Park), located very close to the cave of Bédeilhac (page 119) and not far from Niaux (page 123), will appeal to the cave-art enthusiast because in its main building it houses several important facsimiles. These include the area of the Réseau Clastres (an extension of Niaux, not accessible to the public), which contains the footprints of three youngsters walking along (they are not definitely palaeolithic, but certainly prehistoric), and also its five black drawings, which were arranged either side of its original entrance: to the right, three bison, two of them drawn in a very abbreviated form, and, to the left, a horse, and an enigmatic small animal which is generally interpreted as a weasel, but this remains uncertain.

In the building's main chamber, the Grand Atelier, there is a superb copy of Niaux's Salon Noir. As the original cave is still open to the public, there was little point in making a copy of its present state; but since many of the figures have been damaged over the

The main building in the Parc de la Préhistoire.

millennia, or coated with calcite, it was decided to present the Salon Noir as it would have looked when fresh and complete.

In addition, the room contains casts of some of the best portable art of the period, and some grouped facsimiles of the engravings in Niaux's clay floor – with adjustable spotlights to help the visitor pick them out more easily.

**Address**
Route de Banat, 09400 Tarascon sur Ariège
Tel. (33) (0)5 61 05 10 10
www.sesta.fr
sesta3@wanadoo.fr

**Nearest city/town** Toulouse/Tarascon sur Ariège.

**Nearest airport** Toulouse, Carcassonne.

**Nearest car rental** Foix.

**Nearest train station** Tarascon.

**Nearest bus route** Toulouse station to Tarascon (5km from the site).

**Nearest taxi or private car hire** Tarascon.

**Restaurants in the vicinity** Bédeilhac, Tarascon, Foix.

**Hotels in the vicinity** Tarascon, Foix.

**When is this site open?** July and August 10.00 to 20.00 (ticket office closes at 17.30); 1 April to 30 June and 1 September to 7 November 10.00 to 18.00 (19.00 on weekends and holidays). Closed Mondays except in June, July and August and on school holidays and national holidays. Open even in bad weather. Dogs not allowed, but free kennel (4 spaces) available.

**Admission prices** Adults 9.40 euros; children (5–12) 5.70 euros; youngsters (13–18) 7 euros; students up to 26 7.20 euros. Family pass (2 adults, 2 children) 27 euros. Group rate: 7,30 euros per adult; 4,20 euros per child.

**Storage facilities?** Yes.

**Do you have to make up a group?** No.

**Can you reserve a place in a group?** Guided visits of the Grand Atelier are only for groups; individuals cannot make reservations for such visits.

**Languages of the guides** For the indoor exhibition area, audio guide available in French, English, German, Dutch, Spanish and Catalan.

**Length of tour** From 40 minutes with guide to as long as you wish.

**Is the cave privately owned?** No.

**Is there a gift shop?** Yes.

**Is there a café (water)?** Yes, and a picnic area.

**Are there WC facilities?** Yes.

**Handicapped access?** Yes.

**Is any climbing necessary?** No.

**Distance to walk** You can walk about 500m inside the exhibition hall and 1km outside; the site covers 13ha. The park contains ramps rather than stairs.

**Level of fitness required** Minimal.

**Equipment required** None.

**Is it lit?** The exhibition hall is lit.

**Is it slippery?** Outside when wet, in places.

**Is photography allowed?** Photos are allowed outside, but not usually inside the exhibition hall.

# MUSEE D'ARCHEOLOGIE NATIONALE

The Musée d'Archéologie Nationale, housed in the sixteenth-century royal castle at St Germain-en-Laye just outside Paris, was created at the instigation of Napoleon III in the 1860s. It contains a magnificent collection of portable art and ornaments from the last Ice Age; in terms of parietal art, it is well worth a visit for the original bas-relief Solutrean sculptures on blocks from Roc de Sers, and also the fallen fragments of magnificent sculptures from the walls and ceiling of the shelters at Angles-sur-l'Anglin. (The museum also has a cast of the main section of the great Magdalenian sculpted frieze from this site in the chapel.)

---

**Address**

Musée d'Archéologie Nationale, Château, Place Charles de Gaulle, 78105 St Germain-en-Laye; Tel. (33) (0)1 39 10 13 00
www.musee-archeologienationale.fr
culturel.man@culture.gouv.fr

**Nearest train station** Most easily reached by RER line A, going west from central Paris to St Germain-en-Laye.
**When is this museum open?** 1 May to 30 September and Saturdays, Sundays and holidays 10.00 to 18.15. At other times 09.00 to 17.15. Closed Tuesdays. On Mondays open only for groups, with prior reservation.
**Admission prices** Adults 4.5 euros; reductions (those under 25; not OAPs) 3 euros; children under 18 free. Free entry on the first Sunday of each month. Guided visits are available, rates depending on length of time.
**Storage facilities?** Yes.
**Is there a gift shop?** Yes.
**Is there a café (water)?** No, but there are some just outside on the square. Museum ticket permits repeated entrance for the day.
**Are there WC facilities?** Yes.
**Handicapped access?** Yes.
**Is any climbing necessary?** There are stairs inside, but also elevators.
**Is photography allowed?** Yes, without flash.

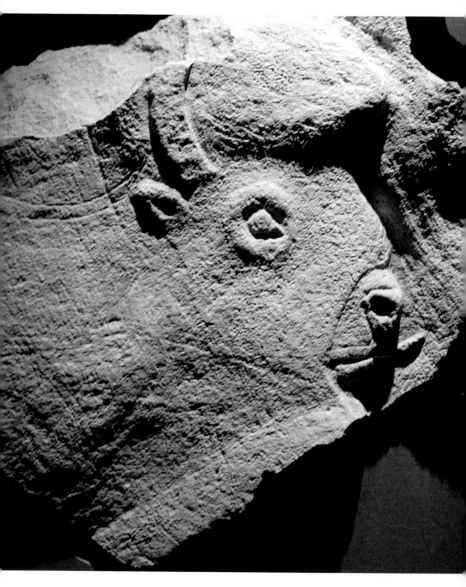

Sculpted bison head from Angles-sur-l'Anglin, in the Musée d'Archéologie Nationale.

# SPAIN

## COVALANAS

The second decorated cave to be discovered in Spain after Altamira, Covalanas had its art revealed by Hermilio Alcalde del Río on 11 September 1903. Excavations in its entrance chamber found virtually nothing. This was not a cave that was ever occupied; it was a cave visited for artistic purposes only. The large cave of El Mirón, directly below it, was the major occupation site of this area, and presumably it was one of the people inhabiting that site who made his or her way up the cliff to this small cavity and decided to decorate it.

The details of technique and content make it highly probable that all the figures in Covalanas were made by a single person in one artistic episode, thought to have taken place in the Solutrean period (c.18–20,000 years ago), because of their style. The animal figures are all drawn with the same technique – done in outline with dots of iron oxide (red ochre, or hematite). Some dots were clearly applied with fingers, others with the more flexible thumb; some are very separate, others juxtaposed. In any case, with this deceptively simple technique the artist managed to express a tremendous variety of posture, perspective and movement.

The technique – also found at the nearby cave of La Haza, and at those further afield of La Pasiega and Arenaza (none of them open to the public) – was for a long time thought to be that of a single artist or, at best, a school. However, since the discovery of the same technique in El Pendo (page 160), and also in caves as far away as in Asturias to the west, it has become clearer that this must be a regional and chronological phenomenon which was widespread in northern Spain at one time.

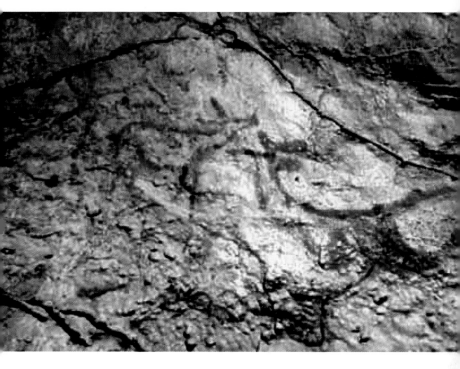

Group of female deer at Covalanas.

The entrance chamber of Covalanas contains a strange stone arrangement in the floor. Often mistaken by visitors for a palaeolithic fireplace, it is in fact a recent device for catching and channelling infiltrating rainwater.

The cave itself, through its lack of concretions, is more or less exactly as the palaeolithic artist saw it. It contains some remarkable panels of marine fossils, and some crystal formations. There are also torch wipes on one panel, some of which have been radiocarbon dated to the medieval period – a time when bandits, who preyed on travellers on the ancient Camino Real below, used the cave.

The art begins some way into the cave, after a point where you are walking on the original floor level. It is noticeable that the art

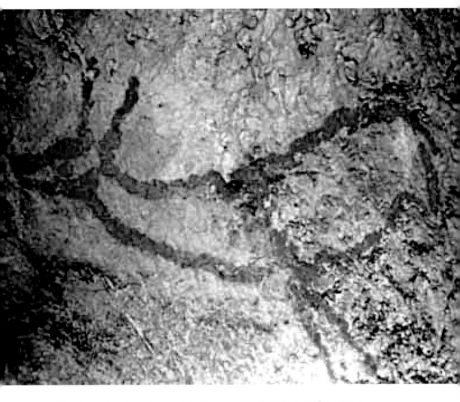

The 'jumping female deer' in the special chamber at Covalanas.

occurs in the part of the cave that is narrowest and highest. As in many caves, the start of the decoration seems to be 'announced' by three discrete red dots on the left-hand wall.

Almost all the animals drawn on both walls are female red deer (seventeen), although one larger deer on the right wall is thought to be a male (which has shed his antlers) because of its pronounced musculature. A large animal on the left wall is variously interpreted as a large reindeer or an aurochs; be that as it may, it displays a masterly use of the rock shape for its body. The best group of females on the right wall display twisted perspective (the bodies in

profile, but both ears shown) and superimposition, while one animal is looking back over its shoulder.

Towards the end of the gallery, on the right, is a large horse, with flowing mane and a long tail; there are three small female deer figures around its head, with a geometric sign above. Opposite it, there is a special, small chamber in which only two or three people can stand at a time. Here you find some more geometric motifs, but also and especially two of the best-preserved female deer figures in the cave – so fresh that they look new. One seems to be jumping down from a rock.

It is highly probable that Covalanas was studied carefully by the artist before the figures were drawn, for there are signs of planning and symmetry: for example, is it a coincidence that all the animals on the left wall (as you enter) are facing the cave's entrance, while those on the right wall face in both directions?

Alcalde del Río, H., Breuil, H. and Sierra, L., 1911, *Les cavernes de la région Cantabrique (Espagne)*, Imprimerie Chêne: Monaco.

García Diez, M. and Eguizabal Torre, E., 2003, *La cueva de Covalanas*, Consejería de Cultura: Santander.

Moure Romanillo, A., González Sainz, C. and González Morales, M.R., 1991, *Las cuevas de Ramales de la Victoria, Cantabria*, Universidad de Cantabria: Santander.

**Address**
C.I.T., Ason-Agüera, C/Baron de Adzaneta 5, Ramales de la Victoria, Santander
Tel./fax (34) 942 646504 or mobile 629 135444
http://cuevas.culturadecantabria.com
reservascuevas@culturadecantabria.es

**Nearest city/town** Santander/Ramales de la Victoria (2km away).
**Nearest airport** Bilbao, Santander.
**Nearest car rental** Laredo.
**Nearest train station** Ramales de la Victoria (3km away).

**Nearest bus route** To Ramales from Santander and Bilbao.
**Nearest taxi or private car hire** Ramales de la Victoria.
**Restaurants in vicinity** Several in Ramales de la Victoria.
**Hotels in the vicinity** Ramales de la Victoria; but the cave is also easily accessible from Santander, Santillana del Mar and Bilbao.

**When is this cave open?** May to September every day 09.30 to 14.30 and 16.00 to 20.00; October to April Wednesday to Sunday 09.30 to 13.45 and 14.45 to 17.00.
**Admission prices** Adults 3 euros; children (4–12) 1,50 euros. Credit cards not accepted.
**Storage facilities?** Bags and valuables can be left inside the locked cave entrance.
**Do you have to make up a group?** Yes. October to April, maximum of 60 people per day, in groups of up to 10; May to September, groupsof up to 6.
**Can you reserve a place in a group?** Reservation is essential – you cannot simply turn up.
**Languages of the guides** Spanish, English.
**Length of tour** 50 minutes.
**Is the cave privately owned?** No.
**Is there a gift shop? No.**
**Is there a café (water)?** No.
**Are there WC facilities?** No.
**Handicapped access?** No.
**Is any climbing necessary?** 500m up a steep track to the cave.
**Distance to walk** 500m up to the cave; 70m to the back of the cave.
**Level of fitness required** The ascent would prove strenuous to people with walking difficulties.
**Equipment required** Flashlights are provided by the guide.
**What are the conditions inside the cave?** Flat and generally dry.
**Is it lit?** No.
**Is it slippery?** Not usually.
**Is photography allowed?** No.

# ALTAMIRA II

Located 2km south of the village of Santillana del Mar (Santander), near the north coast of Spain, the cave of Altamira – nicknamed the Sistine Chapel of Cave Art – was decorated at various times between c.16 000 and 14,000 years ago. First discovered by a hunter in 1868, it was visited in 1876 by a local landowner, Don Marcelino Sanz de Sautuola, who noticed some black painted signs on a wall at the back, but thought little of them. In 1879 he returned to do some excavating and, while he was digging in the cave floor, searching for prehistoric tools and portable art of the kind he had recently seen displayed at a Paris exhibition, his eight-year-old daughter Maria was playing in the cavern. Suddenly she spotted the cluster of great polychrome bison paintings on the ceiling. Her father, at first incredulous, became more interested when he found that the figures seemed to be done with a fatty paste, and noticed a close similarity in style between these huge figures and the small portable depictions from the Ice Age which he had recently seen at the exhibition in Paris; he therefore deduced that the cave art was of similar age. But his attempts to present his views and his discovery to the academic establishment met widespread rejection and accusations of naivety or fraud. Sanz de Sautuola died prematurely in 1888, a sad and disillusioned man.

Altamira is 296m long, comprises a series of chambers and passages, and ends in a very long, narrow section known as the Horse's Tail. Although the site is best known for its magnificent decorated ceiling, its galleries contain an abundance of engravings, including some particularly fine deer heads identical to some engraved on deer shoulder blades in the cave's occupation layers. There are also some meandering finger tracings, some of which form a bovine head. One remarkable feature is a series of 'masks', where natural rock shapes were turned into humanoid faces by the addition of eyes and other details. Most of these masks can only be noticed when one is leaving, rather than entering, the Horse's Tail.

The Great Hall, with its high vault, has engravings and also some red compartmentalized quadrilateral signs, similar to those of the cave of El Castillo (page 148) in the same region. The cave also has black paintings (black figures often occur in different zones from red figures), some stencilled hands and some (far rarer) positive painted handprints.

To the left, as you enter Altamira, is the Great Hall of paintings, measuring about 20m by 10m. The floor has been lowered in order to allow visitors easier access and viewing of the very low ceiling, on which a score of large painted animals are spread: there are eighteen bison, a horse and a hind, the latter being 2.5m in length, the biggest figure in the cave. They are polychromes, done in ochre, manganese and charcoal. Most animals are standing, but a few natural bosses in the ceiling are occupied by curled-up bison, which thus appear three-dimensional. Two or three painted figures on the ceiling have often been described as boars (a very rare animal in Ice Age art) but they are now seen as streamlined bison (especially since one has horns).

The curled-up bison on the bosses have been described as sleeping, wounded or dying, falling down a cliff, or clear pictures of females giving birth. Currently the dominant view is that they are males, rolling in dust impregnated with their urine, in order to rub their scent on territorial markers, even though one of them has udders! In fact, they may simply be bison drawn to fit the bosses – they have the same volume, form and dorsal line as those standing around them, but their legs are bent and their heads are down. Some researchers see this chamber as a symbolic pound, with a bison-drive depicted on the ceiling (the curled-up animals at the centre are dead, while those around them stand and face the hunters – there are male humans engraved at the edge); another interpretation is that the ceiling is a depiction of a bison herd in rutting season.

Although the Altamira ceiling has sometimes been taken as a single accumulated composition, it actually comprises a series of superimpositions: researchers have distinguished five separate

phases of decoration, beginning with some continuous-line engravings, followed by figures in red flat-wash, then some multiple-line engravings, some black figures and finally the famous polychromes. The multiple-line figures are identical to some portable specimens from the cave, dated to 14,480 years ago, so it is clear that the two earlier phases predate them, while the black figures and polychromes are younger. Charcoal used in some polychrome bison on the painted ceiling has produced radiocarbon dates from 14,820 to 13,130 years ago. The cave was probably blocked shortly after this period.

The decorated chamber at the Altamira facsimile.

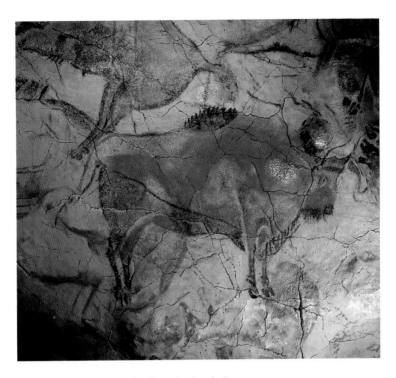

Bison on the ceiling at the Altamira facsimile.

Sanz de Sautuola saw the ceiling as a unified work, and many subsequent researchers have declared that one artist of genius could have done all the cave's polychromes. Recent detailed observations have confirmed these intuitions that one expert artist was probably responsible for at least all the polychrome bison on the ceiling. The different radiocarbon dates, if accurate, may indicate subsequent retouching.

The occupation layers at Altamira have yielded material from the Mousterian; the Solutrean, including classic shouldered points and the engraved deer shoulder blades; and the early Magdalenian, with perforated antler batons, and antler spear points with complex decorative motifs. The Magdalenian fauna is dominated by red deer,

and has abundant seashells reflecting the cave's proximity to the coast; seal bones occurred in the Solutrean layers. Between the Solutrean and Magdalenian periods, the cave was used by cave bears for hibernation. Altamira's wealth of occupation material and of portable and parietal art suggests strongly that it was an important regional focus at times, perhaps the scene of seasonal or periodic aggregations when people from a wide area might meet for ritual, economic and social activities.

Altamira became a UNESCO World Heritage Site in 1985. In July 2001, a magnificent facsimile of the cave, constructed a few hundred metres from the original, was opened to the public. It not only contains a perfect replica of the decorated ceiling (illustrated on page 29), with every crack, engraving and painting on it, but places it in its original context by reconstructing the whole of the cave's entrance chamber and its gaping mouth, which has not been seen since it collapsed towards the end of the Ice Age.

The original cave was closed to the public a few years ago in order to combat some bacteria, but all now seems well and it is probable that it will re-open to very limited public visits quite soon. In the meantime, the facsimile is recommended very strongly, and indeed in many ways it is better than the original – the only things missing are the odour of the cave and the emotion of knowing that one is seeing an original. The advantages include:

- The chance to see the decorated chamber in its original position in relation to the cave's entrance and to daylight. This is impossible in the original.
- The opportunity to see, and walk beneath, the entire ceiling. In the original cave, the floor has been lowered only at one side, so you cannot go under much of the other side; the facsimile was therefore a revelation of the 'hidden' side of the ceiling. Lights along the wall indicate the original floor level – at the entrance to the chamber, the artists could more or less stand, but at the far end they had to crouch. In other words, it was never possible for them to see the whole ceiling at once as we can.

- The facsimile's entrance chamber and decorated chamber are pristine, whereas in the original some hideous concrete walls were installed in the early twentieth century to prevent the ceiling from collapsing. Although supposedly made to look like cave walls, they look ugly and artificial; you walk between two of them to enter the decorated chamber.
- The engravings on the ceiling in the original are often very hard to see (and your time is always limited), so in the facsimile some of them have been slightly enhanced with white to make them more visible.

In addition, just before you enter the decorated chamber facsimile, several small screens show an excellent very short film of Pedro Saura's hands engraving and colouring a bison, which tells you all you need to know about how it was done. On leaving the decorated chamber, you pass facsimiles of some of the figures in other parts of the cave, and notably the Horse's Tail – 'masks', geometric black figures, and some fine engravings of a horse and two bison. Finally, in the museum, there is an evocation of Sanz de Sautuola's study, a fine collection of portable art of the region and facsimiles of decorated panels from Urdiales, Fuente del Salín, Chufín (page 144), Las Monedas (page 153) and El Pendo (page 160).

Beltrán, A. (ed.), 1999, *The Cave of Altamira*, Abrams: New York (original Spanish edition, 1998).

Breuil, H. and Obermaier, H., 1935, *The Cave of Altamira at Santillana del Mar, Spain*, Tipografía de Archivos: Madrid.

Cartailhac, E. and Breuil, H., 1906, *La caverne d'Altamira à Santillane, près Santander (Espagne)*, Imprimerie de Monaco.

Freeman, L. and González Echegaray, J., 2001, *La grotte d'Altamira*, La Maison des Roches: Paris.

García Guinea, M.A., 1979, *Altamira y otros cuevas de Cantabria*, Silex: Madrid.

Lasheras, J.-A. (ed.), 2002, *Redescubrir Altamira*, Turner: Madrid.

**Address**
Museo de Altamira, 39330 Santillana del Mar
Tel. (34) 942 818005. Group bookings: tel. 942 818102 (Tuesday to Friday
09.30 to 14.30); fax 942 840157
museodealtamira.mcu.es
altamira@museo.mec.es

**Nearest city/town** Santander/Santillana del Mar.
**Nearest airport** Santander.
**Nearest car rental** Torrelavega.
**Nearest train station** Puente San Miguel.
**Nearest bus route** Puente San Miguel to Santillana, and then a 2km walk or
(in the summer) a small tourist 'train' to Altamiro.
**Nearest taxi or private car hire** Santillana del Mar, Torrelavega.
**Restaurants in the vicinity** Many.
**Hotels in the vicinity** Many.

**When is this cave open?** May to October 09.30 to 20.00; October to May
09.30 to 18.00; Sundays and holidays 9.30 to 15.00. Closed Mondays,
1 and 6 January, 1 May, and 24, 25 and 31 December. Tickets can be bought
on site, and in advance at branches of the Banco Santander Central Hispano
(tel. 902 242424) or through its website (www.bancosantander.es).
**Admission prices** Tuesday to Friday, and Saturdays up to 14.30, adults 2,40
euros; students 1.20 euros; children under 18 and OAPs free.
**Storage facilities?** Yes (lockers).
**Do you have to make up a group?** Yes, for the facsimile. A maximum of 20
people per group, with visits every 5 minutes.
**Can you reserve a place in a group?** Yes. Group visits should be arranged at
least 2 weeks in advance.
**Languages of the guides** Spanish, English.
**Length of tour** 25 minutes in the facsimile; no time limit in the museum.
**Is the cave privately owned?** No.
**Is there a gift shop?** Yes.
**Is there a café (water)?** Yes.
**Are there WC facilities?** Yes.
**Handicapped access?** Yes.
**Is any climbing necessary?** There are a couple of steps inside the museum.

**Distance to walk** About 200m from the car park and a few metres inside.
**Level of fitness required** Minimal.
**Equipment required** None.
**What are the conditions inside the cave?** Easy and dry.
**Is it lit?** Yes.
**Is it slippery?** No.
**Is photography allowed?** No.

# CHUFIN

The cave of Chufín was long known to local people, and got its name from a mythical Moor who supposedly hid treasure in the cave. Its art was discovered only in 1972. A subsequent excavation in the vestibule uncovered late Solutrean levels, with a radiocarbon date of 17,420 years ago. The cave's entrance is now located on the edge of the Palombera reservoir, built in the 1960s, but before that it was at the confluence of the valleys of the Lamasón and Nansa, and the waters were about 30m lower.

The broad vestibule, 11m wide, is followed by a low crawl into a larger passage, 50m long, which slopes down to a lake. In the vestibule, in the daylight, you see a large limestone block, 5m long, bearing a panel of deep engravings – about fourteen stylized hinds, and a few bovids, including a bison. Each figure is very simple, drawn with just three lines. A facsimile of this main panel can be seen in the museum at Altamira (page 137).

Numerous cave-bear hollows can be seen in the crawl. Inside the cave, the right-hand wall has a few simple red outline drawings, including a bovid, two horses and a group of lines. There are also groups of red dots, particularly on the left wall, where they are arranged in multiple rows forming rectangular or elliptical shapes. Below these you see a series of fine engravings, including three bison and two horses.

The deep engravings at the entrance have been attributed to the

late Gravettian or early Solutrean period, *c*.22,000–19,000 years ago, and are considered earlier than the fine engravings of the interior, which are thought to be associated with the occupation and the radiocarbon date. The red drawings, on the other hand, may be from the same period as the exterior engravings.

Almagro, M., 1973, 'Las pinturas y grabados de la cueva de Chufín, Riclones (Santander)', *Trabajos de prehistoria* 30: 9–67.
Almagro, M., Cabrera, V. and Bernaldo de Quirós, F., 1977, 'Nuevos hallazgos de arte rupestre en Cueva Chufín', *Trabajos de prehistoria* 34: 9–30.

**Address**
Riclones, Rionansa
Tel. (34) 629 136165
http://cuevas.culturadecantabria.com
reservascuevas@culturadecantabria.es

**Nearest city/town** Santander/Riclones.
**Nearest airport** Santander.
**Nearest car rental** Torrelavega.
**Nearest train station** Unqueras.
**Nearest bus route** Celis (2km away).
**Nearest taxi or private car hire** Puente Nausa.
**Restaurants in the vicinity** Riclones, San Vicente de la Barquera.
**Hotels in the vicinity** San Vicente de la Barquera.

**When is this cave open?** May to September daily 09.30 to 14.30 and 16.00 to 20.00; October to April Wednesday to Sunday 09.30 to 13.45 and 14.45 to 17.00.
**Admission prices** Adults 3 euros; children (4–12) 1,50 euros.
**Storage facilities?** No.
**Do you have to make up a group?** Yes. Maximum of 5 people per visit.
**Can you reserve a place in a group?** Yes, either on the spot or when phoning the guide (on the telephone number above).
**Languages of the guides** Spanish.
**Length of tour** Two and a quarter hours.

Is the cave privately owned? No.
Is there a gift shop? No.
Is there a café (water)? No.
Are there WC facilities? No.
Handicapped access? No.
Is any climbing necessary? No.
**Distance to walk** The visit normally starts at the guide's house. Then there is a 30-minute walk along a path to the cave. The path runs parallel to the river, and when the river is high a boat is needed to get to the cave. The entrance to the cave is narrow and like a labyrinth, and for the first 8m you have to crawl.
**Distance walked inside the cave** 50m.
**Level of fitness required** Fit enough to crawl.
**Equipment required** The guide provides flashlights.
**What are the conditions inside the cave?** Narrow and low at the entrance; the floor is rocky and irregular.
Is it lit? No.
Is it slippery? No.
Is photography allowed? No.

Rows of red dots at Chufín.

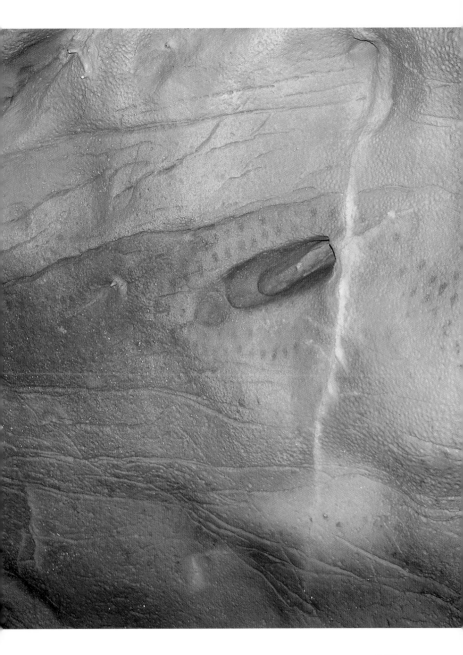

# EL CASTILLO

The village of Puente Viesgo in Santander Province (northern Spain) is overlooked by a conical hill, Monte Castillo, containing a number of palaeolithic decorated caves: La Pasiega, Las Monedas (page 153), Las Chimeneas and, the most important, El Castillo. The latter, located at an altitude of 197m, was discovered in 1903 by Hermilio Alcalde del Rio, who published the first studies of its art. Material from excavations in the 20m of palaeolithic deposits at the cave mouth includes a major collection of engravings on deer shoulder blades, now housed in Madrid's Museo Arqueológico Nacional (page 198).

Although it is only about 164m in length, the cave contains about 1km of galleries, which can be divided into two main parts: the first comprises a large initial chamber (the Gran Sala, 30m by 25m) with side passages, the second a series of corridors and galleries. These two parts are separated by an enormous chaos of large blocks, which, in prehistoric times, left only two narrow, difficult passages to link them.

Since the deposits at the cave's entry span the entire palaeolithic, scholars believe that the art is quite heterogeneous, belonging to a number of different phases, and making this a 'multiple sanctuary'. For example, the cave's 155 animal figures have been shared out among all the cultures from the Aurignacian to the Upper Magdalenian. Leroi-Gourhan, on the other hand, saw only four phases, assigning the quadrilateral figures (compartmented rectangular shapes) to his Style III (c.18,000 to 14,000 BC), and the other three phases to his Style IV (13,000 to 10,000 BC). Charcoal used in two adjacent bison figures has produced radiocarbon dates of 11,110 and 10,960 BC.

The cave's art includes engravings and drawings of bovids, horses, ibex and deer. Some figures are black, others red (the two

Vertical bison, semi-natural and semi-drawn, on stalagmite in El Castillo.

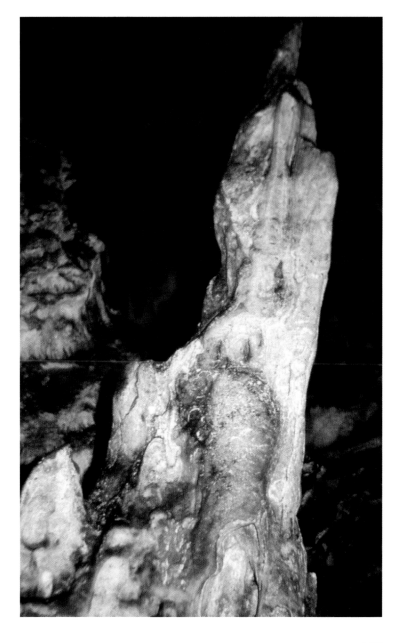

colours are used in different parts of the cave). Altamira and El Castillo both have fine engravings of doe heads, both on their walls and on shoulder blades from layers dating to about 13,550 BC. El Castillo has about 50 red hand stencils (comprising at least 35 left hands), mostly grouped in large panels or found beneath animal figures. Among the cave's most famous figures are a mammoth in red outline (now very faded, and not accessible to the public); a bison drawn vertically to incorporate the natural shape of a stalagmite for its back, tail and hind leg; and, especially, numerous dots (some associated with hand stencils, others in long lines) and also signs, the many strange quadrilateral signs being grouped in a special alcove.

The cave is so large and its art so abundant that only a fraction can be seen during a normal visit. You begin to the right of the entrance chamber where, halfway down a staircase, you find a great decorated panel. There is a large horse drawn high up, and a huge red bison figure, drawn head downwards, which makes great use of the natural rock shape. Two small doe figures and two large bison can also be seen – the bison have often mistakenly been seen as polychromes, like those of Altamira, but in fact they are black figures placed on top of some more ancient red hand stencils. At the foot of these dark stairs, on the right, is a major collection of hand stencils on the ceiling of an alcove (the lower you can crouch, the more you will see), as well as two bison figures and, on the wall, some strange geometric signs.

As you proceed around a corner, along the right-hand wall is another hand stencil immediately before you arrive at the intriguing stalagmite bearing the semi-natural and semi-drawn vertical bison. Shadows cast by the top of this stalagmite also resemble a bison skull.

Passing through a short tunnel, you can see two bison drawn high up on the left wall (palaeolithic people had to take that path, since the tunnel did not exist). After an empty chamber, noteworthy only for its fine concretions, you reach a small aurochs head, and then, finally, the corridor of the dots, which has red dots

of different sizes strung out along the right-hand wall, sometimes in a single row, sometimes in two; you also see other signs such as 'X' and fish-like shapes. You then retrace your steps, but after the vertical bison stalagmite you ascend directly to the entrance rather than via the hand alcove and the first panel.

Alcalde del Rio, H., 1906, *Las pinturas y grabados de las cavernas prehistóricas de la provincia de Santander*, Blanchard y Arce: Santander.
Alcalde del Rio, H., Breuil, H. and Sierra, L., 1911, *Les cavernes de la region Cantabrique*, Imprimerie Chêne: Monaco.

**Address**
Centro de Interpretación y Cuevas de Monte Castillo, Puente Viesgo, Santander
Tel (34) 942 598425; fax 942 598305
http://cuevas.culturadecantabria.com
reservascuevas@culturadecantabria.es

**Nearest city/town** Santander/Puente Viesgo.
**Nearest airport** Santander.
**Nearest car rental** Torrelavega.
**Nearest train station** Renedo (9km away).
**Nearest bus route** Santander to Puente Viesgo.
**Nearest taxi or private car hire** Torrelavega or Renedo.
**Restaurants in the vicinity** Puente Viesgo, Santillana del Mar.
**Hotels in the vicinity** Puente Viesgo, Santillana del Mar.

**When is this cave open?** May to September every day 09.30 to 20.00; October to April every day except Mondays and Tuesdays, 09.30 to 17.00.
**Admission prices** Adults 3 euros; children (4–12) 1,50 euros; children under 4 free.
**Storage facilities?** No.
**Do you have to make up a group?** Yes; maximum of 13 people per group May to September and 15 per group October to April, 380 people per day.
**Can you reserve a place in a group?** Yes.
**Languages of the guides** Spanish.

**Length of tour** 45 minutes.

**Is the cave privately owned?** No.

**Is there a gift shop?** No, but souvenirs can be found in Puente Viesgo.

**Is there a café (water)?** No.

**Are there WC facilities?** Yes.

**Handicapped access?** No.

**Is any climbing necessary?** No, if you arrive by car. From the visitor centre, there are many steps down and up to the cave's door. Inside the cave there are many stairs.

**Distance to walk** About 500m inside.

**Level of fitness required** Medium; sure-footedness is necessary.

**Equipment required** The guides deal with the lighting, but parts of the cave are very dark, so personal flashlights are useful for seeing where you are stepping.

**What are the conditions inside the cave?** Often slippery and dark.

**Is it lit?** Yes, in places.

**Is it slippery?** It can be extremely slippery in places.

**Is photography allowed?** No.

# LAS MONEDAS

Located in the same hill as El Castillo (page 148), as well as the two decorated caves of La Pasiega and Las Chimeneas (not open to the public), this cave, at an altitude of 187m, was discovered in 1952 when the land was being cleared for the planting of eucalyptus trees. It was originally baptized Cueva de los Osos (Cave of the Bears) because of the cave-bear bones found on its floor; the later discovery of some fifteenth-century coins led to its present name.

The art in the cave is located quite close to the present entrance but forms the climax of the visit, since you visit first the geological wonders of Las Monedas: its unusual flat ceilings, its magnificent concretions – including huge discs (some fallen) – and an unusual spiralling stalagmite and its spectacular mineral colours.

One large chamber contains a number of notable features: a huge hole in which cave-bear bones were found, together with a flint tool from Neanderthal times (but all these may have arrived here by water action); river cobbles still pinned to the high walls by fossilized mud; and an extremely long stalactite above a long stalagmite – the stalactite was broken in ancient times (a new, smaller stalactite grows at the break), but the missing fragment has never been found.

Along a passage you can also see the deep shaft down which some visitor ventured in the fifteenth century. Their purpose in doing so remains a mystery, but they either deposited or lost down there their purse, which contained twenty-three silver and copper coins from the time of the Catholic kings.

The art of Las Monedas is extremely homogeneous, and was most likely produced quite quickly by one person; it comprises only charcoal drawings which were carefully positioned throughout a fairly small area – a narrow passage about 13m long with an alcove at its end. You first see an indecipherable panel of signs or abstract marks on the left. Four metres further on, on the

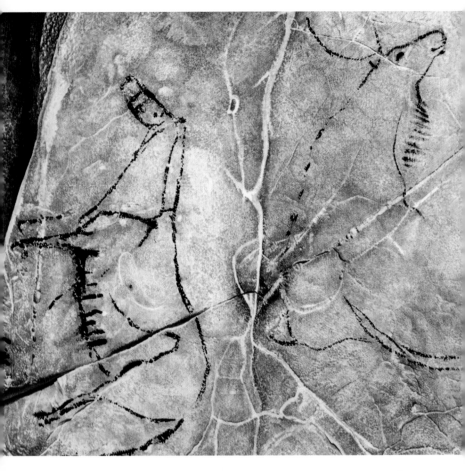

Vertical horse and reindeer figures, Las Monedas (after Ripoll Perelló).

right, you encounter the most important and famous figures of the cave, also reproduced in facsimile in the Altamira museum (page 137): a horse and a reindeer, drawn vertically, back to back, on two contiguous surfaces. The horse has the typical 'M' mark on its belly, indicating the different colours of its coat. The reindeer is one of the best depictions we have of this animal in cave art.

Curiously, most of the best reindeer figures on cave walls are in northern Spain (see Tito Bustillo, page 171), perhaps because this was the southerly limit of the animal's presence, so it was more of a novelty in these parts.

Two metres further on, where the passage is narrowest, there are more figures, including three horses, another reindeer and two ibex. Finally, you reach the alcove or small chamber at the end, where there are the last figures, including a fox or wolf, a vertical bison, etc. To the left, just before you descend the stairs, there are more small figures, including horses and a 'star', which may be a tiny human figure.

The black drawings in Las Monedas have been dated by radiocarbon to about 12,000 years ago, the end of the Magdalenian period. A few years ago some engravings were discovered in a different part of the cave.

Ripoll Perelló, E., 1972, 'The cave of Las Monedas in Puente Viesgo (Santander)', *Monographs on Cave Art* No. 1, Diputación Provincial de Barcelona.

---

**Address**
Centro de Interpretación y Cuevas de Monte Castillo, Puente Viesgo, Santander
Tel. (34) 942 598425; fax 942 598305
http://cuevas.culturadecantabria.com
reservascuevas@culturadecantabria.es

**Nearest city/town** Santander/Puente Viesgo.
**Nearest airport** Santander.
**Nearest car rental** Torrelavega.
**Nearest train station** Renedo (9km away).
**Nearest bus route** Santander to Puente Viesgo.
**Nearest taxi or private car hire** Torrelavega, Renedo.
**Restaurants in the vicinity** Puente Viesgo, Santillana del Mar.
**Hotels in the vicinity** Puente Viesgo, Santillana del Mar.

**When is this cave open?** May to September open every day 09.30 to 20.00; October to April open every day except Mondays and Tuesdays, 09.30 to 17.00 (last visit 16.00).

**Admission prices** Adults 3 euros; children (4–12) 1,50 euros; children under 4 free.

**Storage facilities?** No.

**Do you have to make up a group?** Yes; maximum of 13 people per group May to September and 15 per group October to April, 380 people per day.

**Can you reserve a place in a group?** Yes.

**Languages of the guides** Spanish.

**Length of tour** 45 minutes.

**Is the cave privately owned?** No.

**Is there a gift shop?** No, but souvenirs can be found in Puente Viesgo.

**Is there a café (water)?** No.

**Are there WC facilities?** Yes.

**Handicapped access?** Yes.

**Is any climbing necessary?** Not if you arrive by car. The cave contains stairs in several places.

**Distance to walk** A level 600m from the ticket office to the cave, and about 300m inside the cave.

**Level of fitness required** Moderate.

**Equipment required** The guides deal with lighting.

**What are the conditions inside the cave?** Sometimes dark and wet.

**Is it lit?** The cave is electrically lit.

**Is it slippery?** It can be very slippery in places.

**Is photography allowed?** No.

# HORNOS DE LA PEÑA

The art in this cave was discovered by Alcalde del Río in 1903. Excavations uncovered a series of occupations from Mousterian (Neanderthal), Aurignacian, Solutrean and Middle Magdalenian times. More than thirty figures are known on the walls, and these comprise an interesting series of engravings, some incised with stone tools and others made by fingers in the clay. The cave and its art have suffered much over the years, not least during the Spanish Civil War, when the cave was used as a shelter.

The cave is in a hillside, 60m above the River Tejas. Its entrance is large, 7m wide and 4m high, and faces south. Immediately inside the entrance wall, the back end of a deeply incised horse can be seen on the left, in the daylight; there used to be a headless bison figure opposite, on a block on the right-hand side of this entrance chamber, but it disappeared decades ago.

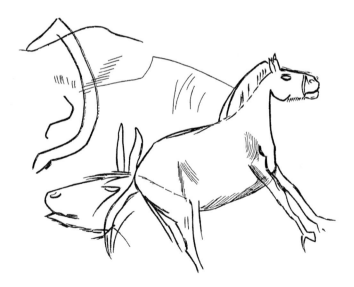

Tracing of a horse and other figures at Hornos de la Peña (after Breuil).

After a low passage, 25m long, the cave opens out into a complex series of chambers. On the left you see a primitive figure of an aurochs, drawn with broad lines in the clay in a hollow of the wall. The cave's finer engravings follow. Only a selection of these can be seen during a normal visit – about a dozen – but they include a number of bison, a deer, a remarkable large horse and the cave's most famous and enigmatic figure: an anthropomorph, facing right, with one arm raised.

The dating of the cave's figures remains uncertain, since it relies entirely on style, about which opinions differ. The general consensus is that the engraving at the entrance together with some of the cruder figures on clay may date to the early or Middle Solutrean, while the finer engravings are probably early or Middle Magdalenian (13,000 to 15,500 years old).

Alcalde del Río, H., Breuil, H. and Sierra, L., 1911, *Les cavernes de la région Cantabrique*, Imprimerie Chêne: Monaco.

---

**Address**
Tarriba, San Felices de Buelna, Los Corrales de Buelna
Bookings must be made through the cave of El Castillo: tel. (34) 942 598425, fax 942 598305
http://cuevas.culturadecantabria.com
reservascuevas@culturadecantabria.es

**Nearest city/town** Santander/San Felices de Buelna.
**Nearest airport** Santander.
**Nearest car rental** Los Corrales de Buelna.
**Nearest train station** Los Corrales de Buelna.
**Nearest bus route** From Torrelavega and from Los Corrales to Tarriba.
**Nearest taxi or private car hire** Torrelavega.
**Restaurants in the vicinity** Torrelavega (San Felices has only bars).
**Hotels in the vicinity** There is a two-star hotel in Tarriba, more hotels in San Felices and Torrelavega. The area is full of *casas rurales*.

**When is this cave open?** 1 May to 30 September every day 09.30 to 14.30 and 16.00 to 20.00; 1 October to 30 April Wednesday to Sunday 09.30 to 13.45 and 14.45 to 17.00.

**Admission prices** 3 euros per person. School parties of children over 12 1,50 euros per child. No children under 12.

**Storage facilities?** No.

**Do you have to make up a group?** Yes; maximum of 3–4 people per group May to September and 4 per group October to April, 25 people per day.

**Can you reserve a place in a group?** Yes.

**Languages of the guides** Spanish.

**Length of tour** 50 minutes.

**Is the cave privately owned?** No.

**Is there a gift shop?** No.

**Is there a café (water)?** No.

**Are there WC facilities?** No.

**Handicapped access?** No.

**Is any climbing necessary?** 300m to the cave; no stairs inside.

**Distance to walk** 300m to the cave and 200m inside.

**Level of fitness required** Considerable.

**Equipment required** The guide provides lighting. Safety helmets are obligatory and provided at the site.

**What are the conditions inside the cave?** Difficult.

**Is it lit?** No.

**Is it slippery?** It can be slippery at times.

**Is photography allowed?** No.

# EL PENDO

Although this cave was first excavated by Sanz de Sautuola (of Altamira fame) in the 1870s, its art was discovered only in 1907 and 1908 – engravings of two birds, possibly great auks. These figures are not seen during a normal visit, for reasons of conservation; in any case, they are much deteriorated and barely recognizable. However, the cave is well worth a visit because of the panel of painted figures that were found in 1997 (a facsimile of part of this panel can be seen in the Altamira museum, page 137).

The main decorated panel of El Pendo.

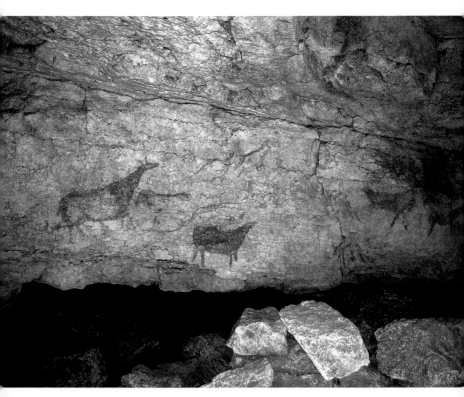

The frieze, 8.8m long, is on a broad rock within the main chamber, within the dark zone, although daylight can be seen from it. The paintings had escaped attention for decades because they were covered with dust and a white fungus; now that the wall has been carefully cleaned, the figures can be seen quite clearly. They comprise a series of eight or nine hinds, all drawn in red (except for one in yellow ochre), often using the same technique as that used at Covalanas (page 132) – that is, outlined with dots, although there are also continuous lines and areas of flat wash. There are also a horse, a goat, some headless animals, and signs and dots. The presence of the Covalanas technique, like the style, ascribes the paintings to a period *c.*20–19,000 years ago.

The composition appears to be centred on a large hind opposite the horse, with other hinds distributed around them. When the frieze was illuminated, it would have been very visible from all parts of the main chamber. Much of it could have been painted by standing on the boulders below; some of it definitely required scaffolding or ladders, especially the figures on the left.

Excavations in the 1920s, 1930s and 1950s in the cave's huge main chamber, 30m high and 40m wide, revealed a long stratigraphic sequence from the Middle Palaeolithic to the end of the Ice Age, and yielded a wealth of Magdalenian portable art in bone and antler, now housed in Santander museum and Altamira museum.

Montes Barquín, R. et al, 1998, 'Cueva de El Pendo: nuevas manifestaciones rupestres paleolíticas', *Revista de arqueología* 201: 10–15.

Montes Barquín, R. and Sanguino González, J. (eds), 2001, *La cueva de El Pendo: actuaciones arqueológicas 1994–2000*, Gobierno de Cantabria: Santander.

---

**Address**

Cueva de El Pendo, Escobedo de Camargo, Santander
Tel. (34) 942 259214 and 670 439010; fax 942 259214
http://cuevas.culturadecantabria.com
reservascuevas@culturadecantabria.es

**Nearest city/town** Santander, Escobedo de Camargo/Maliaño.

**Nearest airport** Santander.

**Nearest car rental** Santander.

**Nearest train station** Maliaño.

**Nearest bus route** Maliaño.

**Nearest taxi or private car hire** Maliaño.

**Restaurants in the vicinity** Puente Arce and Escobedo.

**Hotels in the vicinity** Santillana del Mar.

**When is this cave open?** May to September daily 09.30 to 14.30 and 16.00 to 20.00; October to April Wednesday to Sunday 09.30 to 13.45 and 14.45 to 17.00.

**Admission prices** Adults 3 euros; children (4–12) 1,50. Credit cards not accepted.

**Storage facilities?** Yes.

**Do you have to make up a group?** Yes; maximum 17 people per group May to September and 25 per group October to April, up to 7 groups per day.

**Can you reserve a place in a group?** Yes.

**Languages of the guides** Spanish, English, French.

**Length of tour** About 45 minutes.

**Is the cave privately owned?** No.

**Is there a gift shop?** No.

**Is there a café (water)?** No.

**Are there WC facilities?** Yes.

**Handicapped access?** No.

**Is any climbing necessary?** Some steps down to the cave; many metal stairs inside.

**Distance to walk** 1km from the coach park to the car park and ticket office; 300m from the car park to the cave; 80m into the cave.

**Level of fitness required** Moderate.

**Equipment required** Flashlights are not provided, and not really required.

**What are the conditions inside the cave?** Easy walking.

**Is it lit?** Yes.

**Is it slippery?** Not usually.

**Is photography allowed?** No.

# SALITRE II
## (SOPEÑA)

The cave of Sopeña has been turned into a re-creation of the Cueva del Salitre, a decorated cave where art was found in 1906 but which is not open to the public. At the same time, it presents displays of a palaeolithic campsite, and remains of cave bears. The Camarín de las Pinturas Rojas has the red drawings – a hind, a possible goat and two lines which could be horns; while the Panel de las Pinturas Negras, further inside, has two small black figures, thought to be a horse and a bovid.

The original paintings are thought to date to the Solutrean, *c.*20,000 years ago.

Alcalde del Río, H., Breuil, H. and Sierra, L., 1911, *Les cavernes de la région Cantabrique*, Imprimerie Chêne: Monaco.

---

**Address**
Ayuntamiento de Miera, Cantábria
Tel. (34) 942 539746 (town hall)
www.turismodecantabria.com

**Nearest city/town** Santander/Liérganes, Miera (4km away).
**Nearest airport** Santander.
**Nearest car rental** Santander.
**Nearest train station** Liérganes (12km away), and then taxi to the cave.
**Nearest bus route** A bus stops near Miera but from there to the cave you have to walk 7km.
**Nearest taxi or private car hire** Liérganes.
**Restaurants in the vicinity** Liérganes and San Roque.
**Hotels in the vicinity** Liérganes, Solares and Santander.

**When is this cave open?** Saturdays and Sundays, and daily July and August, 10.30 to 13.00 and 16.00 to 19.00. Closed from November to Holy Week.

**Admission prices** Adults 2,50 euros; children and OAPs 1 euro. Credit cards not accepted.

**Storage facilities?** No.

**Do you have to make up a group?** No.

**Can you reserve a place in a group?** Yes. 15 people maximum per group.

**Languages of the guides** Spanish.

**Length of tour** 40 minutes.

**Is the cave privately owned?** No.

**Is there a gift shop?** No.

**Is there a café (water)?** No.

**Are there WC facilities?** No.

**Handicapped access?** No.

**Is any climbing necessary?** 40m to the cave; easy steps inside.

**Distance to walk** 150m inside.

**Level of fitness required** Moderate.

**Equipment required** None.

**What are the conditions inside the cave?** 13°C. Flat and easy steps, irregular floor. The replica of the art is inside the cave.

**Is it lit?** Yes.

**Is it slippery?** No.

**Is photography allowed?** Yes.

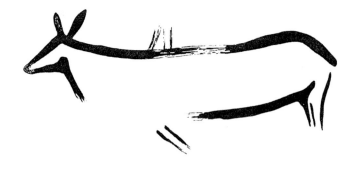

ABOVE Tracing of a hind at Salitre (after Breuil).

OPPOSITE The large red hind at El Pindal.

# EL PINDAL

The cave of El Pindal has one of the most beautiful and spectacular locations of all the decorated caves, and is well worth visiting for that alone – its magnificent view of the rocks and natural arch on this part of the rugged Asturian coast. The visitor should remember, however, that in Upper Palaeolithic times the sea level was lower, and the coast was therefore several kilometres further to the north.

Pindal's art, first discovered by Alcalde del Río in 1908, is also very fine, and contains one of the most famous images in Spanish cave art – the mammoth with the 'heart'.

The main panel, on the right-hand wall, 240m from the entrance, is about 20m wide. On it can be seen a whole series of red

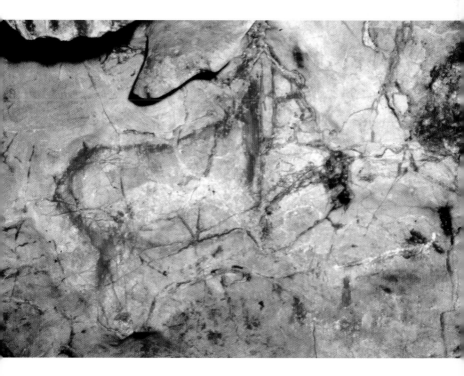

geometric shapes, dots and lines, as if marking edges and rock hollows was an important activity here. There are also a large red hind, a horse head and three bison, associated with a series of six red claviform (club-like) signs – the association of bison with claviforms is characteristic of the Middle Magdalenian period, albeit principally in the French Pyrenees. There are also numerous engravings on this panel (nine bison, four horses), although they cannot be seen from the viewing platform. Further to the left, on top of more red finger marks, is one of the cave's most intriguing figures: an engraving of a fish which seems to be a cross between a trout and a tuna.

Further on, again on the right-hand wall, is the famous red mammoth – but note that at some times of the year it cannot be shown to visitors (see below). It has a long curling trunk, but no tusks, and a large red dot inside its body; some have seen this as a heart, or a wound, but it could equally well simply be a dot. This is the only mammoth image in a Spanish cave that can be visited by the public (that of El Castillo, page 148, cannot be seen). A few years ago, a second, smaller mammoth, harder to see, was discovered on the right-hand end of Pindal's main panel.

Opinions differ over the art's date, but most specialists assign most, if not all of the figures to the Middle and later Magdalenian, between *c*.14,500 and 12,000 years ago.

Alcalde del Río, H., Breuil, H. and Sierra, L., 1911, *Les cavernes de la région Cantabrique*, Imprimerie Chêne: Monaco.

---

**Address**
Pimiango, Asturias
Tel. (34) 608 175284
http://tematico.asturias.es/cultura/yacimientos/pindal.html

**Nearest city/town** Colombres/Pimiango-Ribadedeva.
**Nearest airport** Santander.

**Nearest car rental** Llanes.

**Nearest taxi or private car hire** Colombres.

**Nearest train station** Colombres.

**Nearest bus route** None.

**Restaurants in the vicinity** Colombres, El Peral, La Franca, Llanes.

**Hotels in the vicinity** Ribadedeva, Llanes.

**When is this cave open?** All year round, except 1 and 6 January, 1 May, and 24, 25 and 31 December; closed Mondays and Tuesdays. Visits at 10.00 to 14.00 and 15.30 to 16.30. It is advisable to check availability in advance. From June to October the famous mammoth is not shown, because of increased humidity in that part of the cave.

**Admission prices** Adults 3 Euros; children (7–12), pensioners, and students with an international student card 1,50 euros. Admission free on Wednesdays. No children under 7. Credit cards not accepted.

**Storage facilities?** Yes.

**Do you have to make up a group?** Yes. Visits are in groups of up to 25, with a maximum of 200 people per day.

**Can you reserve a place in a group?** Reservation in advance is only possible for groups. 200 places per day are sold in chronological order, with a pause after every 25.

**Languages of the guides** Spanish; English is available for whole groups.

**Length of tour** About 30 minutes.

**Is the cave privately owned?** No.

**Is there a gift shop?** No.

**Is there a café (water)?** No.

**Are there WC facilities?** No.

**Handicapped access?** No.

**Is any climbing necessary?** There is a staircase down to the entrance, and more stairs inside.

**Distance to walk** 200m from the car park to the entrance and 300m into the cave.

**Level of fitness required** Moderate.

**Equipment required** The cave has electric light and flashlights are not allowed.

**What are the conditions inside the cave?** 12°C; 97 per cent relative humidity.

**Is it lit?** Yes, but only in places.

**Is it slippery?** It can be very slippery in places.

**Is photography allowed?** No.

# EL BUXU

The cave of Buxu is really for enthusiasts, because its art is modest in quantity and quality, although it does contain some fine horse figures. The cave and its art were discovered in 1916, and subsequent work to accommodate tourist visits has altered it substantially. For example, the original entrance, 25m above the valley floor, was a large rock shelter (most of which collapsed in ancient times) with a hole at the back, only 45cm wide, leading into the cave. A deep trench was dug to facilitate entry, and a metal gate installed.

Excavations in 1970 and the 1980s uncovered occupations of the late Solutrean (c.18,000 years ago), including some portable art objects. The first figures occur about 60m inside, where a limestone arch forms the start of a 'canyon' 6m in length. When first discovered, this arch was only 1m above the cave floor, but the floor has now been lowered. You can see two small black figures of hinds, and three stags also painted in black, as well as a series of short vertical black lines.

At the end of this passage, a quadrilateral grid-like sign can be seen engraved on the right-hand wall, together with a ladder shape. The passage now turns sharply to the left, and you enter the final

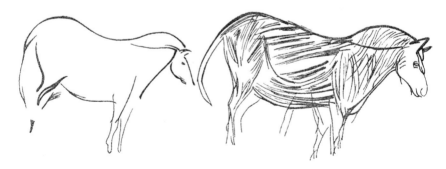

Tracing of horses at El Buxu (after Obermaier).

and most important decorated sector. Immediately, on the right-hand wall, there are two ibex figures – one black and one engraved, as well as about a dozen more engraved quadrilateral grids.

After 7m, an alcove opens up on the right which contains some important animal figures: three complete horses were engraved on the left – the heads are particularly fine – as well as a bison engraved and drawn in black. To the right, in the centre, there is a black stag, with a raised head and open mouth. Inside it is the engraving of another horse, while below it is another stag (engraved and drawn in black) and an engraved ibex. Above the central stage there used to be the cave's largest figure, an engraved and black stag, but nowadays only the lower part of its front legs remain. Opposite this alcove, on the left-hand wall, there is a large engraved horse, which also has some fine features.

The age of Buxu's art remains a subject of some debate. From superimpositions, it seems that the engravings were made before the black drawings, so it is possible that the former date to the final Solutrean or early Magdalenian (*c*.18–17,000 years ago), and the latter to the early to mid-Magdalenian (*c*.16–14,000 years ago).

Menéndez, M., 1984, 'La cueva del Buxu: el arte parietal', *Boletín del Instituto de Estudios Asturianos* 112: 755–801.

Obermaier, H. and Vega del Sella, C. de la, 1918, 'La cueva del Buxu (Asturias)', *Comisión de investigaciones paleontológicas y prehistóricas*, Memoria No. 20. Madrid.

**Address**
Cardes, Cangas de Onís
Tel. (34) 608 175467
http://tematico.asturias.es/cultura/yacimientos/buxu.html

**Nearest city/town** Cangas de Onís/Cardes.
**Nearest airport** Asturias.
**Nearest car rental** Cangas de Onís.
**Nearest train station** Arriondas.

Nearest bus route Cangas de Onís.
Nearest taxi or private car hire Cangas de Onís.
Restaurants in the vicinity Many in Cangas de Onís.
Hotels in the vicinity Many in Cangas de Onís.

When is this cave open? All year 10.30 to 14.30. Closed Mondays and Tuesdays.
Admission prices Adults 3 euros; children (7–12), OAPs and students with international student card 1,50 euros. No children under 7. Credit cards not accepted. Free on Wednesdays.
Storage facilities? No.
Do you have to make up a group? Yes; 4 people per group, by reservation; maximum of 25 people per day.
Can you reserve a place in a group? Reservation is essential.
Languages of the guides Spanish.
Length of tour 20 minutes.
Is the cave privately owned? No.
Is there a gift shop? No.
Is there a café (water)? No.
Are there WC facilities? No.
Handicapped access? No.
Is any climbing necessary? A path slopes up to the cave; there are a few stairs inside.
Distance to walk 1km from Cardes to the cave; 50m inside the cave and the same out again.
Level of fitness required Moderate.
Equipment required The cave has electric light; flashlights are not allowed.
What are the conditions inside the cave? Small and narrow cave; 14°C; 95 per cent humidity.
Is it lit? Yes.
Is it slippery? It can be slippery in places.
Is photography allowed? No.

The main panel at Tito Bustillo.

# TITO BUSTILLO

This huge cave was only discovered in April 1968 by a group of young speleologists, and it was named after their eighteen-year-old leader, Celestino Fernández Bustillo, who was killed in a mountain accident nineteen days later. Today, you enter through an artificial tunnel, punched into the mountain from a natural shelter. After a series of four doors, you reach what used to be the back of the cave,

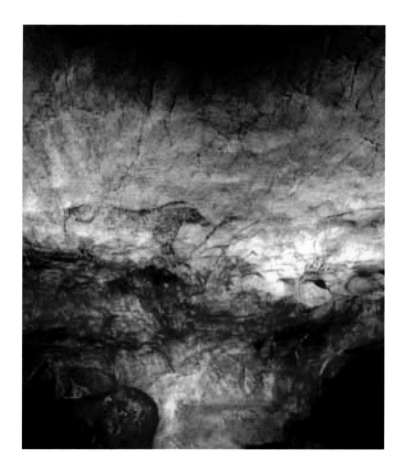

and then begin the long walk towards the original entrance. The cave itself is spectacular, with magnificent stalagmites and stalactites. There is a wealth of art throughout, but only a small portion can be shown on a normal visit; nevertheless, it is well worth the trip, because the main panel of Tito Bustillo, which you reach after a walk of about 500m, is one of the glories of Ice Age cave art (illustrated on page 1).

The big, isolated black horse head on the ceiling was, not surprisingly, the first figure spotted by the discoverers. But a large number of figures were accumulated on this complex panel – a sequence of up to nine phases of decoration has been discerned. There are red paintings, black paintings and engravings, made both before and after the application of a big area of red that covers much of the panel. Some engravings have striated lines, and others are combined with black paint. In the final phase, big bichrome figures were added, in black and violet (an unusual colour in cave art). These wonderful images, depicting horses and reindeer – as at Las Monedas (page 153), among the finest cave images we have of this species – were also engraved and scraped.

It is noteworthy that the roar of the underground river can be heard here. Excavations at the foot of this panel uncovered a hearth to give light, a few food remains, some stone and bone artefacts, and colouring materials. Excavations at the cave's original entrance have yielded Magdalenian material, including portable art, as well as seashells containing pigments. This occupation has been dated to the Middle and late Magdalenian, ending around 12,700 years ago, just before the entrance collapsed and was blocked. This material correlates well with the assumed age of the cave art.

Balbín Behrmann, R. de, 1989, 'L'art de la grotte de Tito Bustillo (Ribadesella, Espagne): une vision de synthèse', L'anthropologie 93 (2): 435–62.
Balbín Behrmann, R. de and Moure Romanillo, A., 1982, 'El panel principal de la cueva de Tito Bustillo (Ribadesella, Asturias)', Ars praehistorica 1: 47–97.

**Address**
Cueva 'Tito Bustillo', 33560 Ribadesella, Asturias
Tel. (34) 985 861120 and 902 190508 (cave, during office hours, Wednesday to
Sunday); 985 861118 (Aula Didáctica); fax 985 860376
http://tematico.asturias.es/cultura/titobustillo.html
cuevatb@princast.es

**Nearest city/town** Oviedo/Ribadesella.
**Nearest airport** Asturias (Aviles).
**Nearest car rental** Ribadesella.
**Nearest train station** Ribadesella.
**Nearest bus route** Ribadesella.
**Nearest taxi or private car hire** Ribadesella.
**Restaurants in the vicinity** Many.
**Hotels in the vicinity** Many.

**When is this cave open?** 1 April to 30 September 10.00 to 16.30 (ticket office
opens at 10.00); closed Mondays and Tuesdays. The Aula Didáctica next to
the cave is open all year (except Mondays and Tuesdays), 10.00 to 16.15
between 1 October and 31 March and to 17.15 from 1 April to 30 September.
**Admission prices** Adults 4 euros; children (7–12) and OAPs 2 euros;
international student card holders 2 euros. No children under 7. The cave is
free on Wednesdays, and the Aula Didáctica is always free. Credit cards not
accepted.
**Storage facilities?** Yes.
**Do you have to make up a group?** Yes. Maximum of 20 to 24 people per
group, and 360 people per day.
**Can you reserve a place in a group?** You must reserve in advance through
the website.
**Languages of the guides** Spanish.
**Length of tour** 60 minutes.
**Is the cave privately owned?** No.
**Is there a gift shop?** No.
**Is there a café (water)?** Refreshments are available from machines.
**Are there WC facilities?** Yes.
**Handicapped access?** No.
**Is any climbing necessary?** Not outside the cave; inside there are a few stairs.

**Distance to walk** No distance to the cave mouth; a tunnel of 160m, and more than 500m into the cave, and the same out again – a total of 1.5km.
**Level of fitness required** Moderate.
**Equipment required** The guide deals with lighting.
**What are the conditions inside the cave?** 13°C. Flat apart from a few stairs and easy.
**Is it lit?** Yes.
**Is it slippery?** It can be slippery here and there.
**Is photography allowed?** No.

# LA LOJA

The cave contains some fine engravings which were discovered by Alcalde del Río and others in 1908, and which stand out clearly in white against the dark rock, like chalk on a blackboard. There are also some traces of red paint 3m from the entrance on the right-hand wall. The main panel, on the right wall, about 45m into the cave and more than 4m above the present floor, features six animal figures, all facing into the cave: originally seen as five aurochs with a possible carnivore at top right, they are now seen either as six aurochs or as a horse at top left plus five aurochs. The realistic style of the figures, together with the material unearthed in excavations in the cave, point to a Middle or late Magdalenian date (between 14,000 and 11,500 years ago).

Alcalde del Río, H., Breuil, H. and Sierra, L., 1911, *Les cavernes de la région Cantabrique*, Imprimerie Chêne: Monaco.
Gómez Tabanera, J. M., 1978, 'Para una revisión del arte rupestre de la cueva de La Loja', *Boletín del Instituto de Estudios Asturianos* 93/94: 385–449.

Tracing of the engraved panel at La Loja (after Breuil).

**Address**
El Mazo, Peñamellera Baja
Tel. (34) 985 414297 (reservations: tourist office of Panes); 985 414008
(Peñamellera Baja town hall)
http://tematico.asturias.es/cultura/yacimientos/laloja.html

**Nearest city/town** Llanes/Panes.
**Nearest airport** Santander.
**Nearest car rental** Llanes.
**Nearest train station** Colombres.
**Nearest bus route** Panes.
**Nearest taxi or private car hire** Panes.
**Restaurants in the vicinity** Panes.
**Hotels in the vicinity** Panes, Colombres, Unquera, Llanes.

**When is this cave open?** During Holy Week, and from 15 July to 15
September. Ask for information at the tourist office at Panes, from 10.00.
Usually 4 visits per day, at 10.00, 12.30, 16.00 and 18.00; closed Mondays.
**Admission prices** Adults 2 euros; children (7–12) and OAPs 1 euro. Free on
Wednesdays. Credit cards not accepted.

**Storage facilities?** No.

**Do you have to make up a group?** Yes. Maximum of 35 people per day, 6 people per group. Reservation at the tourist office.

**Can you reserve a place in a group?** Yes. Phone the town hall or tourist office.

**Languages of the guides** Spanish.

**Length of tour** 50 minutes.

**Is the cave privately owned?** No.

**Is there a gift shop?** No.

**Is there a café (water)?** No.

**Are there WC facilities?** No.

**Handicapped access?** No.

**Is any climbing necessary?** No.

**Distance to walk** 20 minutes' walk inside.

**Level of fitness required** Moderate.

**Equipment required** The guides provide flashlights.

**What are the conditions inside the cave?** 13°C; 95 per cent humidity.

**Is it lit?** No.

**Is it slippery?** It can be slippery at times.

**Is photography allowed?** No.

Horse and other motifs painted high up in Candamo's Camarin.

# LA PEÑA DE CANDAMO
## (AND INTERPRETATION CENTRE)

The interpretation centre at Candamo, opened in 1999, provides an excellent introduction to the cave, not only by means of a video but also through a facsimile of the main panels, on which it is far easier to see the figures than it is on the originals. This greatly helps the inexperienced visitor to derive more from visiting this than the actual cave. In addition, the centre contains a facsimile of the external engravings at the site of La Lluera (near Oviedo) and photographs of other similar sites in Asturias which are not open to the public.

The art of Candamo was first studied in 1914, but suffered greatly over the years, not least during the Spanish Civil War, when people hid here. It comprises both engravings and paintings, and contains some very fine figures. Only a portion of the images can be seen during a normal visit.

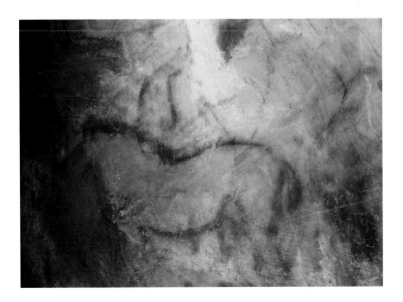

You first enter the principal chamber, 25m long, 20m wide and 15m high. Here you see the main panel, 8m long and 2m high, which is already familiar from the facsimile in the interpretation centre. It contains a complex accumulation of engraved and painted figures – black, red, even yellow, including some lines of black dots. The most famous engraving is a big stag, which is turning its head and is apparently pierced by many spears. Among the confusion of superimposed figures, there are also other deer, bison, horses, some seal-like figures and two strange anthropomorphs. The earliest figures – the first to have been placed here – seem to be yellow aurochs painted in outline, and associated with the black dots. The later figures include two large bulls facing each other – that on the left is almost 2.5m long.

Immediately around the corner from the main panel is a fine, large, red horse painting. You then look high up to the left where, in the Camarin (a cavity also seen in facsimile in the interpretation centre) there are two horses and other figures. These are of great importance because of their dominant position. The concretions in front of them were broken so that, when lit, these figures would have been very visible from throughout the main chamber: the artist(s) wanted these figures to be seen by his or her fellows. To the left of the Camarin, and also high up, is a black ibex figure.

No archaeological material was found in Candamo, but a nearby cave yielded Solutrean tools. The cave art is generally ascribed to this period and to the succeeding early and Middle Magdalenian – that is, from 21,000 to 13,000 years ago.

Hernández Pacheco, E., 1919, 'La caverna de la Peña de Candamo (Asturias)', *Comisión de investigaciones paleontológicas y prehistóricas*, Memoria No. 24: Madrid.

**Address**
San Román de Candamo, Asturias
Tel. (34) 985 829702 (centre) or 985 828056 and 985 828351 (cave bookings,
Monday to Friday 09.00 to 14.00); fax 985 828228
www.ayto-candamo.es and
http://tematico.asturias.es/cultura/yacimientos/candamo.html

**Nearest city/town** Oviedo/San Román de Candamo.
**Nearest airport** Ranon.
**Nearest car rental** Oviedo.
**Nearest train station** San Román de Candamo (every hour from Oviedo).
**Nearest bus route** Bus from Oviedo to Grado; then take the train to San Román.
**Nearest taxi or private car hire** San Román de Candamo.
**Restaurants in the vicinity** San Román de Candamo, Concejo de Candamo.
**Hotels in the vicinity** San Román de Candamo.

**When is this cave open?** 15 June to 15 September. Closed Mondays. The
centre is open all year round, except on Mondays, 11.00 to 14.00. Guide
services at 11.00, 12.00 and 13.00.
**Admission prices** Adults 1,20 euros; children (under 16) 60 cents. Free on
Wednesdays. Groups of more than 15 adults 90 cents each; groups of more
than 15 children 45 cents each. Admission to the cave is free. Credit cards not
accepted.
**Storage facilities?** At the centre.
**Do you have to make up a group?** Yes, for the cave; a maximum of 25 people
per day with visits at 12.00 and 13.00.
**Can you reserve a place in a group?** For the cave, advance reservation is
necessary.
**Languages of the guides** Cave: Spanish; centre: Spanish and French.
**Length of tour** 30 minutes in the cave.
**Is the cave privately owned?** No.
**Is there a gift shop?** In the centre.
**Is there a café (water)?** At the centre.
**Are there WC facilities?** At the centre.
**Handicapped access?** No.
**Is any climbing necessary?** Not outside the cave, but there are some steps
inside.

**Distance to walk** Short distance to the cave entrance from car park; 60m into the cave and the same out.
**Level of fitness required** Moderate.
**Equipment required** The guide supplies lamps.
**What are the conditions inside the cave?** 15°C. Easy.
**Is it lit?** No.
**Is it slippery?** No.
**Is photography allowed?** No.

# LOS CASARES

This cave contains a large collection of really strange engravings, as well as a few painted images, first discovered in 1933. Of the roughly 169 figures known and published so far, only about a third can be shown during a normal visit, but they include some of the oddest figures in Ice Age art – in particular a series of about twenty anthropomorphs or humanoids, including two with 'masks', as well as horses (including one with a remarkably fine head), aurochs, ibex, deer, possible mammoths and so forth. One particularly interesting area contains a collection of humanoids, some fish and what may be a humanoid copulation scene – in which case it is the only one in all cave art – although some specialists see the large phallus as a fish. Another human figure appears to be diving or swimming.

On the basis of style, the art of Los Casares has been attributed to the Solutrean (*c.*20,000 years ago) and Magdalenian (*c.*15,000 years ago).

Acosta González, A. and Molinero Barroso, J.M., 2003, 'Grabados de la cueva de los Casares, Riba de Saelices (Guadalajara)', *Tierra de Guadalajara* 42, Aache ediciones: Guadalajara.
Balbín Behrmann, R. de and Alcolea Gonzalez, J.J., 1992, 'La grotte de Los Casares et l'art paléolithique de la Meseta espagnole', *L'anthropologie* 96: 397–452.

Cabré Aguiló, J., 1998, *Investigaciones en las cuevas de Los Casares y de La Hoz (1934–1941)*, Ediciones de Librería Rayuela: Sigüenza.

---

**Address**
Riba de Saelices, Guadalajara
Tel. (34) 949 304006 (Emilio Moreno, cave guide – call between 09.00 and 10.00 or 21.00 and 22.00); 949 213301 and 949 212773 (Guadalajara Museum)
http://usuarios.lycos.es/loscasares/
cueva_los_casares@yahoo.es

**Nearest city/town** Guadalajara/Riba de Saelices.
**Nearest airport** Madrid.
**Nearest car rental** Guadalajara.
**Nearest train station** Sigüenza.
**Nearest bus route** Flora Villa and Samar buses run from Madrid and/or Guadalajara to Saelices.
**Nearest taxi or private car hire** Saelices de la Sal (3km away).
**Restaurants in the vicinity** No, only bars.
**Hotels in the vicinity** Guadalajara. Locally there are only *casas rurales*.

**When is this cave open?** One visit in the morning (10.00) and one in the afternoon (15.00); Sundays and holidays: morning only. This timetable may be flexible – always contact Emilio Moreno. Closed Mondays and Tuesdays, and 15 September to 15 October.
**Admission prices** 60 cents. Free at weekends. No children under 16.
Credit cards not accepted.
**Storage facilities?** No.
**Do you have to make up a group?** Yes. Maximum group size is 6 people.
**Can you reserve a place in a group?** Yes.
**Languages of the guides** Spanish.
**Length of tour** 90 minutes to 3 hours – average 2 hours.
**Is the cave privately owned?** No.
**Is there a gift shop?** No.
**Is there a café (water)?** No.
**Are there WC facilities?** No.
**Handicapped access?** No.

**Is any climbing necessary?** About 500m of sloping path to the cave; no stairs inside.

**Distance to walk** 500m from car park; about 200m into the cave, and the same back again.

**Level of fitness required** Moderate.

**Equipment required** The guide provides lamps.

**What are the conditions inside the cave?** Easy.

**Is it lit?** No.

**Is it slippery?** Conditions vary between dry and wet.

**Is photography allowed?** No.

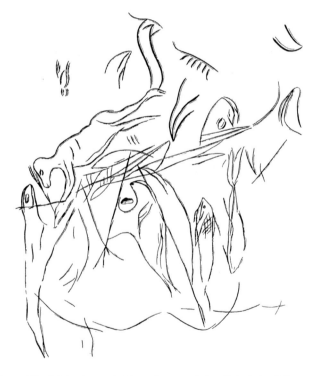

Tracing of the 'diving' panel at Los Casares (after Cabré Aguiló).

# LA PILETA

La Pileta takes its name (the water source, or washbasin) from a small spring inside the cavern. The cave was discovered by the grandfather of the present owners in 1905, while he was searching for guano to fertilize his lands, but its art was first investigated by Colonel W. Verner in 1911. The cave comprises a complex series of galleries, chambers and chasms.

About four hundred paintings and engravings are known in the cave, but many of these postdate the Ice Age – the most recent schematic figures are ascribed to the second millennium BC. From the Upper Palaeolithic, about sixty animal figures have been deciphered, but there are also numerous geometric shapes, meanders, serpentiforms, spirals and other motifs. There are figures in yellow, red and black; superimpositions indicate that the yellow are the earliest, followed by the red and then the black. Many of the figures were clearly drawn with the finger.

One of the cave's most remarkable panels is to be found in the Sanctuary, a low and uncomfortable corridor about 15m long, 2m wide and 2m high. Among the aurochs, horses and ibex, and the wide variety of motifs such as serpentiforms and dots, there is a big-bellied horse, 70cm long, with different sets of double finger marks inside it. This figure, which makes good use of the rock shape, is often interpreted as a pregnant mare, but this is not necessarily so – you simply cannot tell from a profile view, and there are plenty of male horses in Ice Age art with similarly large bellies.

Further on, several ibex figures can be seen. One black specimen has been carefully placed so that it can be seen through a natural porthole, 80cm wide, in the rock.

Later you reach the Fish Chamber, dominated by one of the cave's most famous figures: a large black fish, 1.5m long, and thought to be a halibut, with what seems to be the outline of a seal inside it.

Also noteworthy in La Pileta are the numerous 'corral' signs, comprising a roughly circular or oval design with series of finger marks inside, and with pairs of short lines sticking out of the

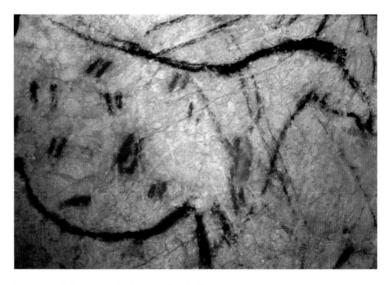

Horse and finger marks in La Pileta's Sanctuary.

edges. There is no particular reason to believe that they do indeed depict corrals.

The dating of the Ice Age art of La Pileta is still a matter of some debate. Most specialists would agree that the black figures are late Magdalenian, but the earlier figures could be Solutrean or even earlier (*c.*20,000 years ago).

Breuil, H., Obermaier, H. and Verner, W., 1915, *La Pileta à Benaojan (Málaga)*, Imprimerie Chêne: Monaco.

Dams, L., 1978, *L'art Paléolithique de la caverne de La Pileta*, Akademische Druck-u, Verlagsanstalt: Graz.

**Address**
Benaoján, Málaga
Tel. (34) 952 167343
www.cuevadelapileta.org
pileta@cuevadelapileta.org

**Nearest city/town** Ronda/Benaoján.

**Nearest airport** Málaga.

**Nearest car rental** Ronda.

**Nearest train station** Benaoján-Montejaque or Jimera de Libar (but there is no public transport to the cave from either station).

**Nearest bus route** There are buses to Benaoján, but that is 5km from the cave, with no public transport available.

**Nearest taxi or private car hire** Benaoján.

**Restaurants in the vicinity** Benaoján or Jimera.

**Hotels in the vicinity** Ronda; there is one hotel between Benaoján and the cave.

**When is this cave open?** 16 April to 31 October 10.00 to 13.00 and 16.00 to 18.00; 1 November to 15 April 10.00 to 13.00 and 16.00 to 17.00.

**Admission prices** Adults 6 euros; children 5–10 3 euros; children 10–13 and students 4 euros. Credit cards not accepted.

**Storage facilities?** Yes, shelves inside cave.

**Do you have to make up a group?** No.

**Can you reserve a place in a group?** Yes. Reservations are possible only for non-holidays, and only for the first visit (10.00); maximum of 15 to 25 people per group.

**Languages of the guides** Spanish, English.

**Length of tour** 1 hour.

**Is the cave privately owned?** Yes.

**Is there a gift shop?** No.

**Is there a café (water)?** No.

**Are there WC facilities?** No.

**Handicapped access?** No.

**Is any climbing necessary?** There is a stone staircase from the car park to the cave; there are some (not steep) steps inside.

**Distance to walk** From car park to cave is 500m; a total of 1km is walked inside the cave.

**Level of fitness required** Moderate.

**Equipment required** The guide provides flashlights.

**What are the conditions inside the cave?** 15°C; easy.

**Is it lit?** No.

**Is it slippery?** Not usually.

**Is photography allowed?** No.

# ARDALES
## (CUEVA DE DOÑA TRINIDAD)

The cave of Doña Trinidad takes its name from Doña Trinidad Grund, a noblewoman from Seville who was married to a local landowner in the mid-nineteenth century. It was she who first prepared the cave for tourist visits, by means of paths and staircases. It had been discovered in 1821, thanks to an earth tremor, but its

Detail of engraved hind in Ardales.

art was not spotted until 1918, when the abbé Breuil visited it. It contains both paintings and engravings, with four colours present (yellow, red, brown, black) and several different incising techniques, from deep and broad to extremely fine. The pigments were applied sometimes with fingers and elsewhere by brush. There is a great deal of use of natural rock shapes. The subjects include animals, humans, ten hands (both stencils and positives) and abstract signs. There are more than eighty animal figures – primarily hinds, together with horses, ibex and others. One of the most interesting engravings reproduces a flamingo-like bird.

It is thought that the cave's art spans a long period, from *c*.25,000 to 11,000 years ago.

Cantalejo Duarte, P. et al., 2006, *La cueva de Ardales: arte prehistórico y ocupación en el Paleolítico superior: estudios 1985–2005*, Centro de Ediciones de la Diputación de Málaga: Málaga.
Ramos Muñoz, J. et al., 1992, *Cueva de Ardales: su recuperación y estudio*, Ayuntamiento de Ardales: Málaga.

**Address**
Centro de Interpretación, Avenida Málaga No. 1, 29550 Ardales, Málaga
Tel. (34) 952 458046 (Museo Municipal de la Historia y las Tradiciones de Ardales)
www.cuevadeardales.com
informacion@cuevadeardales.com

**Nearest city/town** Málaga/Ardales.
**Nearest airport** Málaga.
**Nearest car rental** Campillo.
**Nearest train station** Santa Ana (AVE Madrid–Seville) and then taxi to the museum.
**Nearest bus route** Málaga–Seville. Alight in Ardales and get a taxi or walk 2km.
**Nearest taxi or private car hire** Ardales.
**Restaurants in the vicinity** Many.
**Hotels in the vicinity** Many in Ardales.

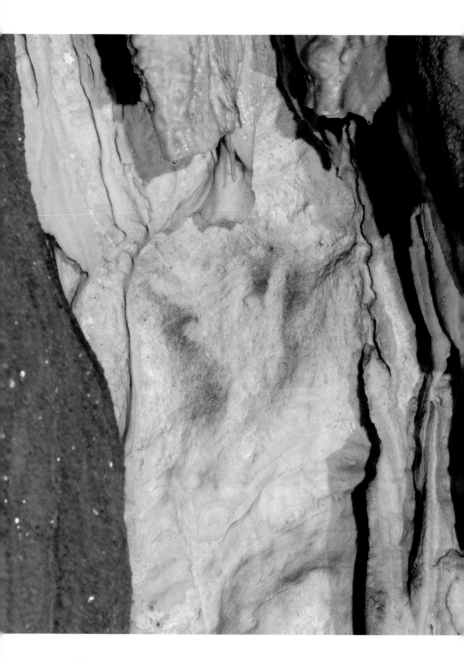

**When is this cave open?** One visit per day at 10.00 on Tuesdays, Thursdays, Saturdays and Sundays in July and August and only on Saturdays and Sundays the rest of the year. You need your own vehicle to reach the cave.

**Admission prices** Adults 5 euros; children (6–12) 3 euros. Not recommended for children under 6. Credit cards not accepted.

**Storage facilities** Yes, in the cave.

**Do you have to make up a group?** No. There is one visit per day, maximum of 15 people.

**Can you reserve a place in a group?** Yes. This is crucial.

**Languages of the guides** Spanish.

**Length of tour** 2 hours.

**Is the cave privately owned?** No.

**Is there a gift shop?** In the Museo/Centro de Interpretación.

**Is there a café (water)?** In the museum.

**Are there WC facilities?** In the museum.

**Handicapped access?** No.

**Is any climbing necessary?** No.

**Distance to walk** 3km from the museum to the cave (or use your own vehicle); 900m inside the cave.

**Level of fitness required** Moderate.

**Equipment required** The guides provide flashlights.

**What are the conditions inside the cave?** 16.5°C.

**Is it lit?** No.

**Is it slippery?** Yes, in the winter.

**Is photography allowed?** Not without the authorization of the Consejeria de Cultura de la Junta de Andalucia.

Hand stencil at Ardales.

# AMBROSIO

The large rock shelter of Ambrosio had long been known for its important Upper Palaeolithic occupation levels. In 1992, in the course of some new excavations, some engraved and painted figures were discovered on its walls, lit by daylight. Three panels are known. The first contains engravings: notably a horse and what may be a bird. Panel two, further into the shelter, at the same side, was masked by sediments and rubble from previous excavations. The principal figure here is a horse, 92cm long, in red ochre. Above it there seem to be two engraved horse heads, facing each other. The third panel merely has some patches of colour. Thanks to the date of the layers that originally covered these panels, as well as to stylistic features, the figures can safely be attributed to the Solutrean period, *c.*17–16,000 years ago.

Ripoll López, S. et al., 1995, 'Art pariétal paléolithique de la grotte d'Ambrosio (Almería, Espagne)', *Bulletin de la Société Préhistorique Ariège-Pyrénées* 50: 97–116.

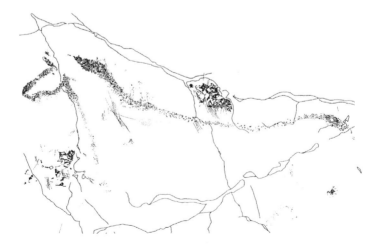

Tracing of the red horse of Ambrosio (after Ripoll et al.).

**Address**
04830 Vélez Blanco, Almeria
Tel. (34) 950 614800 (town hall) and 950 415354 (visitor centre)
www.losvelez.com
velezblanco@telebase.es

**Nearest city/town** Almeria/Vélez Blanco.
**Nearest airport** Almeria and Granada.
**Nearest car rental** Lorca, 50km from Vélez.
**Nearest train station** Lorca, Murcia.
**Nearest bus route** From Lorca and/or Almeria to Vélez Blanco.
**Nearest taxi or private car hire** Vélez Blanco.
**Restaurants in the vicinity** Many in Vélez Blanco.
**Hotels in the vicinity** Vélez Blanco.

**When is this cave open?** All year round. No timetable. To book, call the town
hall between 08.00 and 15.00, Monday to Friday.
**Admission prices** Free.
**Storage facilities?** No.
**Do you have to make up a group?** No; arrangements are very flexible.
Maximum 15 people.
**Can you reserve a place in a group?** Yes.
**Languages of the guides** Spanish.
**Length of tour** 30 minutes.
**Is the cave privately owned?** Yes.
**Is there a gift shop?** No.
**Is there a café (water)?** No.
**Are there WC facilities?** No.
**Handicapped access?** No.
**Is any climbing necessary?** Mild walk, up and down.
**Distance to walk** 50m inside.
**Level of fitness required** Minimal.
**Equipment required** Not applicable.
**What are the conditions inside the cave?** Dry.
**Is it lit?** The art is in daylight.
**Is it slippery?** No.
**Is photography allowed?** Yes.

# SIEGA VERDE

The rock art of Siega Verde was discovered in 1988. The first figure to be spotted was one of the few on a horizontal surface, a small horse (not included in normal visits). The vast majority of figures are pecked into vertical surfaces of the schist rocks along the left bank of the río Agueda, a tributary of the Douro; no figures occur on the other bank. Currently about 94 panels are known, containing more than 500 figures, only a few of which can be seen

Pecked horse at Siega Verde.

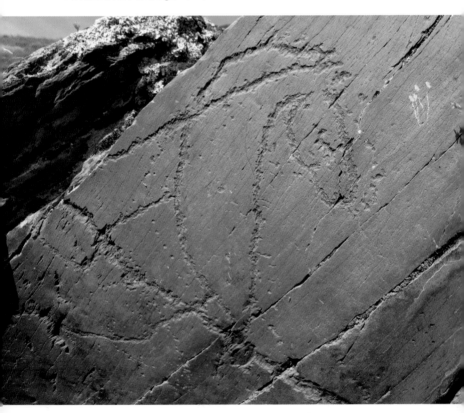

during the visit, since they extend over a distance of 1.5km. They are dominated by horses and aurochs, as well as deer. Among the most interesting figures are a large aurochs, facing left, with a small fox or wolf inside it; some depictions which are now incomplete because the modern bridge's supports mask them; and a large stag looking over its shoulder, which has become the logo of the visitor centre. From their style, these homogeneous figures are mostly attributed to a period around 18,000 years ago.

Alcolea González, J.J. and de Balbín Behrmann, R., 2006, 'Arte rupestre al aire libre: el yacimiento rupestre de Siega Verde', *Arqueología en Castilla y León* 16: Salamanca.

---

**Address**
Siegaverde, Villar de la Yegua, Salamanca
Tel. 34 902 910009 (Monday to Friday)
http://www.fundacionpatrimoniocyl.es
rutasfortificaciones@adecocir.e

**Nearest city/town** Ciudad Rodrigo/Villar de la Yegua.
**Nearest airport** Salamanca.
**Nearest car rental** Ciudad Rodrigo.
**Nearest train station** Ciudad Rodrigo.
**Nearest bus route** Ciudad Rodrigo to the site.
**Nearest taxi or private car hire** Ciudad Rodrigo.
**Restaurants in the vicinity** One restaurant in Castillejo Martin Viejo
(1km away); many in Ciudad Rodrigo.
**Hotels in the vicinity** Salamanca, Ciudad Rodrigo. There are two
hotel/restaurants in El Cruce de Espeja.

**When is this site open?** 1 November to 1 March, weekends and holidays
11.00 to 17.00; 1 March to 1 November, Thursday to Sunday 11.00 to 14.00
and 16.00 to 17.00; July and August daily 11.00 to 14.00 and 17.00 to 20.00.
Groups can be accommodated outside this timetable if they book in advance.
**Admission prices** Standard ticket 4 euros; children up to 12, students, OAPs
and group rate 3 euros. Credit cards not accepted.

**Storage facilities?** Yes.
**Do you have to make up a group?** No. There is no minimum number for groups; maximum between 15 and 20 per group.
**Can you reserve a place in a group?** Yes.
**Languages of the guides** Spanish.
**Length of tour** One itinerary takes 30 minutes, the other 1 hour.
**Is the site privately owned?** No.
**Is there a gift shop?** Yes.
**Is there a café (water)?** There is a vending machine for refreshments.
**Are there WC facilities?** Yes.
**Handicapped access?** Yes.
**Is any climbing necessary?** There is a slope down to the site. Inside there are some steps here and there.
**Distance to walk** 50m from the visitor centre to the site and 200m on the site.
**Level of fitness required** Minimal.
**Equipment required** None, but a mirror is useful for reflecting light on to the figures.
**What are the conditions?** Normal. Hot in the summer in the middle of the day.
**Is it slippery?** Not usually.
**Is photography allowed?** Yes.

# DOMINGO GARCIA
## (CERRO DE SAN ISIDRO)

The hill known as Cerro de San Isidro (at Domingo García) has long been well known for its abundance of petroglyphs from later periods of prehistory or perhaps later. However, in 1970 a large pecked horse was found here and recognized as being of 'palaeolithic style', thus constituting the first discovery of Ice Age open-air art. In the 1990s, new studies were carried out here, which led to the cleaning of some rocks. A second, smaller pecked horse was found behind the first (and subsequently traces of part of a third); and, especially, numerous small fine line engravings were discovered on different schist rocks. More than a hundred figures were eventually found at eight centres in an area of 40 sq. km.

The Cerro de San Isidro, with its old chapel, is the most important of these centres, with 7 engraved rocks, 14 panels and 57 palaeolithic figures, in addition to its post-palaeolithic art. The figures are dominated by horses, aurochs, deer and ibex, and their style assigns them to the end of the Solutrean period and the early Magdalenian (*c.*18–17,000 years ago).

A selection of the best palaeolithic and post-palaeolithic panels are marked with explanatory boards on an itinerary around the hill. Panel 1 is the most important, with its pecked horses; but the small horse head of panel 7 is particularly beautiful.

Ripoll López, S. and Municio Gonzalez, L.J. (eds), 1999, 'Domingo García: arte rupestre paleolítico al aire libre en la meseta castellana', *Arqueología en Castilla y León* 8, Junta de Castilla y León: Salamanca.

---

**Address**
Cerro de San Isidro, Domingo García, Segovia
www.uned.es/dpto-pha/domingo/centros.htm

**Nearest city/town** Segovia/Domingo García.
**Nearest airport** Madrid.
**Nearest car rental** Segovia.
**Nearest train station** Segovia.
**Nearest bus route** There is a bus from Segovia, but its timetable is unreliable, so a taxi or car hire is recommended.
**Nearest taxi or private car hire** Segovia.
**Restaurants in the vicinity** Santa María de Nieva or Bernardos (both 5–6km away).
**Hotels in the vicinity** Nava de la Asunción (12km away); and there is a *casa rural* in Domingo García.

**When is this site open?** Always open.
**Admission prices** Free.

OVERLEAF  Head of large pecked horse at Domingo García.

**195**

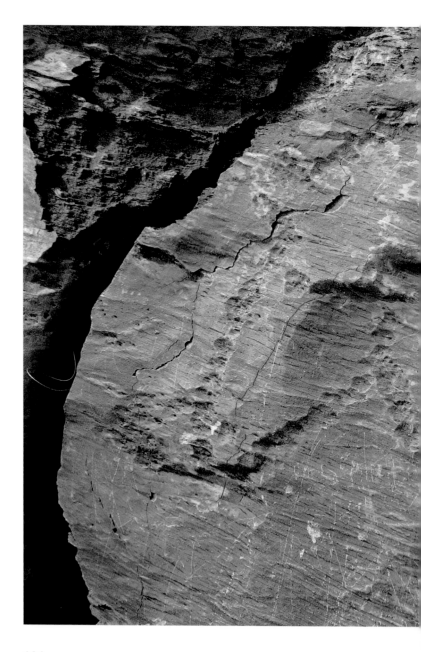

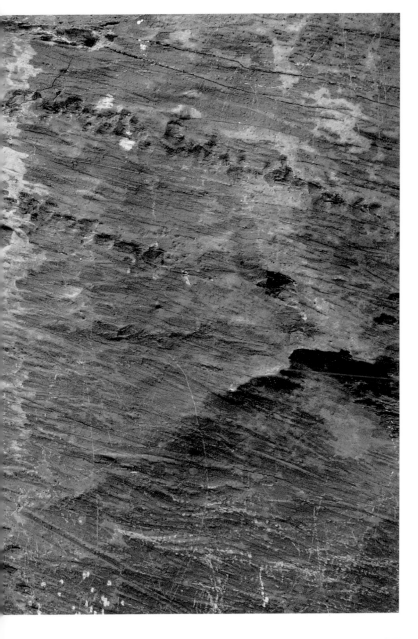

Storage facilities? No.
Do you have to make up a group? No.
Languages of the guides No guides.
How long are you allowed on site No limit.
Is the site privately owned? No.
Is there a gift shop? No.
Is there a café (water)? No.
Are there WC facilities? No.
Handicapped access? Yes.
Is any climbing necessary? There is a slope up from the nearest road. No stairs.
Distance to walk A few hundred metres up from the nearest road.
Level of fitness required Minimal.
Equipment required None.
What are the conditions? Normal.
Is it slippery? Not usually.
Is photography allowed? Yes.

# MUSEO ARQUEOLOGICO NACIONAL

Madrid's National Archaeological Museum is a splendid old building and its palaeolithic section features some wonderful pieces of portable art, including some of the magnificent engraved shoulder blades from the caves of Altamira (page 137) and El Castillo (page 148). In the courtyard in front of the building, you can descend to a facsimile of the decorated chamber of Altamira. Unfortunately, though, as this was made decades ago its technology is now long outdated, and its inadequate lighting makes it very dark. Those who are able should visit the facsimile at Altamira itself rather than this disappointing alternative.

Tracing of an engraved shoulder blade from El Castillo in the Museo Arqueológico Nacional (after Breuil).

**Address**

Museo Arqueológico Nacional, c/o Serrano 13, 28001 Madrid

Tel. (34) 915 780203 (recorded message) or 915 777912 (group reservations); fax 914 316840

www.man.mcu.es

**When is this museum open?** Tuesday to Saturday 09.30 to 20.00; Sundays and holidays 09.30 to 15.00. Closed Mondays and 1 and 6 January, 25 July, 15 August, 9 September, and 24, 25 and 31 December.

**Admission prices** Adults 3 euros; 50 per cent reduction for students with cards; children under 18 and OAPs free. Free entry on Saturday afternoons and Sundays.

**Storage facilities?** Yes.

**Languages of the guides** The museum has no guides or audio guides.

**Is the museum privately owned?** No.

**Is there a gift shop?** Yes.

**Is there a café (water)?** No café, just water fountains.

**Are there WC facilities?** Yes.

**Handicapped access?** Yes.

**Is any climbing necessary?** There are steps at the front; inside there are stairs but also elevators.

**Is photography allowed?** Yes, but no flash.

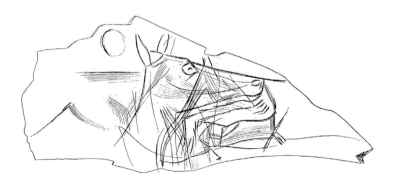

# PORTUGAL

## ESCOURAL

The cave and its art were discovered in 1963, during explorations for a marble quarry. It contains more than a hundred motifs – mostly engravings, together with a few paintings. They are primarily clustered in the largest chamber and its adjacent galleries. Among the figurative designs, horses and bovids

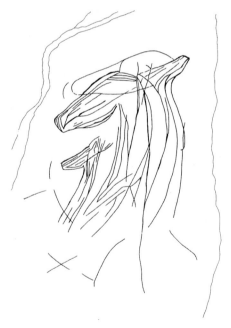

Tracing of the engraved horse heads of Escoural (after Lejeune).

dominate; there are also numerous non-figurative motifs. There is a distinct preference for black lines and fine engravings in the figurative designs; the same techniques are also used for the non-figurative, together with red lines. The cave's best known and most memorable figures are several engraved horse heads with internal striations.

Superimpositions have shown that the black figures are the oldest, followed by the fine engravings, with the red figures the youngest. It is thought that most of the art dates to the Middle or Upper Solutrean, c.20,000 years ago, although some non-figurative motifs may belong to the Magdalenian (c.17–12,000 years ago) or even later, especially as the cave also contained an important Neolithic necropolis.

Araújo, A.C. and Lejeune, M., 1995, 'Gruta do Escoural: nécropole Neolítica e arte rupestre Paleolítica', *Trabalhos de arqueologia* 8, Instituto Português do Património Arquitectónico e Arqueológico: Lisbon.

**Address**
Gruta do Escoural, Santiago do Escoural, 7000 Evora
Tel. (351) 266 857 000/266 769 800; fax 266 769 855
www.ippar.pt/monumentos/sitio_escoural.html
dre.ippar@ippar.pt

**Nearest city/town** Evora, Montemor-o-Novo/Vila de Santiago do Escoural.
**Nearest airport** Lisbon.
**Nearest car rental** Evora and Montemor-o-Novo.
**Nearest train station** Evora.
**Nearest bus route** There is a bus service from Evora to Escoural, with a stop near the cave, but it does not run frequently.
**Nearest taxi or private car hire** Santiago do Escoural.
**Restaurants in the vicinity** Good restaurants in Santiago do Escoural.
**Hotels in the vicinity** Several hotels in Evora; rural tourism house near the cave.

**When is this cave open?** All year round, except 1 January, Easter, 25 April, 1 May, 25 December and Mondays, 09.00 to 12.00 and 13.30 to 17.00.

**Admission prices** Adults 2,50 euros; youngsters (15–25) and OAPs 1,25 euros; under 15s free. The price includes access to the interpretation centre in Vila de Santiago do Escoural (2km from the cave). Tickets can be bought at the interpretation centre (R. Magalhaes Lima 48, 7050-556 Santiago do Escoural).

**Storage facilities?** Yes.

**Do you have to make up a group?** No.

**Can you reserve a place in a group?** No, but individuals can visit as well as groups by appointment (phone or fax).

**Languages of the guides** Portuguese, English.

**Length of tour** About 20–25 minutes.

**Is the cave privately owned?** No.

**Is there a gift shop?** Yes, at the interpretation centre.

**Is there a café (water)?** No.

**Are there WC facilities?** Yes, at the interpretation centre.

**Handicapped access?** No.

**Is any climbing necessary?** There are some stairs at the entrance.

**Distance to walk** A few metres to the entrance; about 50m inside.

**Level of fitness required** Minimal.

**Equipment required** None.

**What are the conditions inside the cave?** Easy.

**Is it lit?** Yes.

**Is it slippery?** A little.

**Is photography allowed?** No.

The overlapping horse heads at Ribeira de Piscos, Côa Valley.

# CÔA VALLEY

This tributary of the Douro in north-east Portugal is the location of the biggest known collection of open-air Ice Age art: numerous pecked animal images, as well as fine incisions, on the very fractured vertical schist rocks by the riverside. In 1989, preparations began for the construction of a huge dam along the river, which would have raised its water level by about 100m. During the ensuing archaeological survey of the region, rock carvings were first noticed in 1992 at Canada do Inferno. By 1994, the news of the ever-growing number of discoveries had reached the outside world, and specialists from around the globe, together with many local people, not least the schoolchildren of Vila Nova de Foz Côa, began a campaign to try and preserve this unique resource – a seemingly impossible task, since work on the dam was already well under way and millions had

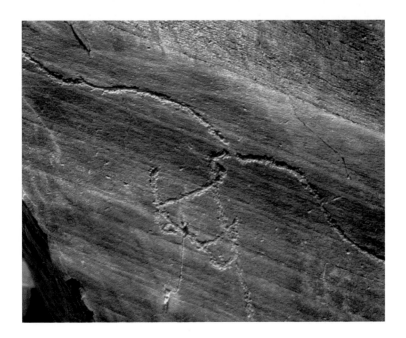

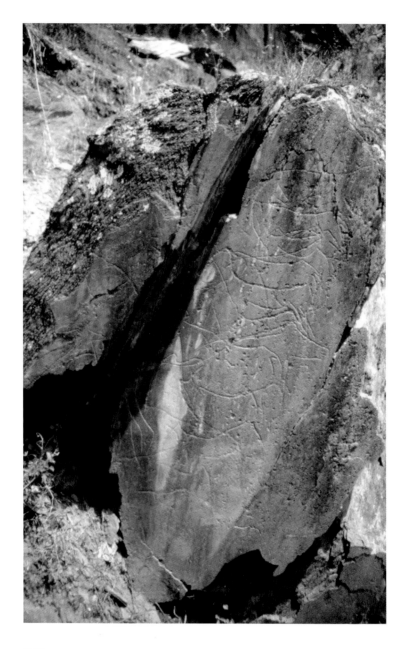

already been spent. Nevertheless, thanks to the campaign, and to a change of government, the building of the dam was indeed stopped at the end of 1995. Subsequently, the area was made an archaeological park, as well as a UNESCO World Heritage Site.

Today, work continues on discovering and studying the valley's art, which is scattered over a distance of 17km. Three important concentrations of petroglyphs can be visited by the public and these provide an excellent sample of this remarkable art.

At Canada do Inferno, it is known that many figures are already beneath the water, thanks to the Pocinho dam, constructed in the 1980s, which raised the water level of the river by several metres. But many remain to be seen by the visitor, both on the riverbank and up the rocky slope: primarily aurochs, horses and ibex, the three most common species depicted in the Côa valley.

Some figures are isolated and clearly visible, while others are superimposed and more difficult to decipher. Down at the water's edge some very recent petroglyphs can also be seen, mostly religious in nature.

At Penascosa, on a rock above the area where you park, a large stag figure can be seen; this is abraded on to the rock rather than pecked. Further on, to the left, is a splendid panel of aurochs, horses and ibex (illustrated on page 23), while several other major collections of images of these animals are to be seen further on still, at different levels. These include a really big horse figure, facing left. Below it is a fish depiction. Near by you can see a horse with three heads in different positions – a characteristic feature of Côa art – which may possibly be in a copulation scene.

Finally, at Ribeira de Piscos, you pass one of the glories of the Côa: a composition of two horses, facing each other and with overlapping heads. Further on, there are rocks bearing fine figures of two aurochs as well as a remarkable ithyphallic human figure. At the confluence, around the corner to the left, you climb up past

An engraved panel at Penascosa, Côa Valley.

some modern petroglyphs, including a clockface, to reach some huge aurochs figures dominating the river; these must originally have been visible from quite a distance. On your return, it is possible to climb the slope and see one or two of the small, very fine horse engravings that exist on many rocks. So fine that they are almost invisible, they are best studied at night with oblique light. Since their discovery and study entail the cleaning of the rocks, very few have been exposed; untold quantities of them remain for future generations to discover.

On stylistic grounds, the Côa art has been attributed to a period from the Gravettian (c.24,000 years ago) to the Magdalenian (c.10,000 years ago). Excavations of occupation sites in the area, and also at the site of Fariseu where palaeolithic sediments (containing stone tools and portable engravings) covered some pristine panels of petroglyphs, have fully confirmed this attribution.

Baptista, A.M., 1999, *No tempo sem tempo: a arte dos caçadores Paleolíticos do Vale do Côa*, Centro Nacional de Arte Rupestre: Vila Nova de Foz Côa.

**Address**
Parque Arqueologico do Vale do Côa, Av. Gago Coutinho 19, 5150 Vila Nova de Foz Côa
Tel. (351) 279 768 260/1; fax 279 768 270. Visitor centre at Castelo Melhor: tel. 279 713 344. Visitor centre at Muxagata: tel. 279 764 298
www.ipa.min-cultura.pt/coa
visitas.pavc@ipa.min-cultura.pt

**Nearest city/town** Guarda/Vila Nova de Foz Côa.
**Nearest airport** Porto.
**Nearest car rental** Guarda.
**Nearest train station** Pocinho from Porto; Celorico da Beira from Lisbon.
**Nearest bus route** Two express buses from Lisbon stop at Vila Nova de Foz Côa daily.
**Nearest taxi or private car hire** Vila Nova de Foz Côa, Torre de Moncorvo and the above-mentioned train stations.

**Restaurants in the vicinity** Vila Nova de Foz Côa, Torre de Moncorvo.
**Hotels in the vicinity** Vila Nova de Foz Côa, Torre de Moncorvo.

**When is this site open?** All year round 09.30 to 12.30 and 14.00 to 17.30.
Closed Mondays, Boxing Day, New Year's Day, 1 May and Easter Day. Boat
visits are only on weekends in September and October.
**Admission prices** 5 euros per person and per site. Night visits to Penascosa
at times of full moon 7,50 euros per person.
**Storage facilities?** Yes.
**Do you have to make up a group?** Yes. Groups are taken from the visitor
centres by guides in the park's vehicles.
**Can you reserve a place in a group?** It is essential to book your place,
preferably at least a week ahead.
**Length of tour** Penascosa site, about 90 minutes (from Castelo Melhor
centre); Ribeira de Piscos site, about 150 minutes (from Muxagata centre);
Canada do Inferno site, about 90 minutes (from park office in Vila Nova de
Foz Côa).
**Languages of the guides** Portuguese, English, French, Spanish.
**Is the site privately owned?** No.
**Is there a gift shop?** Yes, at the park office and in the visitor centres.
**Is there a café (water)?** Yes, at the two visitor centres, and close to the park
office.
**Are there WC facilities?** Yes, at all three centres.
**Handicapped access?** No, except to part of the Penascosa site.
**Is any climbing necessary?** There is a climb down to Canada do Inferno, a
climb up at Ribeira de Piscos, and an optional small climb up at Penascosa.
There are some steps at all three sites, especially Canada do Inferno.
**Distance to walk** Penascosa, about 500m; Canada do Inferno, about 1km;
Ribeira de Piscos, about 4km.
**Level of fitness required** Moderate at Canada do Inferno and Ribeira de
Piscos; minimal at Penascosa.
**Equipment required** Hat, sunscreen, water (especially in summer),
comfortable shoes, raincoat in wet weather (umbrellas are forbidden).
**What are the conditions?** Normal.
**Is it slippery?** It can be slippery in wet weather.
**Is photography allowed?** Yes.

# ITALY

## LEVANZO
### (GROTTA DEL GENOVESE)

This cave is now on a small island about 12km off Sicily, but in the Ice Age the lower sea level meant that there was a land bridge between the two. The palaeolithic art here was first discovered in 1950, and comprises only engravings – about thirty-four of them, not all of which can be seen during a normal visit. But the inner chamber where the engravings are located also contains numerous little red and black paintings from a later period of prehistory – perhaps the

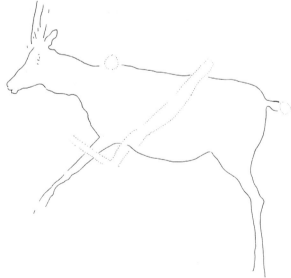

Tracing of engraved deer at Levanzo (after Graziosi).

Neolithic or Bronze Age – which were discovered in 1949 and which consist mostly of anthropomorphs, animals, fish and 'idols'.

The cave's engravings include 5 deer, 10 bovids and 12 horses. There are some striking figures, such as a young stag turning its head, a bull with protruding tongue, another bull seen from the front and a little horse with its foal, as well as some humanoids. The style of the engravings, together with that of a portable engraving of a bovid unearthed at the site, place Levanzo's earlier art at the very end of the Ice Age (a radiocarbon date of 9,694 BC was obtained).

Graziosi, P., 1962, *Levanzo: pitture e incisioni*, Sansoni: Florence.

**Address**
31 Via Calvario, 91010 Isla de Levanzo, Sicily
Tel. (39) 0923 924032; mobile (39) 339 7418800. For bookings, ask for Mr Natale Castiglione
www.grottadelgenovese.it
info@grottadelgenovese.it

**Nearest town** Trapani in Sicily.
**Nearest airport** Birgi Trapani.
**Nearest car rental** Trapani.
**Nearest train station** Trapani.
**Nearest bus route, taxi or private car hire** No buses, taxis or car hire on the island, but a tour of the island is included when you visit the cave.
**Restaurants in the vicinity** Trapani.
**Hotels in the vicinity** Trapani.

You can reach the cave from the island of Levanzo, either on foot (about 150 minutes there and back) or by Land-Rover and then about 700m on foot along a steep but even mountain path; or by sea from Trapani by jetfoil (Siremar, tel. 0923 27780; Ustica Lines, tel. 0923 22200) – the sea trip lasts about 50 minutes.

All paintings but only part of the engravings are accessible to the public – bovids, equids, cervids.

**When is this cave open?** All year round 10.30 to 13.30 and 15.00 to 17.00.
**Admission prices** 15 euros per adult; children 6–10 3 euros, 10 and over 15 euros, under 6 free.
**Storage facilities?** No, but bags can be left at the Café Arcobaleno in Trapani.
**Do you have to make up a group?** No.
**Can you reserve a place in a group?** Yes; ask when in the area.
**Languages of the guides** Italian.
**Length of tour** About 2 hours.
**Is the cave privately owned?** Yes.
**Is there a gift shop?** No, but souvenirs are available at a shop called La Grotta near the café.
**Is there a café (water)?** No.
**Are there WC facilities?** No, but there are at the café.
**Handicapped access?** No.
**Is any climbing necessary?** None to get to the cave; there are some stairs inside the cave.
**Distance to walk** The cave is small, so there is minimal walking inside.
**Level of fitness required** Moderate. Avoid if you have serious heart trouble or knee problems.
**Equipment required** Flashlights are provided.
**What are the conditions inside the cave?** A little damp.
**Is it lit?** No.
**Is it slippery?** A little.
**Is photography allowed?** No.

# GROTTA DEI PUNTALI – CARINI (PA)

There is a group of small caves near the coast of Sicily, close to Palermo, which contain linear incisions – parallel, convergent or intersecting – on their walls, which may date back to the Ice Age. Puntali is less than 1km from the sea (but would have been further from it in the Ice Age), and is a horizontal cave about 110m long and 15m wide. It contains a few naturalistic engravings which were

first discovered in 1963 – a couple of horses and a probably incomplete deer. Their similarity in style to the animals of Levanzo (page 208) ascribe them to the end of the Ice Age.

Graziosi, P., 1973, *L'arte preistorica in Italia*, Sansoni: Florence.

Mannino, G., 1978, 'Le grotte di Armetta (Carini, Palermo)', *Sicilia archeologica* 38: 73–83.

**Address**
Via Castello 3 and 7, 90044 Carini (PA)
Tel. (39) 091 866 0163 (operator speaks English); mobile (Mr B. Umberto) 338 7690730 (Italian only)
www.grottadeipuntali.it
info@grottadeipuntali.it

**Nearest city and town** Palermo (25km away), Carini.
**Nearest airport** Punta Raisi (Palermo).
**Nearest car rental** Palermo airport.
**Nearest train station** Carini (about 800m from the office at Via Castello).
**Nearest bus route** Near the office. No bus reaches the cave.
**Nearest taxi or private car hire** Taxi: Palermo airport; private car hire: Carini.
**Restaurants in the vicinity** Yes, but not near the cave.
**Hotels in the vicinity** Yes.

**When is this cave open?** All year round Monday to Saturday 09.00 to 14.00; Mondays and Wednesdays also 15.00 to 18.00. Closed Christmas and Easter.
**Admission prices** Free, but as the site is a wildlife reserve only small groups are admitted, by permission from Gruppi Ricerca Ecologica: Gestore Grotta dei Puntali, Via Castello 7, 90044 Carini (PA), tel. (39) 091 609 0663.
**Storage facilities?** No, but it is possible to leave small items at the office.
**Do you have to make up a group?** Only parties of 5 or 6 people at a time are allowed in the cave. Individual requests can also be satisfied. Either contact the office in Via Castello or call 091 866 0160 and make arrangements for the visit.
**Can you reserve a place in a group?** Yes.
**Languages of the guides** Italian, some English.

**Length of tour** Public is allowed only in part of the cave (about 200m). The tour lasts about 20 minutes.

**Is the cave privately owned?** No.

**Is there a gift shop?** Yes, near the office.

**Is there a café (water)?** Yes, near the office.

**Are there WC facilities?** By the cave, in the house of a shepherd family. On request they show how typical cheese is made and provide samplings of their products.

**Handicapped access?** No.

**Is any climbing necessary?** There is a minor climb to the cave (about 200m). There are no stairs inside.

**Distance to walk** The cave is about 3km from the office. You must reach the meeting point (about 200m from the cave) by your own means.

**Level of fitness required** Normal.

**Equipment required** The guides can provide a small number of flashlights but it is best to bring your own.

**What are the conditions inside the cave?** It is cool, and there is a big colony of bats living at the back end of the cave (they are not shown to the public).

**Is it lit?** No.

**Is it slippery?** Not inside. A little outside in bad weather.

**Is photography allowed?** Only outside.

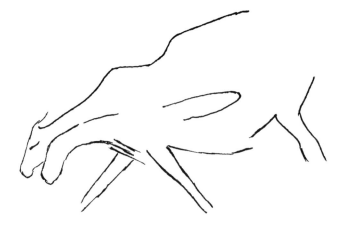

Sketch from photos of the engraved horses at Puntali.

# GROTTA DEL CAVIGLIONE E BALZI ROSSI

The Balzi Rossi (Red Rocks) on the Italian coast close to Monaco house seven big rock shelters, some of which – such as Barma Grande and the Grotte des Enfants – played a hugely important role in early studies of the Upper Palaeolithic, yielding important burials and female figurines. Three of the caves are open to the public. In one of them, the Grotta del Caviglione, excavations were carried out in the late nineteenth century, which lowered its floor by 5m. So it was only in 1971 that a small horse engraved on the wall was discovered: by then it was not only almost 7m above the floor, but masked with soot from the locomotives which had passed near by for sixty years. It is located on the western wall, in the daylight zone, facing into the cave, and measures 39.5cm long and 19.5cm high. Curiously, it was drawn on top of six vertical grooves cut into the rock. Some traces of red and yellow ochre on the walls suggest that there used to be more art

Tracing of the engraved horse at the Grotta del Caviglione (after Vicino).

here. Thanks largely to the age of the cave's occupation deposits, it is thought that the horse dates as far back as the Aurignacian (*c*.30,000 years ago). Other shelters and fissures near by also contain linear incised marks.

Vicino, G. and Simone, S., 1972, 'Les gravures rupestres paléolithiques des Balzi Rossi (Grimaldi, Ligurie italienne)', *Bulletin de la Société Préhistorique de l'Ariège* 27: 39–58.

---

**Address**
Museo Balzi Rossi, Via Balzi Rossi 9, 18039 Grimaldi di Ventimiglia (IM)
Tel: (39) 0184 38113
http://www.archeoge.arti.beniculturali.it (the website of the Soprintendenza per i Beni Archeologici per la Liguria)
archeoge@arti.beniculturali.it

**Nearest town** Ventimiglia (Italy), Mentone (France).
**Nearest airport** Nice (France), Albenga (Italy) and Genova (Italy).
**Nearest car rental** Ventimiglia.
**Nearest train station** Ventimiglia for long-distance trains. On the route Ventimiglia–Nizza (only local trains) there is a stop in Garavan, which is about 500m from the museum.
**Nearest bus route** None.
**Nearest taxi or private car hire** At the train stations.
**Restaurants in the vicinity** Yes, the Balzi Rossi restaurant (very well known and expensive), and several cafés for snacks.
**Hotels in the vicinity** Mentone (2–3km away).

**When is the cave open?** Daily 08.30 to 19.30. Closed Mondays, 25 December, 1 January and 1 May. Visits are suspended in wind and bad weather for safety reasons.
**Admission prices** 2 euros, and 1 euro reductions. Credit cards not accepted.
**Storage facilities?** No, but bags can be left with the museum attendants.
**Do you have to make up a group?** No.
**Can you reserve a place in a group?** No. Large groups should make special arrangements, as the site is small.

**Languages of the guides** Italian, French, English. The museum attendants show the caves to the tourists.

**Length of tour** About 1 hour, including the museum.

**Is the cave privately owned?** No.

**Is there a gift shop?** No. There is a newsstand near the museum where you can buy guidebooks.

**Is there a café (water)?** Yes, about 50m from the museum.

**Are there WC facilities?** Yes, there are three in the museum.

**Handicapped access?** Yes for the museum (ground floor only), but not for the caves.

**Is any climbing necessary?** There is a minor climb to the site (about 40m) and some steps leading to a footbridge over the railway. There are no stairs inside.

**Distance to walk** The whole tour, including the museum, is about 300m.

**Level of fitness required** Normal.

**Equipment required** None.

**What are the conditions inside the cave?** Similar to those outside.

**Is it lit?** Natural light.

**Is it slippery?** Not particularly.

**Is photography allowed?** Only outside.

# RIPARO DI ROMITO

The engravings of Romito were discovered in 1961. They are located on blocks in front of a large rock shelter, which has a dark passage inside. To the east, a block bears numerous linear incisions of different lengths, depths and orientations. They were originally covered by late Upper Palaeolithic deposits, which prove their antiquity. To the west a block contains the glory of the site: a large aurochs bull, 1.2m long, deeply engraved with a continuous line, with forward-pointing horns. It faces left, and its nostrils, eyes and hoofs are carefully depicted.

OVERLEAF The two engraved aurochs of Romito.

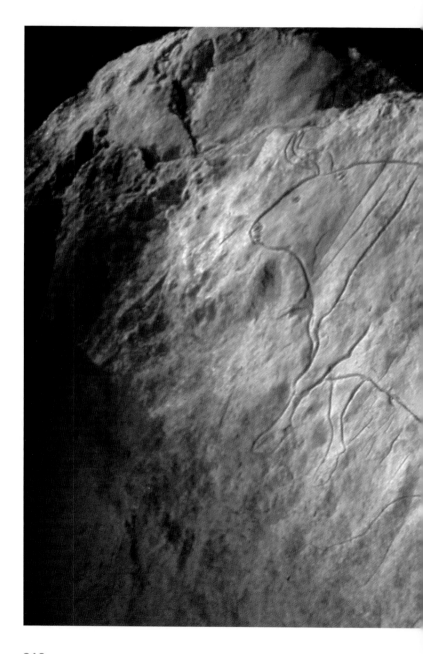

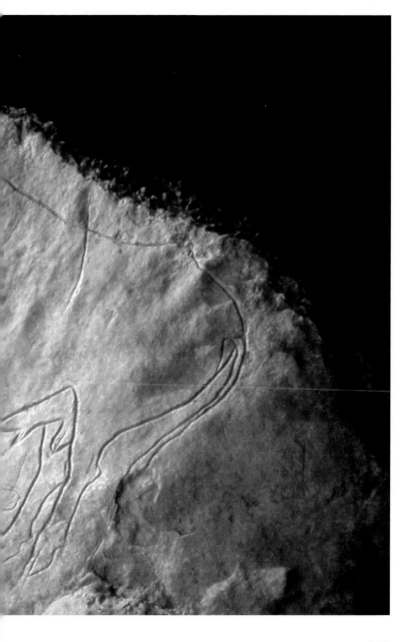

Immediately below it is a much smaller horned bovid figure, facing right and upwards, as well as some simple linear incisions, and a small horned bovid head, facing left.

Excavations in front of the shelter revealed six Upper Palaeolithic skeletons, notably a grave found in 1963 containing a small middle-aged female together with an adolescent male dwarf – the earliest dwarf known anywhere in the world, since this layer of the site has been dated to 11,150 years ago. This kind of age would also be perfectly acceptable for the site's engravings. The dwarf, just over 1m tall, survived to an age of about seventeen, despite his physical impediments. The fact that he was buried in a decorated shelter may be because he was very special within his society; at the only other burial known in an Ice Age decorated shelter, at Cap Blanc in France (page 54), the person appears to have been buried in a place of honour, suggesting that she was special. And as at Cap Blanc, a cast of the skeletons now lies in their original location.

Graziosi, P., 1962, 'Découverte de gravures rupestres de type Paléolithique dans l'abri du Romito (Italie)', L'anthropologie 66: 262–8.

Graziosi, P., 1973, L'arte preistorica in Italia, Sansoni: Florence.

---

**Address**
City Hall, Via Municipio, 87020 Papasidero (CS), Calabria
Tel. (39) 0981 83078 (ask for Mr Grisolía)
vinc.grisolia@libero.it or papasiderocomune@libero.it

**Nearest city/town** Reggio Calabria/Scalea (CS). Papasidero (CS) owns the cave, but is further away.
**Nearest airport** Lamezia Terme (CZ).
**Nearest car rental** Scalea, Mormanno (CS).
**Nearest train station** Scalea.
**Nearest bus route** Public bus service; the nearest bus stop is at Bivio Avena (4km from the site).
**Nearest taxi or private car hire** Scalea.

**Restaurants in the vicinity** Café restaurant by the site.
**Hotels in the vicinity** None in the immediate vicinity.

**When is this cave open?** October to February 09.30 to 16.30; February to April 09.00 to 19.00; May to September 0.90 to 20.00.
**Admission prices** Adults 2,60 euros; children (7–14) 1,55 euros (no children under 7); 1,55 euros per person in groups of at least 10. There is a municipal shuttle to the site. Credit cards not accepted.
**Storage facilities?** Some luggage can be left with the museum attendants.
**Do you have to make up a group?** No.
**Can you reserve a place in a group?** Yes.
**Languages of the guides** Italian, English.
**Length of tour** About 1 hour.
**Is the cave privately owned?** No.
**Is there a gift shop?** No, but the café on the Via Romito sells souvenirs.
**Is there a café (water)?** Yes.
**Are there WC facilities?** Yes, at the small museum Antiquarium.
**Handicapped access?** No.
**Is any climbing necessary?** There is an easy slope to the cave. There are no stairs in the cave.
**Distance to walk** About 4km from the nearest bus stop (a municipal shuttle serves the site); about 100m in the site.
**Level of fitness required** Minimal.
**Equipment required** None.
**What are the conditions inside the cave?** Damp but not cold.
**Is it lit?** No. The decorated rock is in the open air.
**Is it slippery?** A little.
**Is photography allowed?** Yes, including the decorated rock.

# INDEX

# PICTURE CREDITS

## ACKNOWLEDGMENTS

I am profoundly grateful to Nadine Rhodes for her invaluable help with planning and structuring this book, especially the 'template' of practical information for each cave. For particular help with obtaining the relevant information on various caves, I am deeply grateful to Claudia Naretto-Chiarini, Conchita García, María González, Michel Lorblanchet, Pentxo Eguizabal, Margherita Mussi, Gabriel Rocque, António Carlos Silva, Pedro Cantalejo Duarte, Cécile Gizardin, Georges Lévy and Linda Wilson. In addition, I am indebted to numerous friends and colleagues who, over the past decades, have taken me to different sites and shown me the art. Here, in a guidebook, it is only fitting that I should offer special thanks to the guides at each cave – in particular Pentxo and María at Covalanas and Pindal respectively, mentioned above; Chema Ceballos and his team at El Castillo; María Isabel Estrada and all the guides at Altamira; Alfonso Millara González and his team at Tito Bustillo; Jean Archambeau at Cap Blanc; Claude Archambeau and his team at Les Combarelles; Nicole Ussel and her team at Font de Gaume; the Plassard family at Rouffignac; Francis Jach at Cougnac; Serge Roussel and his team at Pech Merle; Yoan Rumeau at Gargas; René Gailli and Nicole Pailhaugue at Bédeilhac; Jean-Noël Lamiable and his team at Niaux; and Ian Wall and his team at Creswell. For illustrations, I would like to thank Yvonne Vertut, Elaine Marshack, Brigitte and Gilles Delluc, Francis Jach, Pentxo Eguizabal, Nadine Rhodes, Pedro Cantalejo Duarte, Ramón Montes, Joëlle Darricau, José Antonio Lasheras, Philippe Plailly and Geneviève Pinçon. Finally I am grateful to Anne Askwith and Anne Wilson at Frances Lincoln for turning this into a book.